ADJUSTED MARGIN

ADJUSTED MARGIN

XEROGRAPHY, ART, AND ACTIVISM IN THE LATE TWENTIETH CENTURY

KATE EICHHORN

The MIT Press
Cambridge, Massachusetts
London, England

© 2016 Massachusetts Institute of Technology

All rights reserved. No part of this book may be reproduced in any form by any electronic or mechanical means (including photocopying, recording, or information storage and retrieval) without permission in writing from the publisher.

This book was set in Univers and Archer by The MIT Press. Printed and bound in the United States of America.

Library of Congress Cataloging-in-Publication Data

Names: Eichhorn, Kate, 1971– author.
Title: Adjusted margin : xerography, art, and activism in the late twentieth century / Kate Eichhorn.
Description: Cambridge, MA : The MIT Press, 2016. | Includes bibliographical references and index.
Identifiers: LCCN 2015038276 | ISBN 9780262033961 (hardcover : alk. paper)
 Subjects: LCSH: Xerography—Social aspects. | Photocopying—Social aspects. | Student movements—History—21st century. | Social movements—History—21st century.
Classification: LCC TR825 .E33 2016 | DDC 686.4/42—dc23 LC record available at http://lccn.loc.gov/2015038276

10 9 8 7 6 5 4 3 2 1

CONTENTS

Preface vii
Acknowledgments xiii

 Introduction: Neglect, Dust, and Xerography 1
1 From Control Revolution to Age of Generative Systems 27
2 Open Secrets and Imagined Terrorisms 57
3 Xerography, Publics, and Counterpublics 81
4 Eros, Thanatos, Xerox 113
5 Requiem at the Copy Machine Museum 147

Notes 165
Works Cited 187
Index 197

PREFACE

In September 2010, I brought a group of students to the exhibition "ACT UP New York: Activism, Art, and the AIDS Crisis, 1987–1993" at the White Columns gallery in New York's West Village.[1] Arriving at the gallery, I expected to find the documentary traces of a movement I had never encountered firsthand. After all, when the AIDS crisis was at its peak and ACT UP was most active, I was the age of the students who had accompanied me to the gallery and was pursuing a degree at a small liberal arts college hundreds of miles away. Despite the fact that I hadn't been *there*—in New York in the late 1980s to early 1990s—when I arrived at the gallery what I encountered was surprisingly familiar. I not only recognized most of the posters on display but also recalled photocopying and distributing many of the same posters. As I would say to my students, "This is what my undergraduate campus looked like." What I meant was that the slogans and iconography on display—words and images put into circulation by art activist groups like Gran Fury—were part of the visual backdrop to my college years in the early 1990s. Just as familiar as the slogans and iconography, however, was the distinctive gritty aesthetic of the posters, many of them photocopied reproductions.

The materials on display were not only familiar to me because they had circulated widely enough to reach my campus far from their site of production, but more significantly because I had participated in their dissemination. Without giving much thought to who had originally produced the posters (usually already photocopies of photocopies of photocopies by the time I encountered them), I felt a responsibility to reproduce and distribute these materials. Indeed, as a student activist in the early 1990s, I spent an extraordinary amount of time copying and distributing posters produced by queer and feminist activists from organizations across North America. The posters became part of my visual memory of the era, because I was part of their reproduction and distribution.

One might conclude that photocopying and distributing posters in the two decades or so preceding the arrival of the web was simply a pre-social-media equivalent to reposting articles about political events on Facebook, but the analogy quickly breaks down. Anyone who has spent time photocopying and postering knows that this is an entirely different activity. You have to find a copy machine—an affordable copy machine, ideally a free one. You have to be willing to fix its endless jams. You have to care enough to keep fixing these jams. You have to find time to put up the posters. You have to choose your adhesive—staples or packing tape or wheatpaste. More importantly, you have to choose either to respect the bylaws (poster only in designated areas) or to reject them. In short, you have to be willing to do the work, deal with the mechanics, and get caught, and none of this has much in common with reposting slogans, photographs, or articles on Facebook or Twitter.

In many respects, the story of the "ACT UP New York" exhibit is where the story of the copy machine told in this book begins—in another era, to be precise in the two decades or so just before the widespread arrival of the web.[2] It is also a story that begins in urban spaces—in New York, Toronto, Chicago, and other cities across North America—but it is by no means a story confined to these spaces. The copy machine, like the web, is a technology that was readily embraced because of its ability to transgress borders. Like other histories of communication technologies, then, this one is at least partially a history of spatial practices.[3] It's about how communication technologies redefine, expand, and collapse spaces and in the process open up the possibility for new types of networks and communities to take shape. Of course, the copy machine is also marked by its own specificity. Despite its status as an office machine, the copy machine is deeply entangled in histories of 1970s, 1980s, and 1990s subcultures, playing an especially notable role in the era's punk, street art, and DIY movements. Yet, as I emphasize throughout this book, the impact of the copy machine cannot

be fully understood by tracing how this office technology became synonymous with the aesthetics of punk rock and downtown art scenes. Beyond being appropriated by artists and anarchists, these machines also played an essential role in late twentieth-century social movements, specifically the activist movements that emerged in response to the AIDS crisis and increased demand for queer rights in the 1980s to 1990s. Finally, because this is not the story of a slick handheld digital device but rather the story of a clunky piece of office equipment dating back to the late 1940s, this is also a history of repeated gestures. In short, it's about the monotony of reproducing documents in the late age of print and about the banality embedded in even our most subversive acts.

As I have worked on this book (a research project that dates back to 2004),[4] the copy machine has undergone a significant decline in use and status. In 2004, it was still impossible for most white-collar workers to imagine carrying out their everyday labor without the aid of copy machines. By 2008, change was imminent, empowering some people, like the dean of my college at the time, to declare that we would be "photocopy-free" by the end of the decade. My dean never realized this ambitious mandate, but his prediction was not entirely unfounded. If I once spent several hours a week making handouts for students and illegally photocopying and binding entire out-of-print books for my research, by 2010, like most of my colleagues and nearly all of my students, I had moved on. I was downloading and uploading rather than copying. Suddenly, everything seemed to be already available as an electronic edition or contraband pdf. So as I finally turned my full attention to this book, my relationship to the copy machine was, in a sense, already on the rocks.

I am well aware of the dangers of ascribing feelings to machines. Yet there is little doubt that many of us have big feelings about copy machines; more oddly, we have a tendency to attribute feelings to these machines. In a 2002 survey commissioned by photocopier

manufacturer Hewlett-Packard Canada Ltd., one in ten workers admitted to kicking or punching their copy machines. A widely circulated newspaper article written about the survey emphasized that rates of "abuse" were significantly higher among women than men: "A total of 48 per cent of women surveyed reported that they had assaulted a photocopier, compared to 37 per cent of men." (The article failed to mention that women are also more likely than men to find themselves relegated to photocopying tasks in the workplace). Most notably, the article emphasized that while there is no question that copy machines are subject to abuse, they may also be partially to blame. One machine technician observed that copy machines are "notorious for not giving you what you want."[5] More than the statistics, which merely confirm what we already know—many of us have a strained relationship with the copy machine—the article is notable for its use of language. Reading between the lines, the reader is left with the impression that copy machines are potential culprits, since they apparently often don't put out when we need them to or don't put out in quite the right way. Copy machines apparently do more than produce documents—they also produce an entire range of affects from blame to anger to anxiety. In the late 1960s, when the copy machine was still a novelty in most workplaces and educational institutions, a feature article in the *New Yorker* painted a remarkably similar portrait. With specific reference to the 914, Xerox's most popular copy machine at the time, John Brooks reported, "I spent a couple of afternoons with one 914 and its operator, and observed what seemed to be the closest relationship between a woman and a piece of office equipment that I had ever seen." Copy machines, he insists, are unique for their living, even animal-like, qualities. "A 914 has distinct animal traits," Brooks explains, "It has to be fed and curried; it is intimidating but can be tamed; it is subject to unpredictable bursts of misbehavior; and generally speaking, it responds in kind to its treatment." To support these claims, he cites the copy machine

PREFACE xi

operator he shadowed. "I was frightened of it at first," the operator explains, but "The Xerox men say, 'If you're frightened of it, it won't work,' and that's pretty much right. It's a good scout; I'm fond of it now."[6]

I too hold a fondness for copy machines, though my fondness has increased as my reliance on them has decreased. I have not only relied on copy machines to carry out my work (at least in the past) but also frequently made copy machines and their ephemeral output the subject of my research. Over the past two decades, I have published articles on topics ranging from zines and illegal book reproduction to public postering and copy shops. For this reason, I appreciate that alongside the fear, rage, dread, and disappointment copy machines evoke, they can be associated with more positive affects. These are machines we love and machines we love to hate. Remarkably, however, despite the strong feelings copy machines appear to incite, to date they have received virtually no attention from media studies scholars or scholars working in allied fields, such as book and publishing history.

What follows, then, is a history of a common machine, and one, as I argue throughout this book, with a deep affinity to people on the margins—people living on geographic margins (e.g., outside urban centers) and people affiliated with symbolic margins (e.g., the margins that gather up the punks, the queers, the immigrants, the visibly marked, and so on). What follows is also a social history of a banal office technology and how it came to play a major role in the development and dissemination of late twentieth-century aesthetic and political movements. Finally, because I write this at the end of the copy machine's era, this is also an elegy to a once ubiquitous technology in the process of being replaced and retooled as its utility wanes. Yet, as this book brings into focus, the margins, broadly defined, were permanently altered by the copy machine. As a result, in the face of the machine's pending demise, the impact of this adjustment continues to leave a mark on our everyday lives.

ACKNOWLEDGMENTS

First, I wish to thank the librarians, archivists, and preservationists who made it possible for me to carry out research for this book. This includes everyone who helped to facilitate my access to documents and artifacts at the National Archives of Canada, The New York Public Library's Manuscripts and Archives Division, City of Toronto Archives, Fales Library and Special Collections, Cinémathèque québécoise, and Deutsches Technikmuseum. I also wish to thank all the individuals, collectives, and corporations who kindly mined their personal and company archives for images and granted permission for me to reproduce them. Like any project that takes years to complete, this book is indebted to countless conversations—to all the people who informed this book by granting formal interviews or talking informally or simply by sharing their insights and enthusiasm for the project, I'm truly grateful. Working on this book with the MIT Press has been an immense privilege. I wish to thank Justin Kehoe and Roger Conover who were patient, supportive, and good-humored about this project throughout its development, as well as my copyeditor, Matthew Abbate. Finally, I thank my collaborator in ideas and life, Angela Carr, for her insights, critiques, and for reminding me that we live in a world where ideas are far more expansive than our present geographies and languages of inhabitance.

**INTRODUCTION:
NEGLECT, DUST, AND XEROGRAPHY**

For over two decades, Kinko's capitalized on our collective desire to seize the possibilities of the copy machine—a machine that would prove as appealing and essential to executives and bureaucrats as it would to anarchists and artists—and it did so all day and all night long. Named after company founder Paul Orfalea's kinky hair, Kinko's was established in 1970 at the back of a burger joint just off the University of California campus in Santa Barbara.[1] Despite the seemingly poor choice in company name and location, Orfalea was on to something—the growing demand for public access to copy machines. In the early days, Kinko's was a campus-based enterprise guided by a legendary startup philosophy. When the cramped premises became overcrowded, Orfalea would wheel his Xerox machine out onto the street. When he needed to increase his cash flow, he hawked office supplies door to door in college dormitories.[2] But Orfalea recognized that the demand for copying was much greater than the reach of the UC campus in Santa Barbara. Without funds to franchise, he formed partnerships with other young entrepreneurs, and soon the hippies and surfers he recruited were scouting potential Kinko's locations up and down the west coast, reportedly sleeping in Volkswagen buses along the way.[3] By the mid 1990s, Orfalea's strategic speculating at a Santa Barbara burger joint and haphazard partnerships with his enterprising peers had mushroomed into over 700 Kinko's outlets across the United States with an estimated billion dollars a year in sales.

In the 1990s, at least officially, the company claimed to be in the business of transforming the concept of office itself. One advertising campaign maintained that Kinko's was turning "office" from a noun into a verb: "More and more the office defines a state of activity rather than a place. Instead of adapting our lives to it, the office is becoming what we want it to be and what we need it to be."[4] But anyone who spent time hanging out at a Kinko's in its heyday (before most of us could easily scan, copy, fax, or email documents from home) knows that only a small percentage of

the clientele were the type of people who frequent offices. At its height of popularity, Kinko's outlets in urban centers across North America were catchbasins for writers, artists, anarchists, punks, insomniacs, graduate students, DIY bookmakers, zinesters, obsessive-compulsive hobbyists, scam artists, people living on the street, and people just living on the edge. Whether you were promoting a new band or publishing a pamphlet on DIY gynecology or faking up ID for an underage friend, Kinko's was the place to be. It is just such a scene that *New York Times* reporter Julia Szabo sought to capture in a 1994 article that ran under the headline "Copy Shop Stitches the Urban Crazy Quilt." Focusing on a 24-hour Kinko's located on Madison Avenue at 34th Street, she observed, "While the upholstery may be strictly gray, there's nothing uniform about the clientele. Spotted over a week or so were these typical patrons: A Tomkins Square Park anarchist, who is a squatter from Avenue C, designing a poster. Two staffers from *Mirabella* magazine's art department having a future cover sized. A pierced club kid designing invitations to an event at the Pyramid. Three Yeshiva University students copying class notes." Later in the same article, Szabo cites conceptual artist Kerri Scharlin, at the time a rising New York art star. Scharlin confesses that she frequently collects fliers out of the Kinko's dumpster "to use in her work," but also emphasizes that Kinko's is about more than copies: "When you stand in line to pay and you look over your shoulder to see what the next guy was doing, 9 out of 10 times it's interesting."[5] Despite its corporate branding and uniformed employees, in the 1990s the eccentricity of Kinko's was not limited to the clientele. In keeping with its roots, the company was still profit-sharing.[6] At its five Manhattan locations, it was also still offering unique and homey touches, from free coffee to the company of house cats (Nick, with a mane the color of toner, resided at the midtown location).[7] So Kinko's was doing more than turning "office" into a verb—it was providing the space and equipment needed to turn an administrative task (copying) into

art and anarchy and a social practice. You could go to Kinko's to copy your resume or make a print run of your zine or just hang out with other people into books, art, and politics, even if it was 3:00 a.m. Hence Szabo's suggestion that Kinko's is "the forum in Marshall McLuhan's global village."[8] There is little doubt that in the two decades or so preceding the arrival of the web, copy centers like Kinko's played an integral role in our experience of public culture and the production of nonlocalized networks and communities.

The historical period with which this book is concerned more or less parallels the rise and fall of Orfalea's copy center enterprise.[9] In short, it is concerned with a roughly three-decade-long period from the early 1970s, when xerographic copying became increasingly accessible to the public, to the late 1990s, when xerographic copy machines started to be displaced by a range of digital platforms—many designed to carry out analogous functions—and copy machines themselves were redesigned as digital machines. It is important to bear in mind, however, that long before the first Kinko's outlet opened and xerography became increasingly accessible outside the workplace, copy machines were already restructuring our everyday lives on numerous levels. After all, while the term "copy machine" is often assumed to refer to xerographic copiers, prior to the introduction of xerography there were a number of attempts to develop copy machines using different methods.

Although office-based printing devices were already common in the early nineteenth century—typically taking the form of letter copying presses and roller copying presses—the copy machine obsession did not fully take hold until the late nineteenth century. Between 1870 and 1910, a wide range of copy machines were introduced to the market both in Europe and North America. Among other machines over this four-decade period, patents were awarded for the Papyrograph (1874), Electric Pen (1875), Cyclostyle (1881), Mimeograph (1889), Rapid Duplicator (1887), Recitgraph (1906), Photostat (1907), Ditto Machine (1910), and Spirit

Duplicator (1923). Relying on either stencil-based or photographic methods, all of these copy machines required a master document, involved some type of messy, toxic, and time-consuming chemical process, and could only produce a limited number of copies from a single master. Nevertheless, an 1877 article in the *Daily Alta California* reported that the Papyrograph, first patented in Europe by Eugenio de Zuccato and later patented in the United States, "offers to business a cheap and expeditious method of producing certain classes of circulars."[10] While papyrography's pitch to consumers was similar to the pitch Haloid would adopt to market their new xerographic method some seventy years later, the method was remarkably different. In the case of papyrography, "Prepared paper is eaten through where touched with a special chemical ink, and is thus converted into a manuscript stencil plate, so that when laid upon white paper and pressed under a cushion containing ink, an exact copy of the writing on the prepared paper is taken."[11] In other words, one must produce a stencil before one begins the process of creating copies. For decades, copy machines would rely on iterations of the same onerous process. Edison's Electric Pen also relied on a stencil-based method. The Electric Pen, also one of the first consumer products to adopt an electric motor, was designed to drive a small needle up and down a pen shaft as one wrote. The user was then left with a stencil, which in turn could be placed in a press where ink was forced through the stencil's holes, leaving the writer with a copy of the original document.[12]

While enthusiasm for Edison's Electric Pen was short-lived, the concept would soon be retooled both as an electric tattooing needle and, more significantly, as the technology underpinning the Mimeograph. After purchasing Edison's patent, A. B. Dick refined the process by developing a machine that used Edison's stencil method in conjunction with a machine capable of turning out a higher volume of copies at a greater rate. In the twentieth century, stencil-based methods of duplication continued to dominate the

copy machine market, even following the introduction of xerographic copiers. For example, the Ditto Machine or Spirit Duplicator—a name inspired by the "spirits" or solvents used to transfer ink from the machine's master copy to paper—remained popular in schools until the 1970s. Indeed, anyone who started school before 1980 will likely still recall their teachers' purple fingers—an unavoidable hazard of turning out copies on a ditto machine. But these machines did more than stain fingers. The isopropanol and methanol contained in the machine's solvents are now considered highly toxic substances and associated with various health conditions.[13] Photo-based methods of document reproduction, such as Kodak's Photostat method and Haloid's Rectigraph method, which the company manufactured prior to and simultaneously with the release of its first xerographic copy machines, also relied on messy and toxic solutions. Unlike mimeography and related processes, however, which were relatively inexpensive and thus persisted (e.g., in schools), photo-based methods of document reproduction were quickly replaced by xerography, which offered a more cost-effective way to reproduce documents without the use of messy chemical solutions.

Xerographic copy machines were not the only copy machines that had a widespread impact on twentieth-century life. In fact, mimeography, which deserves its own book-length study, was adopted in ways that overlap those of xerography. Beyond its popularity in offices, schools, and other public institutions, mimeography was used to produce everything from science fiction fanzines to poetry chapbooks. Unlike xerography, however, mimeography remained a somewhat onerous process and one with notable limitations. With xerography, the difference between making a print run of 20 and 5,000 is negligible. As long as you don't run out of paper or toner, the process is the same. With mimeography, stencils could only be used to produce a limited number of copies, making larger print runs difficult. In addition, since xerography eliminated

the need for a master copy, the types of materials that could be produced on xerographic copy machines was also ultimately much more diverse and included a greater range of materials that might otherwise have been subject to censorship. In short, despite the two reproduction methods' obvious affinities, mimeography and xerography are marked by distinctly different processes, temporalities, and possibilities. Throughout this book, unless otherwise indicated, "copy machines" refer to xerographic copy machines.

In what follows, I offer a brief history of xerographic copy machines and some of their eclectic predecessors. I am less concerned with a linear narrative of the copy machine's evolution than with how it impacted knowledge and cultural production, eventually opening new possibilities for the dissemination of art and writing while simultaneously laying the groundwork for the development of new communities of practice and resistance. Neither confined by a single temporal, disciplinary, or methodological framework nor committed to investigating a specific set of documents or artifacts, in what follows I mine eclectic textual, visual, and material archives with the aim of locating the copy machine in time and space and in competing histories of ideas, art, and activism.

THE INVENTION OF XEROGRAPHY

As Elizabeth Eisenstein observes in the introduction to *The Printing Revolution in Early Modern Europe*, although historians are "indebted to Gutenberg's invention [since] print enters their work from start to finish," they have paid little attention to histories of print and print culture in their research.[14] While much has changed since the publication of Eisenstein's study on the history of movable type, which laid the foundations for important work in the history of books and publishing, a similar observation could be made of a more recent generation of scholars' relationship to

xerography. Although most researchers have spent a substantial amount of time using and fixing copy machines at some point in their career, few have considered the machine's epistemological, aesthetic, political, and social impacts in their research. Indeed, beyond some early technical manuals on xerography, a few more recent studies on the copy machine's eccentric inventor Chester Carlson and the Haloid Company and Xerox Corporation, and some fleeting references to copy machines in cultural studies on subjects ranging from copying to doubles, few researchers have taken up the subject of the copy machine at all.[15] Even when xerography appears to be the focus (e.g., Jean Baudrillard's obscure pamphlet *Xerography and Infinity*), the copy machine frequently remains absent.[16] Whether one looks to the history of technology, of media, or of publishing, copy machines, which have proven integral to the reproduction and circulation of scholarship for more than half a century, receive little or no attention.

The neglect may be akin to the earlier neglect of print—a case of simply failing to notice what is beneath our noses. But the comparison ignores the differences between these two modes of reproduction. While few researchers have ever engaged in the meticulous work of setting type, most by necessity have spent more time than they care to remember using copy machines. If print culture, as McLuhan suggests, had the effect of numbing our senses—of relegating "sensual complexity to the background"[17]—xerography woke our senses back up. Making a photocopy, after all, can be a profoundly physical act. It can force you to get down on your knees or to contort your body into awkward positions (to retrieve jammed pieces of paper) and to do all this in public places ranging from mail rooms to libraries to copy centers. If you're not careful, you can throw out your back or burn your hands making a photocopy. Before digital copiers became common, such incidents might even have left you temporarily marked in streaks of toner. If that's not enough, reading a photocopied document can prove just as

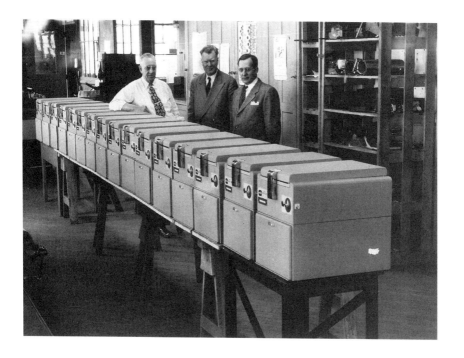

FIGURE I.1 First commercial Xerox copier production at Haloid-Rectigraph, March 20, 1950 (from Chester Carlson's scrapbook collection). Image reproduced with permission from New York Public Library Archives and Manuscripts Division.

demanding. Copies of copies of copies offer none of the ease of reading associated with traditional printing methods. Over time, copy machines pixilate and warp type, forcing the eye out of its print-culture-induced trance.[18] In McLuhan's lexicon, even if photocopies begin as a "hot medium," the process of copying copies cools them down. In short, the pixilation and distortion of a text or image as it is copied and recopied requires readers to become increasingly active in the reading process.[19] Only rarely are we unaware of the fact that we are looking at a photocopied text or image. Photocopies are marked by the machines that reproduce them. In essence, we recognize photocopies as documents and, more specifically, as documents produced by copy machines.[20]

The picture of the copy machine offered here is one of a great mechanical beast—a necessary companion and one to wrestle with. The copy machine as menace, both demonized and personified, is a recurring trope in office-based humor. A 2007 television commercial for Double A Paper featured a copy machine, transformed into a robot, descending from an office building to wreak havoc on pedestrians. The robot is eventually tamed by a female office worker who feeds the enraged machine a stack of Double A Paper—a move that transforms the "King Kong robot" back into a normal copy machine. In a 2010 sequel, another office worker unleashes her expert karate moves on a jammed copy machine, which again transforms into a giant robot and takes revenge in the form of a violent attack on the terrified worker. In the office-related comic strip *Dilbert*, copy machines have been depicted as harboring everything from repairperson-eating colonies of "paper trolls" to poltergeists intent on possessing office workers. Yet despite the popular depiction of copy machines as formidable beasts, the history of the copy machine is populated by a cast of much more innocuous characters. To be precise, it is a history of feathers, lint, dust, and powder.

Much attention is paid to such minutiae in the 1965 publication *Xerography and Related Processes*, which opens with a short

FIGURE I.2 A still from Double A Paper's popular copy-machine-robot advertisement campaign. Image reproduced with permission from Double A Paper (www.DoubleApaper.com).

essay by Chester Carlson. Carlson explains that although xerography has only become widespread since the 1950s, its history stretches back to antiquity. Reading Carlson's essay, one quickly realizes that this lone inventor was not only driven by a desire to find an efficient way to reproduce documents on ordinary paper but also by a desire to copy and perfect earlier inventors' experiments in electrostatic recording. As Carlson remarks, "*Thales of Miletus, circa* 600 B.C., observed that amber which had been rubbed with silk was able to attract small feathers, bits of straw, and lint." Likewise, he observes that Plato "mentions 'the wonderful attracting power of the amber and the Heraclean stone'."[21] His debt, however, is to the pioneers in his field, including William Gilbert, Queen Elizabeth I's physician, who invented the first electrostatic sensing device, the "Versorium," and the late eighteenth-century physicist Georg Christoph Lichtenberg who invented the first electrostatic recording process.[22] In contrast to xerography, however, these early discoveries were only capable of producing the most ephemeral of images. Exposed to a gust of wind, the so-called "Lichtenberg figures," starlike patterns made of charged particles of dust and powder, vanished.[23] Nineteenth-century inventor P. T. Riess's aptly named "breath figures," produced by applying electric charges to coins on a glass plate, removing the coins and then breathing on the glass, were just as fleeting.[24]

Although neither Lichtenberg's celestial figures nor Riess's breath figures held much potential to rival nineteenth- and twentieth-century forms of reproduction, such as photography, building on these experiments Carlson recognized the possibility in principle of perfecting a method of reproduction based on electrostatics. Drawing on personal funds and largely working out of the kitchen of his apartment in Queens, New York, he set out to perfect a method of dry printing that would avoid both the mess and cumbersome equipment associated with photographic-based methods of reproduction and the invariable damage to original

documents that occurred with "wet methods." It was only through much trial and error and eventually with the vital assistance of physicist Otto Kornei, a recently arrived Austrian immigrant, that Carlson produced what is considered to be the first xerographic copy in October 1938. The blurry, black and white reproduction, which appropriately identifies the time and place of Carlson's invention ("10.-22.-38 ASTORIA"), was produced using a method that extended earlier experiments in electromagnetic recording. As Carlson explains, on this historic occasion his assistant printed the time and place in India ink on a glass microscope slide, darkened their makeshift laboratory, then rubbed a sulfur surface with a handkerchief to apply an electrostatic charge, laid the slide on the sulfur surface, and finally placed the combined glass and charged surface under an incandescent lamp for a few seconds. After removing the slide, Carlson and Kornei sprinkled lycopodium powder on the sulfur surface and in Carlson's own words, "By gently blowing on the surface a near-perfect duplicate in powder of the notation which had been printed on the glass slide" appeared.[25]

Between Carlson's initial discovery of electrophotography, a process that would only later be renamed xerography (a coinage from the Greek words *xeros*—dry—and *graphein*—to write), and the launch of the first Xerox copy machines in the late 1940s, his process would undergo a series of improvements. By the time the Haloid Company, which would eventually rename itself Xerox Corporation, started to pitch its "revolutionary, dry, direct positive xerography process" to thrifty executives, copy machine operators were no longer whipping handkerchiefs out of their pockets or blowing powder across charged plates. The process, at least theoretically, had been simplified to enable people to "photocopy anything" with ease, speed, and at a fraction of the cost of existing reproduction methods. Indeed, the company went to great lengths to emphasize both the simplicity and ingenuity of this new method. A press release issued by the Haloid Company on

October 22, 1948, stresses that with xerography, "Chemical solutions, fumes, negatives and sensitized papers are eliminated."[26] The same list is repeated in Haloid's early advertisements for their new dry method: "No negatives, no chemical solutions, no sensitized papers are required."[27]

In the late 1940s and early 1950s, the potential applications for xerography appeared to stretch across media and sectors. A Haloid Company brochure from 1949 lists the following as among the process's "present and future applications":

1. Copying of letters and other typewritten or handwritten materials, documents, plans, charts, line drawings, etc. on ordinary papers for offices, factories, libraries, through a camera or by contact printing.

2. Making master plates for the graphic arts—lithography—photo-engraving—printing.

3. Printing or duplicating with powder instead of ink.

4. Transferring of designs, lettering, printing, trade marks, etc. to ceramics, porcelain, glassware, metal, wood, etc.

5. Printing on cloth and fabrics.

6. Semi-micro photography.

7. Recording dial readings, scale weights, electrical meters, etc.

8. Making templates.

9. Recording X-rays, spectrographs—other scientific and technical uses.

10. Direct continuous tone photography.[28]

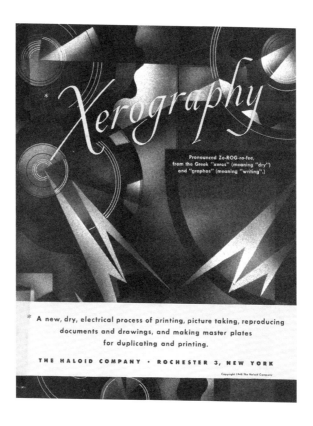

FIGURE I.3 Cover of first Haloid literature on xerography, dated November 1949. Image reproduced with permission from New York Public Library Archives and Manuscripts Division.

In the early years of xerography, the process was pitched to potential consumers not only as a process that would reduce or eliminate the mess and time associated with traditional printing methods and facilitate printing on a wide range of surfaces, but also as a process that promised a compact and potentially portable means of reproducing and circulating documents. Given their reputation as clunky rather than compact, more likely to be associated with the production of waste than the compression of data, this may come as a surprise. The machine's early history, however, suggests that it was invested in the compression, portability, speed, and real-time transmission of data that would revolutionize communications in the late twentieth century.

In the 1940s, copy machines were comparatively compact, often occupying less space than the copy machines that would become fixtures in offices, schools, libraries, and copy shops later in the century. That the copy machine's compactness and potential portability were considered early selling points likely reflects the fact that in the 1940s and 1950s, Haloid did not necessarily see established printing methods as xerography's only or even primary competition. Rather than focus on replacing printing methods, the company appeared intent on revolutionizing photography itself. In an October 22, 1948, press release, a supervisor of graphic arts at Haloid's Battelle Memorial Institute offered the following prediction: "When fully developed, the entire process can be incorporated into a portable xerocamera. With such a camera, the picture taker can snap the shutter and in a few seconds pull out a finished xeroprint. If he doesn't like the picture, he can discard it and try again, using the same xeroplate."[29] This projection presumably reflects the fact that the early development of the copy machine ran parallel to the development of instant cameras. Instant film was introduced by Edward Land in 1947, and his Land Camera, commonly acknowledged to be the first instant camera, appeared

the following year.[30] Here it is also important to bear in mind that before Haloid got into the business of copy machines, the Haloid Photographic Company was a major supplier of photographic paper and equipment.

Besides being a potential rival to existing photography methods, xerography was also considered integral to enhancing existing methods of data compression. From the 1940s onward, Haloid was engaged in developing xerographic applications that effectively combined Carlson's dry method of printing with existing methods of data compression, such as microfilm. A 1962 article in *Graphic Arts Progress* notes that "Xerography has been credited with giving new life to microfilm" by facilitating the rapid and inexpensive reproduction of documents stored on microfilm.[31] In essence, xerography was a way to "download" the compressed data already available on microfilm and related formats—an application that would transform microfilm from a form of archival storage to a technology with increased potential to be used in the circulation of information. Finally and perhaps most notably, xerography would eventually be used to create the first practical means of transmitting documents instantly (or nearly instantly) across spatial boundaries. With the introduction of the Xerox Long Distance Xerography System (LDX) in 1964, xerography—by then already recognized as a compressor of time in document reproduction—showed its potential to compress space as well by enabling documents to be transmitted across long distances in a matter of minutes. A 1966 article in the *Saturday Review* predicted that xerographic technologies would play a pivotal role in achieving "a primary goal of information storage and retrieval—to make all printed information instantly available in the home, laboratory or office, direct from a central storage place." As the article explains, "Xerox has made it possible to produce facsimile copies of books quickly and easily. Its possible future linkage to television

for copying pictures off the screen already is being discussed by leaders in electronics—and these pictures may well be the pages of books (or magazines and newspapers) carried from central libraries on microfilm."[32]

As suggested above, xerography in the mid twentieth century carried the promise of all the advancements that would transform communication technologies in the late twentieth century. It promised consumers the opportunity to reproduce texts and images quickly and inexpensively in a portable format, to make enlarged copies of data stored in compressed formats, and eventually to transmit texts and images across vast distances in a matter of minutes. Beyond revolutionizing printing by enabling one to photocopy anything on a wide range of surfaces in myriad contexts, then, xerography anticipated the mobile, high-speed, real-time forms of communication that would be taken for granted by the end of the century. As Lisa Gitelman emphasizes, for this reason xerography, unlike letterpress or the near-print technologies of the 1930s, remains "entangled with digital processes," a condition that makes it both ubiquitous and difficult to grapple with.[33]

Of course, early copy machines were ultimately not much different from the machines we would come to rely on and despise in the late twentieth century. They were prone to breakdowns; Xerox sales staff often brought several machines to trade shows, banking on the fact that if they had three machines on hand, at least one would still be working during their demonstrations.[34] More serious were the small fires that frequently erupted as a result of paper jams, forcing demonstrators to arm themselves with fire extinguishers.[35] Xerography, in a sense, held all the promise of future digital technologies while remaining mired in the dilemmas and dangers associated with industrial-era machines.

Copy machines nevertheless flourished. Throughout the 1950s and 1960s, Haloid Company's and eventually Xerox Corporation's

stock rose as competitors sought to duplicate the dry-writing process the company had had the foresight to invest in when others were still turning Carlson away.[36] Curiously, however, Haloid never sought to own the key word for the process but simply the applications they developed using the process. Early on, the company made a conscious decision to let "xerography" remain in the public domain. Despite the common perception that "xerography" is a proprietary eponym, this more general term was never trademarked. As Haloid's vice-president in charge of sales explained in a 1952 article:

> Three years ago we took over laboratory development of a new process we believe will revolutionize present office methods of producing multiple copies of original documents. Simultaneously, we coined a new word to describe the promising process: "xerography." Today that word, "xerography," is listed in a standard English dictionary, and the patented process identified by the brand name XeroX, is now used in 25% of the nation's top businesses. One of our first marketing decisions was to resist the natural impulse to copyright the term xerography. We threw it into the public domain—not without a wistful sigh or two—and coined another one, XeroX, to describe our own adaptation of the process. This decision has repaid us many times over in the form of publicity.[37]

In essence, without necessarily endorsing what now might be understood as an open-source approach to technological development, in the late 1940s Haloid's marketing department recognized the potential benefits of supporting rather than prohibiting xerography's widest possible use and circulation. In the process, the company gained both free publicity and the benefit of being able to easily track xerography's surprising adaptations and innovations by users, which the company could in turn exploit.

Notwithstanding xerography's recognized potential to be used across sectors in surprising ways and Xerox's innovative approach to marketing, like Kinko's—the company that would eventually play a major role in expanding public access to copy machines—there was a notable disconnect between the Xerox machine's advertised and actual uses. Xerox ultimately sought to sell its copy machines as machines designed to save companies time and money, but this was by no means why copy machines achieved the cultural status they did in the late twentieth century.

There is at least some reason to believe that Carlson, if not Haloid, recognized the potential of xerography's other—even otherworldly—applications. By the 1960s, Carlson had long finished toiling away in his makeshift kitchen laboratory and had started to dream up more esoteric applications for xerography. Despite his training in both law and science, xerography's inventor was surprisingly open to what later observers might categorize as "new age" phenomena. So as profits rolled in from his patent, he turned his attention to funding various philanthropic causes, including an extrasensory perception laboratory at Duke University and various programs run by the American Society for Psychical Research (a pseudo-scientific organization established in the late nineteenth century to investigate topics ranging from telepathy to clairvoyance to psychokinesis).[38] Carlson was doing more than supporting other researchers' investigations of the paranormal. As if intent on applying his knowledge of electrostatic reproduction beyond the realm of printing, in the early 1960s he started to contemplate an "electrodynamic theory of life." Although biographer David Owen downplays Carlson's interests in the paranormal (notably attributing them to his wife), Hillel Schwartz observes that in the years leading up to his death, he "seemed to be making the xerographic principles of light, conductivity, charge, and imprint into a hypothesis of a higher-order life."[39]

More broadly, despite its banal origins as a time- and money-saving office technology, the history of the copy machine has been deeply shaped by its users' imaginations. As David A. Ensminger speculates, Carlson—who was open not only to the possibility of psychic phenomena but also to some of the most radical causes of his era, including desegregation—may have anticipated and even welcomed what eventually became of his machine. That Carlson supported schools, integrated housing, relief agencies, pacifist causes, and refused to own a car is cited as evidence by Ensminger that "the democratic potential of the Xerox machine, or xerography itself, can thus be seen as an extension of the creator's desire to see a more diverse, integrated, and participatory American culture."[40] While it is impossible to know for certain whether Carlson anticipated, let alone would have welcomed, his machine being deployed by future generations as a tool for creation, subversion, and resistance, copy machines—as discussed throughout this book—have been deployed both in and against the grain of their original intentions since their inception.

ADJUSTED MARGINS

At the center of this book is a single and somewhat audacious argument: that copy machines had a profound impact on how the margins were constructed and experienced in the late twentieth century. To be clear, however, it is not without reservation that I evoke the concept of the margin—a concept as useful as it is beholden to the theoretical and political investments of another era.

References to the margin (and margins) dominated both postmodern theorizing and identitarian politics in the final quarter of the twentieth century. In the 1980s and early 1990s, the margin was evoked in the name of undergrounds and diasporas, subcultures and subalterns. While it was sometimes used to refer to

actual places (e.g., refugee claimant hotels, suburban mosques, and cruising spots for gay men), the margin was also synonymous with more abstract forms of alterity and displacement. Along the way, the margin became bloated with contradictory and conflicting meanings and investments. Postmodernists declared that the margin no longer held as the center had already collapsed. Meanwhile, proponents of identity politics continued to shore up the margin as a strategic vantage point from which to fire critiques at the "center," a location that allegedly was home to those theorists announcing the margin's dissolution. The margin paradoxically became synonymous with infinite potentiality and absolute lack. Jacques Derrida emphasized the signifying effects of the margin—always already an "inexhaustible reserve."[41] For many feminist and postcolonial theorists, however, the margin was understood to be part of a whole yet outside the locus of power—in other words, anything but an inexhaustible reserve.[42] For all these reasons, calling up the margin remains a somewhat perilous endeavor. Over the course of the 1980s and 1990s, the margin accumulated an excessive amount of theoretical and political baggage from which it has not yet recovered. Simply put, the margin is a trope that suffers from oversignification. Nevertheless, since the beginning of this project, the title *Adjusted Margin* has stuck. As anyone who has used a copy machine knows, adjusting the margin is one of the many features modern copy machines offer. Typically, one adjusts the margin to avoid losing text along the edges of a document. However, that is not the only connotation at work in the title of this book. The margin is also evoked here as an abstract concept (e.g., a potentiality), a state (e.g., being outside the center), and in reference to actual geographies (e.g., marginal spaces and communities within and beyond the city's limits). "Adjusted margin" points, then, to a series of repeated gestures—an application we use on copy machines—and to a way of thinking, a political stance, and sometimes also to spaces we traverse in our everyday life.

Chapter 1 examines the rapid migration of copy machines from office technology to creative medium. Despite the skepticism expressed by some writers and publishers at the time, by the 1960s there was considerable optimism about the far-reaching impact of xerography, not simply as a means to reproduce documents but also as a means to create entirely new types of images and texts. Borrowing the concept of "generative systems" from artist and educator Sonia Landy Sheridan, who was optimistic enough to start a new graduate program at the School of the Art Institute of Chicago that centered largely on the use and modification of copy machines and other "generative systems," this chapter focuses on xerography's early impact on cultural production.

Chapter 2 begins with a consideration of xerography's complex and contradictory place in both judicial and national imaginaries. The copy shop has historically been a space where we have been free to violate the law, rarely if ever facing prosecution for our crimes—a place where that law is regularly articulated, even posted on the wall, but rarely enacted. For this very reason, however, the copy shop and more generally xerographic technologies have also at times been constructed as potential threats to public safety and even to state security (e.g., as tools that might be used to counterfeit travel documents). With specific reference to a post-9/11 raid on a Toronto copy shop during a Canadian-initiated antiterrorist operation, this chapter considers how copy shops and xerographic technologies have at times been adopted as targets during political and racialized panics, despite the fact that they have long been used to support administrative and bureaucratic mandates that heighten the surveillance and control of populations. These judicial-political contradictions, I argue, bring xerography's real and imagined possibilities (including its imagined threats) into relief while highlighting the extent to which xerography both consolidated and weakened the nationalisms that arose with earlier printing technologies.

Moving from the urban copy shop into the street, where photocopied materials are salient markers of the urban landscape, chapter 3 examines the role xerography played in the mediation of publics and counterpublics. Focusing specifically on New York's downtown art scene and punk scenes in the 1970s to 1990s, this chapter begins by exploring how xerography changed both what cities looked like in the late twentieth century and how we experienced them day to day. This chapter considers how the renewed interest in cities, and specifically in downtowns in the early 1990s, not only curtailed street art, such as graffiti, but in some cities across North America led to severe restrictions or even bans being placed on postering. Consideration is given both to the ideologies and the assumptions underpinning attempts to outlaw public postering and the often absurd reasons for targeting photocopied posters in particular. In the final section of this chapter, I examine how xerography, especially through forms such as mail art and zines, resulted in a gradual but by no means insignificant deterritorialization of urban spaces in the decade or so preceding the arrival of the web. Xerography, I argue, not only changed our experience of publics, counterpublics, and cities but also served as a precursor to contemporary social media platforms.

In chapter 4, I examine the copy machine's role in two interconnected political movements that emerged in the 1980s: AIDS activism and queer rights. Drawing on archival research as well as interviews with activists and artists engaged in ACT UP and queer artist and activist collectives, this chapter explores how a generation of artists and activists, informed both by the tactics of second-wave feminism and the aesthetics of punk, deployed the copy machine as an essential tool in local and global political battles while simultaneously elevating the copy machine's gritty, DIY aesthetic in international art markets. Specific attention is paid to how xerography was surreptitiously used by artists and activists

to divert resources from the private sector into the fight against AIDS and into queer rights activism long before either cause had received mainstream recognition or support.

In the final chapter I turn my attention to the status of copy machines in our post-xerographic era, focusing specifically on how copy machines—or more precisely their digital descendants—continue to be used and on the more persistent currency of the xerox aesthetic. This chapter begins, however, by examining the somewhat sad fate of xerographic copy machines. With specific reference to the collection of more than two hundred copy machines that once comprised the Museum für Fotokopie in Germany but now sits in a storage facility at the Deutsches Technikmuseum (uncataloged and with few prospects of ever being displayed again), I consider the fate of xerographic copy machines. In contrast to many other old technologies, I maintain that, once their utility wanes, these machines have little use value, even among collectors. Nevertheless, as this chapter further explores, the "xerox effect," a term most often used to describe the distinctive aesthetic associated with xerography, persists. Using the Occupy movement as a central example, this chapter concludes by suggesting that although we are already in a post-xerographic era, xerography, at least its aesthetic, lives on as signifier of a particular attitude, politics, and style.

Although I am concerned with the role copy machines have played on a wide range of fronts and maintain throughout this book that most North American cities and social movements would have taken remarkably different forms without the rapid spread of xerography in the mid twentieth century,[43] this book does not insist that copy machines are responsible for the making of publics and counterpublics in this period. If copy machines and their gritty output of posters, flyers, and zines helped to define and spread movements intent on bolstering the rights of people on the margins, it

was largely against, not with, the grain of the machine's original intentions. The liberatory and subversive histories of the copy machine presented in this book are marked by people inscribing their own desires onto a machine designed to turn out clones, not esoterics, eccentrics, or revolutionaries. By positing the copy machine as an integral part of the late twentieth-century aesthetic and social movements that restructured the margins, my intention is not to imply that copy machines were hardwired for aesthetic, social, and political transformation, but rather to highlight some of the surprising ways in which this cost- and time-saving office technology ended up accompanying us along the way.

FROM CONTROL REVOLUTION TO AGE OF GENERATIVE SYSTEMS

> Equipment isn't art ... the people who use it make it art. ... Some secretary back in the '50s probably made the first generative art when she copied her hand.
>
> **SONIA LANDY SHERIDAN, ARTIST AND FOUNDER OF THE GENERATIVE SYSTEMS PROGRAM, SCHOOL OF THE ART INSTITUTE OF CHICAGO**

Copy machines were engineered to facilitate the duplication of documents and thereby drastically reduce both the time and cost associated with the modern paper trail. While it is impossible to know to what extent Xerox's engineers anticipated the potential of copy machines to be used for creative and even subversive ends, their full potential soon started to be explored by creative workers and eventually by the publishers and artists who adopted these machines not simply as machines for reproduction but, in Sonia Landy Sheridan's words, as "generative systems."

COPY MACHINES AT WORK

A 1954 article in the economic affairs journal *Challenge* declared that copy machines are "finally bringing the industrial revolution to the white collar worker." While bringing the industrial revolution to workers already engaged in the work of the future (e.g., information processing and management) might seem to imply a backward turn, in the mid 1950s industrialization was still synonymous with speed and efficiency. Accelerating document reproduction was a key factor driving the development of paper machines during this period. As the *Challenge* article emphasized, "What once took an expert typist an hour to copy, she can now turn out in less than five minutes. Photo-duplicating machines can exactly reproduce anything written, printed, sketched, typed or in any way inscribed. Without errors, erasures or proof-reading."[1] It was

precisely this promise that Haloid and later Xerox would emphasize in their marketing campaigns.

Beginning in 1947, a series of newspaper advertisements for the Rectigraph Daylight Duplex, which Haloid sold prior to the launch of its full line of xerographic products, featured real clerical staff working in county offices and their real-life stories of success. The advertisements were, in every sense, short tales highlighting the company's ability to bring Fordism from the factory line to the office. One advertisement, for example, featured the impact of the Rectigraph on the Benton County Clerk's Office in Oregon. The advertisement quoted a letter from the county's court clerk: "At the time the machine was installed, we were completely overwhelmed with service discharges and deeds and mortgages, being about 3 weeks behind with our work in both departments. Two days after the machine was in practical use, we had all our discharges on record and two days later our mortgages and deeds were up to date."[2] While the note featured in the advertisement was written by a male county clerk, the photograph accompanying the advertisement pictured two female clerical workers, identified as Beulah Williams and Grace Malone, working alongside the Rectigraph machine. Neither of these women have a voice in the advertisement, but their presence is by no means incidental. Until the mid 1970s when Xerox introduced a new advertising campaign (its widely acclaimed series following the fortunes of a medieval monk discovering the wonders of xerography), nearly all of Xerox's advertising campaigns featured female clerical workers, often in highly demeaning positions.[3] The message was clear and consistent—copy machines are both more accurate and less expensive than the human labor provided by female clerical staff. Indeed, in addition to speeding up administrative work, copy machines, along with other new office technologies of the era, promised to drastically reduce the cost of administrative work: "If a typist makes a copy on the typewriter, her wage cost is about forty-two cents—based on a pay

rate of $1.25 an hour, and typing time of about twenty minutes. But with the opaque copier, the cost is about a dime, and the job takes about a minute."[4] As one early Xerox campaign emphasized, by purchasing or renting a Xerox copy machine, companies may save up to $250,000 annually.[5]

What the *Challenge* article failed to recognize is that in many respects white-collar workers were already products of industrialization, as were the office technologies that promised to speed up and reduce the cost of their labor. As James Beniger argues, the industrial revolution not only transformed manufacturing; by the mid nineteenth century it had also produced a "crisis of control."[6] The crisis of control hinged on a simple but by no means easily resolvable dilemma: the more you produce and the more quickly you do so, the more you require advanced systems to keep track of the products and people involved in the production. While the assembly line effectively sped up and economized production, it did not immediately give rise to new and more complex models of management. "By the mid-nineteenth century," Beniger observes, "the social processing of material flows threatened to exceed in both volume and speed the system's capacity to contain them."[7] In Beniger's account, as the control crisis mounted, a new managerial class emerged to help respond to the ensuing chaos in the manufacturing sector and well beyond. But the crisis required more than new bureaucratic structures; it required new technologies for "recording, storing, and processing information, programming its personnel, and communication with and possibly controlling its internal and external environments."[8]

FIGURE 1.1 A step-by-step guide from an equipment folder on how to use a Xerox copier, dated 1951 (from Chester Carlson's scrapbook collection). Image reproduced with permission from New York Public Library Archives and Manuscripts Division.

From Original to Multiple Copies in 3 Minutes
NO FUSS! NO MUSS! Simple to Operate

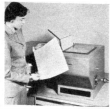

Material to be copied is placed face down on plate glass top of the Xerox Camera.

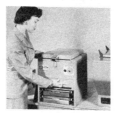

Plate is charged in Copier, then placed in Camera. The image of material to be copied is transferred directly to charged plate.

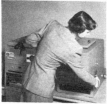

Charged Plate is now being exposed to original copy for a few seconds through the lens of the Camera.

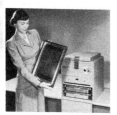

Material to be copied has been transferred directly to the developed plate.

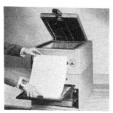

After development, the offset paper master is placed over the image on the plate.

Next, the image is transferred from the plate to the offset paper master. Then it is removed and is ready for fusing.

By placing paper with transferred image in the Fuser for a few seconds, the print is made permanent.

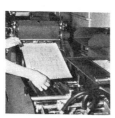

The processed offset paper master is placed in position on the cylinder of the duplicating machine and is ready to run.

The whole process, from placing original material in the Camera unit until first copies are run off, takes about 3 minutes.

Alongside other innovations, such as the mimeograph (1890)[9] and the keypunch machine (1923), Beniger lists several machines designed to reproduce documents, including the Photostat (1910) and Recordak (1927), both precursors to xerographic copy machines. It was in this sense that the copy machines and other "paper-machines" featured in the 1954 *Challenge* article extended the reach of industrialization into the workplace of white-collar workers. In short, xerography realized a process that industrialization had rendered necessary: the ability to reproduce documents in house easily, rapidly, and at a relatively low cost.

Although the demand for efficient and affordable copy machines was first and foremost driven by the modern workplace's practical need to reproduce documents, the popularity of the copy machine ultimately reflected a broader cultural shift in the mid twentieth century. John Brooks's 1967 feature article on xerography in the *New Yorker* not only highlights the copy machine's development, but also the conditions under which the practice of making copies came to be considered a necessity. As he observes, in the 1950s, which he aptly characterizes as the "raw, pioneering years of mechanized office copying,"[10] the market became flooded with new devices designed to reproduce documents without the use of a master page and at a much lower cost than earlier machines, such as those based on photographic methods (e.g., the Photostat). These machines "found a ready market, partly because they filled a genuine need and partly, it now seems clear, because they and their function exercised a powerful psychological fascination in their users. In a society that sociologists are forever characterizing as 'mass,' the notion of making one-of-a-kind things into many-of-a-kind things showed signs of becoming a real compulsion."[11] In other words, according to Brooks, copy machines not only fulfilled a need that already existed in the workplace but impacted people's perception of the need itself. With the arrival of xerography, copying moved from a sometimes necessary task

to a norm of office practice, with the estimated number of copies made in the US jumping from twenty million in the late 1950s to an estimated fourteen billion by 1966.[12] As copy machines became increasingly accessible, rather than spending less time copying documents that needed to be reproduced, people spent more time copying a wider range of documents. In short, an entire culture became increasingly obsessed with copying.

To some extent, the drastic increase in the number of copies made in the years immediately following xerography's arrival in the workplace was an effect of the creativity and persistence of Xerox's own sales team, which was always looking for innovative applications to bring their machines into new settings, from department stores to police stations. However, it seems unlikely that the growing "urge to make two or more copies when one would do, or to make one when none would do,"[13] was simply the result of the company's clever and repeated sales pitch. Just as we now feel ill at ease if the data on our computer is not backed up, be it on a portable hard drive or in a cloud, by the 1960s the practice of making copies had started to seep into everyday life and in ways that were not necessarily anticipated. Making copies (e.g., of one's important documents from birth certificates to driver's licenses) became increasingly equated with security. To have a duplicate became synonymous with taking precautions against the perils of the future; at as little as ten cents a copy, it was a form of security nearly anyone could afford. In reality, however, few of the copies made fell into this category. Despite Xerox's advertising campaign in the 1970s which posited their copy machines as a scriptorium in a box,[14] by the time copy machines were a standard feature in the workplace, they had already exceeded their intended scribal function.

Inviting us to make copies of documents that are too long to transcribe and too difficult to replicate by hand while simultaneously enticing us to make copies of texts, images, objects, and even body parts, copy machines soon gave rise to new practices,

communities, and networks. If copying in a scribal culture was slow, meticulous, and discerning and copying in a print culture was mechanized and collaborative, copying in the age of xerography marked the introduction of an entirely new paradigm of document reproduction. On the one hand, the spread of copy machines made copying an increasingly independent practice—an individual could copy an entire book in secret without anyone else's knowledge or permission. As a result, these machines enabled the reproduction of texts that would never have passed the censors and gatekeepers who regulate the circulation of texts in manuscript and print cultures. Copy machines, after all, were a great way to reproduce militant manifestos, smutty gay fiction, DIY guides on how to build your own bombs or grow your own marijuana, and naughty comic strips. At the same time, copy machines gave rise to new types of textual networks—and not simply to the extent that they connected the writers and readers of the aforementioned manifestos, stories, guides, and comics. Just as the circulation of manuscripts in the Middle Ages fostered rich textual communities, among both the literate and their nonreading counterparts,[15] and movable type intensified the scope, geographic range, and importance of text-based communities (e.g., as exemplified by various forms of print-based nationalisms),[16] so copy machines made space for new types of text-based networks. Free of both the Church, which largely controlled textual reproduction in scribal societies, and the State, which arguably continues to control the production and circulation of printed texts in many contexts, the copy machine helped to foster textual communities well positioned to subvert moral censure, nationalist and capitalist mandates, and copyright laws. Though copy machines were developed in response to a need to manage the control crisis brought about by industrialization, they were also quickly adopted and adapted by workers as a tool of subversion—a form of *perruque* for the information age.

Perruque, Michel de Certeau observes, "grafts itself onto the system of the industrial assembly line (its counterpart, in the same place), as a variant of the activity which, outside the factory (in another place), takes the form of *bricolage*."[17] Literally translated as "wig" or "disguise," *perruque* exists on the assembly line without disrupting the line's pace or flow. More about taking time than taking place, it is synonymous with "making do" in systems that otherwise seek to narrow our possibilities and limit the scope of our imaginations. Copy machines, an integral part of the office assembly line, were easily deployed for just such tactical purposes. With relatively little risk, a worker could borrow a bit of time on a copy machine to make a copy of a magazine article to send to a friend or to reproduce a favorite recipe for a co-worker. With a bit more risk, workers also quickly learned how to use copy machines for more obscene ends. Even as the use of copy machines declines, dozens of videos in the "office worker photocopies body part" category continue to circulate on YouTube, nearly always conveying a simple message: while taking advantage of your workplace's equipment and resources, don't get caught, especially not with your pants down! After all, once exposed, *perruque* ceases to be effective.

But copy machines were not limited to the occasional reproduction of innocuous non-work-related texts and images. Soon after the copy machine's introduction into the workplace, a new form of folklore began to take shape in the white-collar sector. Sometimes referred to as "xeroxlore" (sometimes "photocopylore"), this new form of folklore encompassed diverse genres—parodies of forms and memos, satirical flow charts and business models, and an entire range of cartoons and urban legends mocking the corporate world. In addition to poking fun at various aspects of office culture, xeroxlore was invariably produced and circulated by office workers, usually on borrowed time, borrowed paper, and borrowed copy machines. While there is no way to know where xeroxlore originated, in Chester Carlson's personal scrapbooks

(which otherwise consist of news clippings about xerography and its applications collected between the 1930s and the time of his death) there is a photocopy of what appears to be a particularly early example of xeroxlore. Addressed from the presumably fictional "Hans Gruber" in the "American zone" of Hamburg and written to the presumably fictional "Andrews Coffee Company" in New York City, the letter, dating back to 1951, takes the form of a complaint about the Andrews Coffee Company but is first and foremost designed to mock the German language (by no means an uncommon gesture in the postwar years). "Schentlemens," the letter begins, "Der koffey may be gutt enuf but der ratt durds schboil der trade."[18] The fact that the photocopied letter appears among Carlson's scrapbooks is notable. It is one of the few clippings with no obvious connection to Carlson, his patented invention, or the rising fortunes of Xerox. One can only imagine that on some level this early example of xeroxlore (notably Carlson or someone else has written "Made by Xerography-Multilith Process" at the top of the page) caught the inventor's attention as a potentially humorous and innovative deployment of xerography—a small gesture foreshadowing the unauthorized uses of the machine to come.

Although xeroxlore has now all but been replaced by "netlore" and its spin-offs, for nearly three decades it was a popular source of distraction and subversion in the workplace. Indeed, within a decade of the Xerox 914 appearing in offices across North America, folklorists Alan Dundes and Carl Pagter had already found enough material to compile the first of several anthologies dedicated to the genre. In their introduction to the first edition, much attention is devoted to legitimizing xeroxlore as a form of folklore. The researchers emphasize the extent to which xeroxlore, like the earlier circulation of oral legends, is an adaptable localized practice that typically seeks to convey a simple message, often in a humorous manner. As they further emphasize, xeroxlore cannot be easily reduced to a form of petty humor targeting specific individuals.

Ultimately it is concerned with a larger sociopolitical context; as they argue, it is one weapon used to combat "the states of malaise and anomie" that are rampant within the "mechanistic forces of big business."[19] Yet as Dundes and Pagter's collections reveal, the form of xeroxlore was by no means limited to concerns in the modern workplace; "almost every major problem in urban America is touched upon in these marvelously expressive materials: racism, sex, politics, automation, women's liberation, student riots, welfare excesses, military mentality, office bureaucracy, *ad fininitum*."[20] The copy machine, then, became an integral cog in another type of machine—in this case, a self-regulating, highly dispersed worker-driven engine turning out myriad critical responses to contemporary public issues and doing so largely using the corporate world's own time, equipment, and resources. In short, with the arrival of copy machines, workers could more easily participate in public-sphere debates and do so while on the job.[21]

Because xerography put document production into the hands of individuals and small groups, it demanded a radical rethinking of how the public and private spheres, as well as notions such as community and network, are defined and understood in the communication circuit. With the spread of xerography, publishing could be carried out in the private or semipublic sphere and publishers could be individuals or small collectives. Because photocopying is relatively inexpensive and in some cases free (as demonstrated by workers deploying workplace machines for personal use), publishing networks could also more easily flourish in opposition to capitalist models of production. If profit and print became increasingly tied under print culture, with xerography they could be more easily separated, giving rise to an ever more diverse spectrum of marginal, esoteric, quirky, and renegade texts (a point I expand upon in the following section). What is clear is that the new office companion that arrived on the scene in the 1960s not only transformed the range and amount of work carried out in the

white-collar sector, but also put a form of power once restricted to those with access to printing technologies directly into the hands of millions of laborers. Thus, while established writers and researchers were also significantly impacted by the arrival of copy machines, the greatest beneficiaries were ultimately people who previously had had limited means to circulate their opinions and perspectives.

THE FUTURE OF THE BOOK: AN INCOMPLETE PROJECT

By the late 1960s, xerography had already been discussed in relation to subjects as diverse as psychokinesis and obscenity, so it is little surprise that media guru Marshall McLuhan was, at least fleetingly, fascinated with xerography and specifically with its potential impact on communications and the publishing industry. The project titled "The Future of the Book," proposed by McLuhan in 1967, was one book he would never realize, however.

Initially intended to be a collaboration with his publisher William Jovanovich, the project proposed to explore, among other subjects, the far-reaching effects of xerography on the book and book industry. That McLuhan proposed to collaborate with his publisher was no coincidence. As he explains in "The Emperor's New Clothes," xerography "reverses the characteristics of the printing press," and "author and publisher and reader tend to merge."[22] One can only imagine, then, that his proposed collaboration with Jovanovich was an attempt to manifest one of the consequences of xerography. Their agreed-upon format, however, reflected a much earlier and antiquated form—the epistolary exchange. Rather than a commentary on the future of the book itself, the form may have been chosen for convenience or simply as a feasible way to write with an eccentric coauthor (as Jovanovich proposed to McLuhan, if they opted for an exchange of letters, their collaborative book would simply

"structure itself").[23] In the end, even this spontaneous structuring method failed to rescue the project. By 1969, Jovanovich was gracefully bowing out of the collaboration, explaining that he lacked time to work on the book due to his demanding publishing job—at the time, as president of Harcourt, Brace & World Inc. Elsewhere in the letter, however, there is evidence that the collaboration's demise may have had more to do with ideological clashes between the author and publisher. After all, Jovanovich admits that he "may be able to muster a book of essays" and so suggests to McLuhan that they each keep their material and use it as each sees fit for separate future publications.[24]

While it is unclear which essays intended for "The Future of the Book" migrated into McLuhan's late writings, his personal files reveal that he continued to explore the subject of xerography. In the early 1970s, he was clipping newspaper articles about the Pentagon Papers scandal with an eye to tracking the role of xerography in media leaks (notably, under each of his clippings on the Pentagon Papers, he penned "xerox").[25] The role of xerography in the dissemination of secrets was something McLuhan seemed to apply to individuals as well as institutions: "Any notable figure has only to empty his Xeroxed memos into the publisher's office to have a biography available in a few hours."[26] But McLuhan's primary interest in xerography was its impact on authors and readers and thus on the structure of textual relations broadly defined: "The highly centralized activity of publishing naturally breaks down into extreme decentralism when anybody can, by means of xerography, assemble printed, or written, or photography materials." This shift, in McLuhan's opinion, was nothing short of revolutionary. "Xerography is electricity invading the world of typography," he announced, which will bring about "a total revolution in this old sphere, or this old technology."[27]

If McLuhan understood xerography as a technology that would radically decrease authors' dependency on publishers, his own publisher's views on xerography were far less optimistic. Following the

breakdown of their collaboration, Jovanovich went on to publish an essay about xerography in the *American Scholar*. Notably, the essay is also structured as a response, not to McLuhan but to another writer, William Saroyan. Responding to a claim made by Saroyan that "anything anybody writes has got to be published," Jovanovich opens his essay by citing his reply:

> Your idea that anybody who writes should be able to be published may, in fact, come true. Xerography is a process that can make this possible, but whether it will make people feel better I cannot surmise, unless they happen also to be Xerox shareholders. Certainly, if publishing becomes universal, and if it is regarded as a kind of civil right, or a kind of public requital, then our concept of literary property must change. Everything will be published and it will belong to everybody—power to the people. There is nothing illogical in your idea. If everyone finds a publisher, he will then find a reader, maybe just one reader—the publisher himself. Of course, writers want lots of readers, but this desire will be less and less fulfilled as there are more and more writers. Quantity declines as specialization declines. Eventually, every man will become at once a writer, publisher, librarian, and critic—the literary professions will disappear as a single man undertakes all the literary roles.[28]

In the end, it would take the web to bring about anything approximating Jovanovich's grim predications for the future of authorship, reading, and publishing under xerography, but the publisher was by no means naïve to raise concerns about the impact of the copy machine on the cusp of its widespread entry into the public sphere. As Jovanovich recognized, the copy machine posed a radical challenge to print culture's established notions of copyright.[29] Likewise, he appreciated the fact that the increasing accessibility of

copy machines would also alter how literary works are assessed. Emphasizing that print culture had given rise to popular culture and its accompanying assumption that the importance of a work was necessarily connected to its *mass* circulation, Jovanovich observed that "now, as the twentieth century approaches its final quarter, different notions are being put forth." Evidently writing with an eye to the growing youth cultures and countercultures of his era, he concludes that as property is increasingly held in suspicion, especially by "the Young (as a caste), by separatist Blacks, and by the Intellectuals who are able to subsist outside universities, foundations and government … the radicals, the outsiders, in our society are less interested in the artifact, the object, than in the media." While his list of subcultural and countercultural groups may be limited in scope, his observation is astute—xerography has a special appeal to groups intent on circulating ideas outside established economies of print and in opposition to established social norms. Jovanovich then moves on to his main point and, presumably, his reason for abandoning the collaboration with McLuhan. Like McLuhan, he recognizes that media "create their own meanings" and that "each medium creates new conditions for the artist and the public, which themselves are not separate entities." Unlike McLuhan, however, Jovanovich rejects the claim that the copy machine is in fact a new medium: "I am sure that the widespread use of xerography will not devalue literature, nor will it confuse the identity of reader and writer, nor will it turn to antiquarianism the profession of publishing. It will not do these things because the act of copying is indiscriminate, unselective, uncompetitive. It is not a medium of art."[30]

 Over four decades later, no doubt many observers would still agree that xerography is *not* a distinctly separate medium and certainly not a medium of art but a mere duplication process—a vehicle of reproduction rather than creation. Regardless of how you value its products, however, to conclude that the copy machine

had little or no impact on the book and more broadly on cultural production is to ignore much of what redefined print culture over the past four decades. In light of the much greater changes ultimately brought about by the web, understanding something as seemingly innocuous as the copy machine as a revolutionary medium may be difficult. After all, with the copy machine we continued to turn out reams of paper that we still had to tote around in oversize knapsacks and even briefcases on wheels. If the web liberated us from the tremendous weight of paper, for several decades copy machines contributed to this weight. Yet in other ways the copy machine's parallels to other forms of print reproduction are questionable. Even as copy machines continued to produce documents in paper form, they radically unsettled understandings of authorship, reading, and copyright that had been entrenched for over four centuries; and, as discussed at length in chapter 2, they also eventually diluted print culture's imagined communities.

As previously emphasized, printed materials and photocopies, especially copies of copies of copies, are different types of documents. As I argued in the introduction, as a photocopy is photocopied again and again, it migrates from hot to cool in McLuhan's terms—from a medium that requires only limited participation on the part of the reader to one that requires considerable participation.[31] But this is not the only way to account for the differences between a printed text and a photocopy. Move a document while it is under exposure and the type in the copy will move too, sometimes distorting the text beyond readability. Retrieve a document from the machine before the completion of the exposure and risk leaving a finger or two in the margin of the copy. But copies are not only unique for the distortions and occasional fingers they accumulate along the way. A wall of books, even in our era of mobile digital devices, still signifies a certain degree of cultural capital. A stack of photocopies, while perhaps making one look deeply engaged in work (or its neglect), never has carried the prestige of print and

likely never will. Photocopies, even when bound into booklike objects, are generally considered disposable (hence students' understandable complaints about paying large sums of money for bound course packages). Typically meant to serve a temporary need—a course, a research project, a conference—these documents are not only inexpensively bound but also temporally bound. In short, despite its initial claims, xerography did not necessarily heighten standardization nor promote preservation. Photocopies may even be seen to have more in common with ephemeral forms of media, such as voice mail messages, than with other forms of printed matter. But even if we accept xerography as a medium distinct from other forms of print, how do we account for the copy machine's output? What, after all, do copy machines actually produce?

A cynical observer might conclude that xerography has primarily resulted in the circulation of less aesthetically pleasing versions of texts already in existence, and there is some truth to this claim. In New York City, you can still find a few street vendors hawking photocopied versions of so-called classics, but typically these versions of *War of the Worlds* or *Huckleberry Finn* or *As You Like It* appear on standard eight-and-a-half-by-eleven sheets of paper with single-color covers on standard cardstock. If you're lucky, your black market Huxley or Twain or Shakespeare will feature a cloth rather than cerlox or spiral binding, but that is usually the extent of aesthetic consideration given to the editions turned out by these copy machine book peddlers. What you are buying, after all, are words on paper with an inexpensive binding thrown in for good measure. In contrast to the Louis Vuitton and Gucci knockoffs which you can also buy on many street corners in Manhattan, in the case of counterfeit books, functionality nearly always trumps aesthetics.

Most photocopied volumes, however, are not purchased from vendors on the street but rather compiled by readers themselves. Not unlike the compilations that proliferated in the first century of print (primarily consisting of printed versions of ancient and medieval

texts),[32] since the late 1960s the copy machine has resulted in a wide range of unauthorized editions and compilations. Like those of many scholars of my generation, part of my bookshelf is still home to dozens of these unattractive cerlox-bound artifacts. Some are photocopies of rare and out-of-print books, others are pirated versions of books too expensive to purchase, and many more are compilations of materials from various sources compiled for research or teaching. However ubiquitous these photocopied products may be, their existence remains more or less unaccounted for. After all, they have neither a specific name (how would they be categorized in a twentieth-century history of the book or of publishing?) nor any resale market. For nearly half a century they accounted for a significant part of book production and circulation—significant enough to be acknowledged by publishers as a threat (this was Jovanovich's argument, one he appeared to be making on behalf of the publishing industry, not just himself). Yet these photocopied editions have never been fully recognized as books, nor have they been recognized as their opposite. They fall into a gray area between book and nonbook. They function as books and hence pose a threat to the publishing industry but carry none of the prestige or longevity of other types of books.

Whatever the status of such photocopied editions, since the 1970s copy machines have also had a notable impact on the production and circulation of an entire range of marginal genres, from xerox art and mail art to fan fiction and avant-garde poetry. Although copy machines may have been engineered for bureaucratic and administrative forms of reproduction, then, their impact on art and literature cannot be underestimated.

ART IN THE AGE OF GENERATIVE SYSTEMS

While Jovanovich was rejecting copy machines as an artistic medium, some artists and writers were already exploiting their potential.

No project was more ambitious and optimistic than Sonia Landy Sheridan's establishment of the Generative Systems Department at the School of the Art Institute of Chicago. In the late 1960s, Sheridan was so convinced of the copy machine's potential impact on artistic production that she persuaded the School of the Art Institute of Chicago to let her develop a new master's degree that would place copy art at its center.[33] As a pedagogical tool, the copy machine and its related technologies, including the fax machine, provided Sheridan and her students with an accessible way to explore mechanical apparatuses while further investigating a place where art and science meet. Exploring the unintended creative potential of new technologies (e.g., the copy machine's potential to be used as an imaging device rather than reproduction machine) was a key part of the program's mandate (not to mention one that inadvertently realized Xerox's own original desire to develop copy machines as a potential rival to photography). For this reason, Sheridan, who always wore a lab coat in the classroom, conceived of her classroom space as both studio and laboratory. Xerox, Kodak, and 3M copiers, some salvaged from government surplus sales and others purchased or loaned to Sheridan, including for a short time in the early 1970s a coveted 3M Color-in-Color machine, lined the walls of her classroom.[34] Kathryn Farley, who has documented Sheridan's endeavor in detail on behalf of the archive that now holds her papers, writes:

> Generative Systems' unique curriculum, promoting hands-on exploration of diverse high-speed communication tools, aligned engineers, scientists, industry representatives and arts practitioners with a unique body of undergraduate and graduate students. Primarily, Generative Systems classes sought to provide participants with collaborative art-making opportunities and access to a vast array of industrial equipment, personnel and techniques that had traditionally remained off limits to academic inquiry.[35]

Sheridan's courses employed a range of technologies "from a Thermo-Fax machine (a prototype of the modern copier) to the more complex Color-in-Color copy system, Haloid Xerox technology, video imaging and, eventually, computer graphics software."[36]

If the copy machine's potential seemed great, this was also due to the fact that it resonated with the direction of art making at the time—a direction that was taking artists away from traditional media, out of the confines of the gallery, and into an increasingly mediated and networked world. The copy machine, though only one of the era's many new technologies, exemplified a radical shift in art making with a democratizing potential. As Sheridan argued, "We are now witnessing the reappearance of image-making as a human endeavor, made possible by the instant imaging technology."[37]

Sheridan was not only fascinated by the copy machine's potential but also well aware of the machine's built-in limits. As Steve Ditlea explains in the introduction to *Copy Art* (a 1978 how-to guide), "Most copier manufacturers try to engineer out any possible variables and discourage tampering with their machines' innards by an elaborate series of electrical interlocks."[38] Despite the copy machine's recognized potential as an artistic medium, its status as a "control technology" was by no means lost on artists. Indeed, copy machines' built-in restrictions—the fact that they were engineered to replicate rather than create—was part of their attraction and challenge. For this reason, Sheridan's Generative Systems students spent their first required course, Process I, simply taking the machines apart and putting them back together, with no expectation to produce art work of any kind.[39] In other courses, Sheridan encouraged students to create hybrid machines. As Farley observes in her study of Sheridan and her program, "Sonia Sheridan and her students would often launch a process using a variety of technologies in order to finish by generating images representing their combined, simultaneous actions. ... Sometimes,

FIGURE 1.2 Sonia Landy Sheridan at the School of the Art Institute of Chicago, early 1970s. Image reproduced with permission from Sonia Landy Sheridan and the archives of the Cinémathèque québécoise.

hybridity manifested itself by combining paper from one device with processing powders and solutions designed for another."[40]

Stretching the possibilities of the copy machine and xerographic processes was also part of Sheridan's own artistic practice. In 1970 she was one of only two women artists invited to participate in Jack Burnham's "Software" show, a groundbreaking new media art exhibit hosted by the Jewish Museum of New York. Here, wearing her lab coat just as she did in the classroom, she invited visitors to interact with a rented color copier. A widely circulated newspaper article about the exhibit describes the creative possibilities of xerography:

> Bearded boys, girls in tie-dyed jeans and granny dresses, and many with bare feet said the whole thing was blowing their minds. Everyone was smiling, even the 3M technicians loaned to Miss Sheridan to keep the machines running. She photocopied hands, faces, designs and transferred them to T-shirts or heat-laminated them to paper in just a few minutes.[41]

In other exhibits, such as the 1978 "Energized Artscience: Patterns in Motion" at the Chicago Museum of Science and Industry, Sheridan invited the public to try out several copying systems, including one made out of a fur mitten, a sheet of Plexiglas, a light bulb, carbon, and a stove.[42] The interactivity of copy machines—their potential to turn the public into active participants in the art-making process—was something she sought to exploit both as a pedagogical tool and in her own exhibits.

FIGURE 1.3 Artwork produced by Sonia Landy Sheridan and her students at the School of the Art Institute of Chicago, early 1970s. Image reproduced with permission from Sonia Landy Sheridan and the archives of the Cinémathèque québécoise.

FROM CONTROL REVOLUTION TO AGE OF GENERATIVE SYSTEMS 49

While some artists, like Sheridan, were dismantling copy machines with the aim of exposing how they worked and radically altering their functionality, others were embracing the machines' aleatory potential. A 1990 article about copy art in *Leonardo* by artist and educator Marisa Gonzalez emphasizes that artists who work with copiers "open the door to a new world of imagination, creativity and research." In part this is connected to the speed at which images can be produced and reproduced, a condition that, according to Gonzalez, "incites the mind to create new images and consider new options" because possibilities and variations multiply more often. "The inventor of the photocopying machine," she speculates, "probably did not imagine the manner and degree to which the invention would affect the world of art."[43] The creators of *Copy Art* also emphasize the copy machine's creative potential: "beyond its function as an 'office tool,' the copier has, for many people, become a means of self-expression." "In some strange and mysterious way," they insist, "the copier is a 'magical machine.' You will find that very often the 'accident', the 'unplanned', and the 'unexpected' will produce results you could not even begin to imagine."[44] The authors offer numerous practical and artistic tips. On the one hand, they encourage readers to copy the contents of their wallets to ensure they have a record of all their credit card and personal numbers in case of theft. On the other hand, they encourage their readers to explore "body art." Observing that "almost everyone who has been left alone with a copier has experimented with making copies of their face and hands," they offer a series of "guidelines" on how to further exploit what may be best described as the art of "self-copying." Looking for a two-headed effect? This is easily achieved by "leaving one side of your face down on the document glass for one scan and then turning around to catch the other side for the next two scans."[45] But they also offer profiles of dozens of professional artists using copy machines in a wide range of disciplines, from photography and animated film to performance art and visual collage.

FIGURE 1.4 The back cover of *Copy Art: The First Complete Guide to the Copy Machine*, a 1978 how-to guide on copy art. Photograph by author.

Although copy art would ultimately remain a marginal artistic practice, with most courses on the subject disappearing from art school curricula by the early 1980s, copy-machine-generated works would play an integral role in pushing art beyond the space of the gallery. Indeed, the copy machine would be deployed by an entire generation of artists in an effort to move art into the streets and other spaces free of the expectations, constraints, and hierarchies of the gallery and museum world. As further discussed in chapter 3, artists without access to gallery or museum spaces, and some artists with access to these spaces who wished to expand their potential audience, embraced xerography as a way to break down access barriers in the art world while developing new venues for artistic production.

Visual artists and writers alike also embraced xerography as a way to produce books and booklike objects quickly, cheaply, and collaboratively. From the 1960s on, Fluxus members like poet and composer Dick Higgins were using copy machines to circulate and in some cases produce new works. The Fluxus Performance Workbook (an ever-expanding collaboratively authored encyclopedia of Fluxus "scores") relied on the growing accessibility of xerography, which was used to easily copy and compile "scores" for distribution among an ever-growing coterie of poets, artists, and performers.[46] During the same period, Seth Siegelaub and John W. Wendler initiated work on their groundbreaking conceptual art book *Xerox Book (Untitled)*. While the book was eventually printed in an edition of 1,000 offset copies—which ironically proved less expensive than using the intended xerographic method—the title of the book stuck and speaks at the very least to the optimism artists and writers of this era felt about xerography as a medium with the potential to radically change the conditions of artistic production.

While offset publishing and older accessible printing technologies, such as mimeograph, continued to be used by many small and micro presses, xerography increasingly offered an attractive

and inexpensive publishing alternative as its cost plummeted with growing competition and the arrival of commercial copy shops, resulting in a veritable explosion of small and micro press literatures in the 1970s to 1980s. As Ellen Gruber Garvey observes, inexpensive modes of print reproduction such as xerography were especially important to writers and artists producing work with little potential for profit: "Unlike commercial magazine producers who define a market niche—a group advertisers will want to reach—before they begin, small press publishers in the late 1960s and 1970s, like those of Beat publications, began with writers, not with readers and certainly not with a market."[47] Garvey goes on to note that a survey in the early 1970s discovered, not surprisingly, that most readers of small press publications were writers themselves. What matters here is that xerography created a new, accessible, and low-cost means for writers to become publishers, and for poets and a small coterie of experimental prose writers the impact was profound. No longer obliged to wait for a publisher to accept their work, these writers were free to publish with or without an audience or market. In essence, xerography supported the avant-garde by enabling writers to more easily publish *ahead of* rather than in response to an audience. Yet, while xerography may have facilitated the dissemination of future literatures in the present, it was also deployed as a means to put obscure and marginal literatures back into circulation. Charles Bernstein and Bruce Andrews's groundbreaking poetry journal *L=A=N=G=U=A=G=E*, perhaps the best-known avant-garde poetry publication to appear in the 1970s, is one such example. As Danny Snelson observes:

> *L=A=N=G=U=A=G=E* magazine (1978–1981), from the first issue, was figured as a project in recovering "out-of-print books, magazines, and unpublished manuscripts." This description should strike a note of dissonance in the chorus of common knowledge concerning this influential little magazine,

which is known for shaping the emergent poetics of the L=A=N=G=U=A=G=E writing community. However, skimming along the surface of the issues today, the reader is struck by the density of bibliographic notes on access and availability. Among the contemporary reviews and short essays that characterize the bulk of the magazine, one finds offers from the "L=A=N=G=U=A=G=E Distributing Service," a kind of door-to-door photocopy delivery mechanism for out-of-print works. A catalogue of books and magazines could be ordered for fifty cents from the home address of editor Charles Bernstein, who ran this reprint-on-demand service through a neighborhood Xerox machine.[48]

While the influence of xerography on late twentieth-century art and literature is by no means inconsequential, xerography would arguably have its most notable impact on forms of expression that challenged the very categories of art and literature. Xerography ultimately would become most synonymous with forms of expression best described as antiestablishment, punk, and DIY. For at least three decades, from the 1970s through the 1990s, creating and copying, copying and creating became increasingly entwined, especially in downtown art scenes like the one that emerged in New York at the time. In the process, copy machines would do more than facilitate the rise of new subcultures. These machines would play an integral role in the emergence of a new aesthetic—gritty, spontaneous, and with little regard for markets or censors—and a new way of circulating both art and literature in urban spaces and eventually, via mail art and zines, well beyond the city's limits. While copy machines may have fallen somewhat short of McLuhan's prediction of "a total revolution" in the old sphere of typography, looking back it seems equally certain that Jovanovich's conclusion that copy machines are not a medium of art and not even a distinctive medium was shortsighted. Copy machines never did replace

printed books—more books were published in the decades following the copy machine's mass introduction in the 1960s than in the preceding decades—but the copy machine did profoundly alter what we could do with documents of all kinds. After the copy machine, the sanctity of print and all its related institutions, including copyright and authorship, would never be quite the same again, nor would the economies that had long regulated who could fully participate in the making and circulation of art and literature. As the title of this book emphasizes, copy machines did more than change how texts and images were produced and put into circulation; they had far-reaching social, cultural, and political impacts that have yet to be fully accounted for by media historians and researchers working in allied fields.

OPEN SECRETS AND
IMAGINED TERRORISMS

> If civilization may be measured by the tolerance of unintelligibility, its capacities are weakened by monopolies of knowledge built up in the same political area using the same language. ... Monopolies are subject to competition by new media.
>
> **HAROLD A. INNIS, *EMPIRE AND COMMUNICATIONS* (1950)**

In early 2001, the *Village Voice* published a short interview with Zoe Schonfeld, daughter of the Schonfelds who own Village Copier, a longstanding copy shop on the border of the New York University campus. Schonfeld, at the time a law student at NYU, was not being interviewed about her family's copy shop but rather about the fact that she was living above the shop in New York's West Village rent-free. While she admitted to being born under a lucky star (what student wouldn't want to live for free, especially above a copy shop?), it's the *Village Voice* reporter Toni Schlesinger who ultimately conveys the wonders of living in such close proximity to a xerographic center. "Twenty-four-hour copy shops are like casinos or newspaper offices," writes Schlesinger, "They never stop, never shut you out, no isolation. How fortunate to live above perpetual replication. It's like a hatchery or something."[1]

Like the *New York Times* article about the Kinko's on Madison Avenue cited in the introduction, the *Village Voice* article posits the copy shop as a sort of all-night party with a bit of utility thrown in for good measure. In short, the reader is left with the impression that copy shops are a space of work, fun, and freedom, and why not? Copy shops have long been places where we are all free to break the law often, openly and usually with no fear of prosecution. Copy shops invite us to transgress, and not under a veil of darkness.

That most copying has always been and remains illegal is arguably the world's biggest open secret. Despite ominous signs reminding customers that copying more than 10 percent of any

book is a criminal offense, there has always been a high, even unprecedented degree of tolerance for the illegal activities carried out in copy shops. Of course this is neither entirely surprising nor does it necessarily point to a case of negligence. After all, it hardly seems a valuable use of public resources to crack down on undergraduates making photocopies of Foucault's *Discipline and Punish*. Unlike with home grow-ops or exotic animal collections, one is permitted to be more or less open about one's illegal copying, because most illegal copying is at least implicitly understood to serve rather than undermine the public good. While it would be easy to blame the flagrant violation of copyright laws on the owners of copy shops or on the people who frequent these shops, such illegal activities have also historically benefited from the tacit support of public institutions, especially colleges and universities.

Notwithstanding the considerable efforts colleges and universities make to adhere to copyright laws (e.g., officially requiring faculty to use university libraries and bookstores for the reproduction of course-related materials), they also support illegal copying and the existence of private copy shops by routinely relying on them to create an entire range of inexpensive documents related to teaching and research, from the production of course kits and conference guides to copies of theses and dissertations. As Marcus Boon observes, "Simply put: there is no university without copying, since the university's mandate is itself disseminative mimesis."[2] So copy shops have thrived as an exception—a place where everyone is permitted to be a criminal and to be one openly—in part because it is understood that copyright laws would prohibit pursuits that ultimately serve the public good.

For all the exceptionalism afforded to copy shops, they have by no means entirely escaped policing. While students and educators reproducing articles and even entire books appear to be free to go about their business with little interference, copy shops have occasionally been targeted as sites of criminal activity—activity that

allegedly threatens not just copyright laws but the security of the state itself.

Although the link between copy shops and terrorist activities is speculative at best, as I discuss in this chapter, because many copy shops located in urban centers are owned and operated by recent immigrants, house equipment that is used in the illegal reproduction of documents, and frequently do offer *authorized* services related to travel and immigration (e.g., passport photography), they have at times come under suspicion. Still, for copy shops to become targets of criminal investigation, other exceptional conditions need to be in place. In the weeks following the attacks on the World Trade Center, these conditions emerged. Copy shops, copy shop owners, their employees, and even xerography itself fell under heightened suspicion. As I discuss later in this chapter, in this paranoid climate the copy shop came to be seen as a space where knowledge is reproduced and where certain knowledges—the illicit knowledges connected to terrorist plots—could easily be imagined to take hold and proliferate. As I argue in this chapter, if printing technologies were integral to the rise of nationalisms in the fifteenth to nineteenth centuries, xerography has at times been held in suspicion because it creates real and imagined ways to undermine print capitalism and nationalism, opening up the possibility of a form of perpetual replication that exists within but not necessarily fully under the watchful eye of the nation and its laws. To understand how copy shops (and more generally xerography) have at times been construed in opposition to the state, one must first consider the relationship between established forms of printing and nationalism.

PRINT, XEROGRAPHY, AND NATIONALISM

That printing technologies had a profound impact on the rise of nationalism has now more or less come to be taken for granted by book historians and media theorists alike. In *Imagined Communities*, Benedict Anderson maintains that the spread of printing technologies in the late fifteenth to early sixteenth centuries not only facilitated the mass reproduction of books in Europe but more importantly made books a marketable commodity. Before the book industry could fully capitalize on Gutenberg's invention, however, language itself needed to undergo a series of rapid and profound changes. As Anderson emphasizes, "In pre-print Europe, and, of course, elsewhere in the world, the diversity of spoken languages, those languages that for their speakers were (and are) the warp and woof of their lives, was immense; so immense, indeed, that had print capitalism sought to exploit each potential oral vernacular market, it would have remained a capitalism of petty proportions." Fortunately, these idiolects were capable of being assembled into larger groupings. The result, he maintains, was a dramatic restructuring of language usage in the sixteenth century, which "made it possible for rapidly growing numbers of people to think about themselves, and to relate themselves to others, in profoundly new ways."[3]

Anderson highlights three central intersections between the spread of print from the late fifteenth century onward and the subsequent emergence of nationalism. First, with print Latin waned, but so too did the importance of localized spoken vernaculars. The common languages developed through the spread of vernacular languages created textual communities that connected "speakers of the huge variety of Frenches, Englishes, or Spanishes, who might find it difficult or even impossible to understand one another in conversation." People previously living in relative isolation soon came to appreciate that they were part of something larger: "They gradually became aware of the hundreds of thousands, even

millions, of people in their particular language-field, and at the same time that *only those* hundreds of thousands, or millions, so belonged." This, Anderson insists, formed "the embryo of the nationally imagined community."[4] Print languages were also shaped by the fact that with printing, conventions of spelling and grammar, which were once the prerogative of individual scribes, became increasingly standardized, eventually leading to the development of dictionaries and grammar books.[5] At the same time, printing resulted in the introduction of myriad new conventions, including typographical ones, which in turn further standardized the written word. For this reason, it became increasingly possible to read a text over time (e.g., to read a book published decades and even centuries earlier) and across space (e.g., to read a book published by a writer living in another region or even another country). Finally, and perhaps most notably, Anderson argues that print capitalism created new "languages-of-power" that were distinctly different from older administrative vernaculars. The result was a transformed field of cultural production—one where linguistic capital became increasingly important. In short, with print capitalism, the more one's dialect resembled the established print language, the more likely one was to have one's words put into print and to enjoy the privileges and power of being part of a print culture.

In many respects, Anderson's argument concerning print capitalism and the rise of nationalism simply extended a thesis that had been put into circulation by an earlier generation of communication theorists and book historians. Indeed, in *The Printing Press as an Agent of Change*, Elizabeth Eisenstein suggests (as if giving direct advice to future historians), "Studies of dynastic consolidation and/or of nationalism might well devote more space to the advent of printing." She summarizes the effects of printing on language and its subsequent link to the rise of nationalism in terms that are echoed in Anderson's argument. Specifically, she argues that "typography arrested linguistic drift, enriched as well as standardized

vernaculars, and paved the way for a more deliberate purification and codification of all major European languages."[6] On a somewhat different but by no means contradictory track, Marshall McLuhan argues that print leads to nationalism both by enabling the visual apprehension of one's mother tongue and, with the subsequent production of maps, by enabling the visual apprehension of the nation itself (one could now visualize the borders that contained the other speakers/readers with whom one felt a growing sense of community).[7]

One of the earliest and most elaborate articulations of the relationship between print culture and the rise of nationalisms is found in Harold Innis's *Empire and Communications* (1950) and its follow-up, *The Bias of Communication* (1951). While Innis understands printing more as a culmination of earlier developments in communication than as a radical break with them, he argues that with print, vernacular languages gained increased status and subsequently created new types of empires and nations across vast stretches of space. But here what is most relevant to the discussion is Innis's theorizing of the "bias" of media of communication. He writes:

> Concentration on a medium of communication implies a bias in the cultural development of the civilization concerned either towards an emphasis on space and political organization, or towards an emphasis on time and religious organization. Introduction of a second medium tends to check the bias of the first and to create conditions suited to the growth of empire.[8]

Parchment, clay, and stone, for example, hold a bias toward time but do not have the potential to reach large groups of people simultaneously. Their strength lies in their ability to carry stories from generation to generation. By contrast, print and other modern forms of mass media are more ephemeral but hold the potential to

reach large groups of people simultaneously across vast distances. Innis also maintains that the rise and fall of empires and later of nations happens at moments when old and new media overlap— when the bias of an established medium is "checked" by a new medium. For example, he suggests that "with printing, paper facilitated an effective development of the vernaculars and gave expression to their vitality in the growth of nationalism. The adaptability of the alphabet to large-scale machine industry became the basis of literacy, advertising, and trade. The book as a specialized product of printing and, in turn, the newspaper strengthened the position of language as a basis of nationalism."[9] Did xerography, then, do anything to check the bias of print, and if it did, what were the consequences?

Print, Innis insists, privileges space over time. Print is light, ephemeral, secular, and mobile. In this sense, xerography, which may easily be characterized by the same features, simply extends print's reach. But according to Innis, print is also associated with the consolidation of empires and monopolies of knowledge, and in this respect the comparison begins to break down. Is xerography, then, a time- or a space-biased medium?

While it may be a stretch to situate xerography as a time-biased medium, it does share at least something with earlier time-biased modes of communication, such as speech. After all, in contrast to print, xerography is frequently deployed to communicate locally, not nationally or globally. It's synonymous with the small print run, the micro press, and even the restricted production of four or five posters made to publicize an event or concern to one's immediate neighbors. In short, its uses are localized in a way that shares more with time-biased than with space-biased media. Xerography has also at times been adopted to circulate the very forms of literature associated with oral cultures, including tales and legends (as demonstrated in the case of xeroxlore). So just as xerography troubles McLuhan's binary theory of hot versus

cool media, it cannot be easily accounted for in Innis's equally binary time- versus space-biased theory of media. Attempts to make sense of xerography in the context of these theories at the very least expose the profound ways in which xerography fails to operate as a mere extension of print. This, however, eludes my original question: Did xerography do anything to check the bias of print, and if so, what were the consequences?

As Innis emphasizes, the introduction of "a second medium tends to check the bias of the first and to create conditions suited to the growth of empire."[10] In other words, political consolidation—be it in the form of imperial conquest (British imperialism in the seventeenth to nineteenth centuries) or a solidification of nationalist sentiments (America in the eighteenth to nineteenth centuries or Germany in the early to mid twentieth century)—is facilitated by the convergence of old and new developments in communication. On the one hand, there are considerable grounds on which to argue that xerography did bolster the nationalisms established under the reign of print. Indeed, government offices were among the earliest adopters of xerography and helped to drive the technology's development throughout the 1950s and 1960s, most notably in the United States. To the extent that xerography facilitated the reproduction of documents (and xerographic applications to microfilm opened up new possibilities for their storage and retrieval), in the mid twentieth century xerography also played a significant role in both documenting and archiving the lives of subjects gathered together under many of the nation-states that had solidified as a consequence of print capitalism and the spread of print languages four hundred years earlier.[11] Yet xerography also opened up opportunities to weaken print culture's monopolies of knowledge and eventually even put the reproduction of documents into the hands of people questioning these monopolies.[12] In this sense, one might conclude that xerography offered the equilibrium between time- and space-biased media that Innis felt was

needed but sorely lacking in the mid twentieth century, when his most influential works were published.

Again, as Anderson emphasizes, to capitalize on print required consolidating languages to create an increasingly coherent market. Xerographic reproduction, by contrast, rarely if ever aims to reach a specific market. Xerographic reproductions are typically produced with no intention of being publicly disseminated (e.g., they are intended to serve administrative or bureaucratic functions) or conversely are produced to be distributed at low cost or for free. As a result, if spoken vernaculars became ever more standardized under the reign of print, with xerography minority languages and dialects and even the vernaculars associated with specific scenes and subcultures (e.g., the vernaculars connected to punk) eventually gained strength and visibility as they found their way to the page. Anderson further argues that with print, people previously living in relative isolation came to appreciate that they were part of something bigger—in short, they came to recognize themselves as connected in some way to the millions of other people who shared their language. With xerography, people also came to see themselves as connected to others, but in this case the medium lent itself to the development of microcommunities—for example, the textual communities and networks that exist in parasitic relationship to the larger imagined community of the nation, such as those fostered by the production and circulation of zines, mail art, and other printed ephemera.[13] Third, if print resulted in an increased standardization of language (e.g., uniform spelling and grammar) and of texts (e.g., the entrenchment of typographic conventions, from page numbers to paragraph indentation), xerography opened up opportunities for publishers to ignore such conventions. With xerography, renegade authors and publishers were free to distribute texts using nonstandardized spellings, unconventional grammar, and with or without regard for the paratextual conventions that had come to define printed works. Finally, with

xerography, the need to reproduce "languages of power" weakened as the ability to reproduce documents and distribute them both locally and across vast distances did not depend on whether or not official languages were being replicated. In this sense, one might conclude that the apparent stability and uniformity of print cultures were effectively interrupted by the heterogeneity fostered by xerography.

For all these reasons, xerography might be construed as a medium that weakened the nationalisms originally bolstered by print. The persistent ban on xerography in Soviet-occupied countries throughout the Cold War appears to further support this claim.[14] To appreciate xerography's position more fully, however, one must also take into account the complex relationship and marginal status of copy shops, their owners, and their employees vis-à-vis present-day monopolies of knowledge. To bring these relationships into relief, I begin the following section by examining accounts of a government raid on a popular Toronto copy shop in the weeks following the 9/11 attacks in the United States.

BEST COPY: FROM PUBLIC GOOD TO PUBLIC ENEMY

In the early years of the new millennium, a multicolored business card for Best Copy was tacked to the bulletin board in my office at Ryerson University. I had received the business card from a student whose family ran the shop—the card came with the promise of a discount and free delivery. If the name of the shop sounds familiar, it is because Best Copy is likely one of the world's most notorious copy shops, although its infamy is only partially connected to the services it once offered. In September 2001, Best Copy was the scene of a midnight raid by Royal Canadian Mounted Police (RCMP) officers equipped with machine guns, dogs, and battering rams.

During the raid, part of Project O Canada, a post-9/11 Canadian antiterrorist campaign, several computers and dozens of boxes of documents were seized from the premises. A year later, the *Toronto Star* summarized the raid in the following account:

> A simple, two-page letter signed by a Brampton judge was all that Ahmad Shehab was given when police raided his Charles St. store, Best Copy, just two weeks after the World Trade Center buildings collapsed upon being struck by two hijacked planes. Shehab was never named in the warrant. Aside from the judge and the RCMP officer who oversaw the operation, the only other name on the search warrant was that of his nephew, Nabil al-Marabh. At that point, al-Marabh was already behind bars in Chicago. According to the terrified clerk behind the copy-shop counter that night, 40 or 50 officers, some wearing masks and brandishing machine guns, burst into the store at closing time. They tore the place apart, seized computers and printing equipment, and then left. The search warrant mentions police were looking for evidence of forging equipment, special paper used to make passports, and anything belonging to al-Marabh. Shehab said they kept his equipment for three months, which has resulted in huge financial losses—a situation that continues to this day. "Every time I look at the equipment in my store it reminds me of that night," Shehab said.[15]

As emphasized in this report, it was not Best Copy's owner, a local Muslim cleric, who was under investigation, but rather his nephew, Nabil al-Marabh, who once worked for his uncle at the shop. Arrested in a Chicago suburb in late September 2001, al-Marabh was brought to a Brooklyn detention center where he was held without specific charges for several months. Although al-Marabh had worked as a taxi driver and held a variety of other

FIGURE 2.1 Best Copy in Toronto in 2005. Photograph by author.

part-time and temporary jobs, his link to Best Copy proved to be a key factor in constructing his profile as a terrorist with direct connections to the 9/11 attacks. On September 28, 2001, an article in the *Globe and Mail* introduced al-Marabh as a "34-year-old Syrian" who "worked behind the counter of a small downtown Toronto photocopy shop." The article went on to describe the circumstances of the raid on Best Copy, noting that the shop would have housed "sophisticated lamination and printing equipment."[16]

Less than a month later, the case against al-Marabh was mounting, and his connection to Best Copy had emerged as a key piece of incriminating evidence. The initial case against al-Marabh focused on his Syrian citizenship and the fact that he had once shared a Chicago-area apartment with two other suspects who were found to be in possession of airport employee badges. By late October, al-Marabh's association with the Chicago suspects had been eclipsed by his connection to Best Copy (at least in the Canadian media). On October 23, 2001, the *Globe and Mail* reported that "investigators allege [al-Marabh] produced forged documents for the terrorist network" while working at Best Copy.[17] One week later, Best Copy appeared in another article's lead: "In downtown Toronto, the photocopying shop where Nabil al-Marabh once worked has been closed until further notice, its sidewalk sign blown over by the wind."[18] By this point, the closure of Best Copy had become a chilling reminder that Muslim communities in Canada were not immune to the heightened surveillance and erosion of human rights being experienced by their counterparts in the United States following September 11.

By the end of October, Best Copy's owner was also coming under media scrutiny. Newspaper reports emphasized that the owner had once posted bail for al-Marabh when he was detained in an attempt to cross the border on an illegal passport. Reports also emphasized that he was the vice-principal of a local Islamic school founded by Mahmoud Jaballah, who had been put on trial

on two previous occasions for his alleged connection to terrorist organizations.[19] By November 2001, connections to Best Copy had become commonplace in articles about suspected Canadian terrorists. Hassan Almrei, a Syrian refugee claimant, was described by the Canadian Security Intelligence Service as involved with bin Laden and connected to a "forgery ring with international connections that produces false documents."[20] Evidence supporting Almrei's detainment and the Canadian government's decision to sign a certificate declaring him a security threat included his possession of a false passport, his relationship with al-Marabh, and, as reported in the *Globe and Mail,* the fact that he was known to have "frequented the Best Copy Printing shop."[21]

Neither Almrei nor al-Marabh, who was at one time described by US intelligence as a lieutenant in Osama bin Laden's al-Qaeda terrorist network,[22] were charged with terrorist activities. Best Copy's owner eventually reopened his popular copy shop and for some time continued to cater to the copying needs of students and researchers from the University of Toronto and Ryerson University. My former student, a part-time employee at his family's copy shop, was evidently still working hard to compensate for the loss of business suffered in the aftermath of the post-9/11 raid when he passed along the family's business card and the promise of a discount and free delivery in 2005. Ultimately, however, Shehab closed his shop, never fully recovering from the business lost as a result of the RCMP raid and subsequent negative publicity. Well over a decade after Project O Canada, Best Copy's former location was transformed into a burger restaurant—under new ownership.[23]

How did Shehab's copy shop so quickly become the scapegoat for post 9/11 anxieties about terrorism? How was this small shop, primarily serving faculty and students from two local universities, transformed overnight from an inexpensive place to do one's copying to a believable terrorist enclave? What was it about the copy shop that enabled it to be so quickly and effectively taken up

by the nation's post-9/11 imagination as a potential threat—to the point where simply frequenting the shop was eventually posited as potential evidence of a terrorist link?

THE COPY DISTRICT AS ABJECT ZONE

If you've ever taken time to talk to the people who facilitate your illegal copying, you'll know that copy shops, at least in urban centers, are often run by new immigrants, and that the people who run these shops frequently have academic and professional credentials that extend well beyond the ability to operate and fix copy machines.

For several years, I did my copying at U of T Copy (in no way officially connected to the University of Toronto). The first time I visited U of T Copy, I was illegally copying several out-of-print books borrowed from the University of Toronto library. After commenting on the source of my books and asking about my affiliation with the university, the owner of U of T Copy boasted about the other academics who frequent his shop for the same reason. As he surveyed my books, I surveyed the row of diplomas and certificates hanging on the wall above the self-serve copy machines. The documents offered a familiar narrative of immigration, education, and employment and a possible explanation for the copy shop's out-of-place name (it was located several miles away from any university campus). Diplomas for two bachelor of science degrees and a master of science degree hung next to a certificate verifying the owner's ability to fix copy machines. On subsequent visits, the owner completed the narrative implied by his diplomas, which he dismissively described as "just paper." I was not surprised to learn that he had also completed four years of doctoral studies in chemistry at the University of Toronto before he was forced to abandon his studies due to financial and familial responsibilities in Canada and Vietnam. What was clear to me was that the name of U of T

Copy was never intended to tell customers where they are, but rather to tell them where the proprietor ought to be.

Like so many copy shop owners, the owner of U of T Copy was evidently welcome to serve his adopted nation's monopolies of knowledge (e.g., by providing inexpensive copying services to members of the university community) but was relegated to these monopolies' margins. This shop may have been especially marginalized, since it was distant from any university campus. The highest concentration of copy shops in Toronto exists along the border of the city's two downtown campuses. To the west the copy district borders the University of Toronto campus, and to the east it borders the Ryerson University campus. Best Copy ideally was situated between the two campuses, and thus was well positioned to serve both campus communities.

Copy districts, which are visible along the borders of university campuses across North America, operate as visible buffers between the university and the city. Pedestrian zones inhabited by students, academics, and other university workers, copy districts cater to the needs of the university and its members and are dependent on the university community for survival, but despite such interdependence they belong to the city, not the university. This marginal status is essential, since they are not only known sites of illegal activity (unauthorized copying) but also are sometimes associated with the reproduction of other types of documents used to aid people's movement across borders, such as those required to apply for passports and visas (birth certificates and photo IDs) and those required to move across institutional thresholds (resumes, reference letters, and transcripts). Indeed, in sharp contrast to the conditions under which copy shops were operated in the manuscript cultures of the Middle Ages, when copyists worked for the university (which coincidentally controlled the trade in parchment),[24] few contemporary copy shop owners have any official connection to the university communities they serve. If the copy district is a site

where certain members of the university community and certain modes of production integral to scholarly work are managed, it is the absence rather than the presence of university regulations and recognition that makes this possible. Although copy shops are obligated to post notices about the consequences of breaking copyright law, breach of copyright in copy shops is inevitable and tolerated. People who open copy shops presumably do so on the assumption that such breaches can and will occur without significant legal or financial consequences. Faculty and student complicity in the illegal goings-on at copy shops have been integral to ensuring this remains the case. After all, everyone knows that illegal copying is an essential part of scholarly life for students and faculty; privately run copy shops located just off university property enable this illegal activity to be carried as a convenience but without implicating the university itself.

It is important to emphasize here that the visible expansion of copy districts in cities across North American in the late twentieth century was the result of more than the growing accessibility of xerography. These districts grew as the need for xerographic reproduction expanded, and this need has everything to do with the restructuring of the book industry in the 1980s to 1990s and the changing demographics of the university itself. A survey of annual business directories for the City of Toronto reveals that in 1980 there were no businesses on the border of the University of Toronto's downtown campus that exclusively offered photocopying services; by 1985 at least six shops dedicated to copying had opened on the edge of the campus. Between the mid 1980s and the early 2000s, the number of copy shops in the district spiked, with dozens of new shops, including Best Copy, opening in the span of a decade. While the affordability of photocopying technologies was undoubtedly a factor in the growth of Toronto's copy district (and others like it across North America), other factors need to be taken into account. Throughout this period, the cost

of books increased and so did tuition fees at universities across North America. During the same period, enrollment at universities steadily increased along with the proportion of students from working-class families. Combined, these factors meant that by the mid 1990s there were more students than ever for whom buying books was truly a luxury, making necessary the availability of inexpensive photocopied materials in the form of pirated course readers and textbooks. Finally, but not insignificantly, as the student body changed, so too did the profile of university faculty. It's a much-contested but well-known reality that since the late 1980s the number of courses taught by adjunct faculty has skyrocketed at universities across North America.[25] Although most adjunct faculty officially do have access to photocopying services on campus, their access is often severely limited. Adjunct faculty, who frequently teach early in the morning, late in the evening, or on weekends, may only have access to on-campus copying services during regular business hours, when they are not on campus. In short, their working conditions make them more likely to rely on the services offered at copy shops, where they are typically left to reproduce course materials at their own expense.[26] For this reason, copy districts in cities across North American have been disproportionately populated by both immigrant small business owners (whose degrees and credentials are often not recognized in North America) and a growing itinerant academic workforce—two groups that exist on the margins of the university and of the monopolies of knowledge the university represents.

In an earlier article I argued that the copy districts that cling to the edges of the urban university campus represent "abject zones,"[27] a term I borrow from Anne McClintock who uses it to describe sites that are invariably part of society but are inhabited by people and practices that society at large must repudiate.[28] Although McClintock's discussion concerns abject zones in the context of nineteenth-century British imperialism, there is no doubt that

they also serve an important role in contemporary processes of globalization. Like the Victorian era's slums and brothels, twenty-first-century refugee camps and, less visibly, First World ghettos inhabited by Third World professionals are sites where the erosion of national boundaries is both most apparent and most vigorously policed. In my reading of the interrelations between the academy, the city, and copy districts, the copy districts that border urban university campuses are spaces inhabited by everything the university must reject yet cannot live without, including the unauthorized reproduction of texts and the labor of a skilled but underrecognized workforce comprised of marginal laborers. Thus, copy districts arguably sustain the status and legacy of universities by creating a convenient annex where illegal practices can take place without directly implicating the university, and where highly educated minorities can work *for* the university without being admitted as full-fledged members or being afforded the privileges and support that come with such recognition.

If Best Copy was an easy target for the RCMP in the weeks and months following the attacks on the World Trade Center, then, it is not only because xerographic reproduction holds the potential to weaken the nationalist sentiments entrenched by print but also because copy shops are frequently run by people who either are or can be read as "foreigners," and because these shops are already known sites of illegal activity. This is why al-Marabh's status as a copy shop clerk or Almrei's status as someone who simply frequented a copy shop were so easily circulated as key pieces of incriminating evidence in their construction as potential terrorist suspects. This is also why the raid on Best Copy, which was not the only target of post-9/11 antiterrorist initiatives in Canada, quickly became the most widely publicized and remembered post-9/11 raid to take place on Canadian soil. Once again, the raid was ultimately never about a desire to capture al-Marabh, who was already being detained in the US, nor even to interrogate Shehab about

OPEN SECRETS AND IMAGINED TERRORISMS 77

FIGURE 2.2 In 2005, a Toronto copy shop's broken sign appeared to offer customers passports while they waited rather than passport photos while they waited. Photograph by author.

al-Marabh, but rather to quickly and effectively send a message to Canadians and to allies south of the border that Canada was not the "soft" nation[29] it was assumed to be and was just as able and willing to purge itself of terrorists as its southern neighbor. In a sense, the real suspect was the copy shop itself.

Although the RCMP's interest in Best Copy was officially dropped by February 2002, for many Canadians the shop's alleged link to al-Qaeda persisted. While writing this chapter over a decade later, I still discovered relatively recent blog posts about the copy shop and its apparent terrorist links. One 2011 post, by a blogger who had frequented the shop in the 1990s and described it as "run by Middle Eastern men in their 30s and 40s" who "couldn't care less" about illegal reproduction, begins: "They were always polite and would copy anything we wanted, including jackets for sexually explicit Eurotrash. They were happy to take our money and get us out of there as quickly as possible so they could get back to their work."[30] Later in the same post, the blogger retells the story of the midnight raid on Best Copy with all the embellishments one would expect to find in a bona fide urban legend:

> Not long after the attacks Canadian links to the terrorist cell that brought down the Twin Towers made the news. Best Copy Printing was apparently connected to Islamic extremists and Al-Qaeda itself. An RCMP investigation dubbed "Project O Canada" discovered Best Copy had been churning out fake IDs and Canadian immigration forms. Paper stock, ink and laminates left behind by the nineteen 9/11 hijackers closely matched the supplies the busy bodies at Best Copy were using. According to witnesses, ringleader Mohammed Atta frequented, and even worked at Best Copy in the spring of 2001. … As many in the world wait for a photo confirming the terrorist mastermind's death, a foggy image of an Osama bin Laden portrait on the walls of Best Copy (later found by authorities) comes to mind. But I can't be sure.[31]

The post, with all its erroneous claims, suggests that for the general public, the idea that a Muslim-owned and operated copy shop could have a connection to an international terrorist organization was not only believable but persuasive enough to remain embedded in the public's imagination over time. The raid on Best Copy remains an absurd manifestation of post-9/11 Islamophobia. The fact that accounts of the raid circulated as widely as they did in the weeks following the 9/11 attacks (including in Canada's national newspaper), and continued to circulate in increasingly exaggerated form over the next decade, also reveals something about xerography's place in the national imaginary. In short, while xerography and copy shops are part of the public imagination, they are not necessarily part of the public's imagined national community.[32] As I discuss in the following chapters, however, xerography is a medium implicated in the formation of communities, publics, and counterpublics.

**XEROGRAPHY, PUBLICS,
AND COUNTERPUBLICS**

> It is illegal for any person to paste, post, paint, print, nail or attach or affix by any means whatsoever any handbill, poster, notice, sign, advertisement, sticker or other printed material upon any curb, gutter, flagstone, tree, lamppost, awning post, telegraph pole, telephone pole, public utility pole, public garbage bin, bus shelter, bridge, elevated train structure, highway fence, barrel, box, parking meter, mailbox, traffic control device, traffic stanchion, traffic sign (including pole), tree box, tree pit protection device, bench, traffic barrier, hydrant or other similar public item on any street.
>
> **NEW YORK CITY DEPARTMENT OF SANITATION**

As access to copy machines increased throughout the 1970s, urban curbs, gutters, flagstones, trees, posts, poles, bins, bridges, fences, barrels, boxes, and signs were all claimed as potential parts of this urban canvas. Left to accumulate, over time these stapled and wheatpasted posters also formed their own canvases, eventually wrapping entire structures in layered and peeling boards of pastiched paper—sometimes close to an inch thick. These constantly shifting, collaboratively produced and spontaneous paper structures were the work not only of artists and musicians but also of community activists and just regular citizens seeking to promote their own causes. Before digital social media platforms presented other low-cost alternatives, the production and distribution of photocopied posters played an integral role in publicizing events and concerns that would otherwise have been difficult to promote. This was how you found out what was happening and, perhaps more importantly, how you knew you were somewhere where something *was* happening. In the semiotics of the city, these canvases signified that you'd arrived—in an urban scene or subculture or active social movement. Likewise, the absence of these canvases signified

that you'd landed in a neighborhood that was either highly policed, bereft of culture, or both.

In many cities, these canvases were once the outdoor wallpaper of iconic downtown neighborhoods, like New York's Soho and Lower East Side in the 1970s and 1980s. At the time, real estate was inexpensive and construction hoardings, which offer a convenient and legal place to poster, were plentiful; as a result, downtown city walls were repurposed as outdoor galleries with little or no interference from authorities, who were either absent or too busy addressing more pressing offenses. Of course wallpaper, indoors or out, is an acquired taste, so as real estate prices rebounded in New York and other urban centers, the aesthetics of xeroxed posters increasingly came under attack. For some urban dwellers the sight of a wall covered in posters, even tattered and peeling, remains a welcome sight. Where there are walls blasted with posters, one assumes that a great café, bar, or bookstore must be nearby. For others, the sight of a wall covered in posters is a warning that social disorder is imminent. It's precisely such polarized responses that have structured debates on public postering over the past two decades.

In this chapter, I trace the unanticipated but by no means inconsequential impact of xerography on urban landscapes and more broadly on publics and counterpublics in the late twentieth century. I argue that xerography changed what cities look like and how we organize ourselves in these spaces, and further argue that eventually xerography also deterritorialized scenes and subcultures once synonymous with urban spaces. Building on the argument advanced in chapter 2, I make a case that xerography promoted the emergence of new and increasingly heterogeneous types of publics in the late twentieth century. However, if xerography helped to change both the look and experience of cities at that time, it by no means did so without resistance. From the largest metropolises to minor municipalities, cities across North America over the past three decades have taken sometimes absurd steps

to curtail and even outlaw postering, consistently targeting activists, artists, and other individual citizens and their xerographic reproductions in the process. Significantly, at stake in these debates are a series of broader questions about aesthetics, xerography as a medium, and who has the right to define and enforce definitions of public space and public culture.

PUBLICS AND COUNTERPUBLICS

Like the concepts of margin and community, those of public, public sphere, public culture, and public space are difficult to define and dangerously bloated with connotations and baggage. As Michael Warner warns, "Publics exist only by virtue of their imagining. They are a kind of fiction that has taken on life, and very potent life at that."[1] By the time he published the essays that comprise *Publics and Counterpublics* in the early years of the new millennium, the concepts of "public" and "the public" had already given way to that of "publics." Any discussion of publics, Warner contends, is plural, contingent, and contestable: "The publics among which we steer, or surf, are potentially infinite in number."[2] This is a notably different understanding of "public" than that developed earlier by Jürgen Habermas.

The public sphere as described by Habermas may be said to have emerged optimistically with modernity and later diminished with its excesses—excesses realized through the spread of twentieth-century mass forms of communication. In summary, Habermas's public sphere, in contrast to Warner's, is comprised of individuals, not fragmented subjectivities: it is "a forum in which the private people come together to form a public." Habermas's public sphere, at least in its ideal form, pivots on the division between public spaces and what he describes as "intimate spaces": "In the intimate sphere of the conjugal family privatized individuals viewed themselves as independent even from the private sphere of their

economic activity as persons capable of entering into 'purely human' relations with one another."[3] Said another way, the conception of public presented by Habermas remains committed to the possibility that the intimate sphere—for example, the sphere of domesticity or sexuality—is *not* public, but rather something that serves as a precondition for the public sphere. Finally, and most relevant to my discussion here, Habermas's public sphere is contingent on the existence of an independent print culture. As the availability of printed books and eventually journals and newspapers increased, literacy rates rose and so too did the possibility for private individuals to educate themselves on subjects of import to the public. Essential to this formulation is the implied link between the availability of independent media (e.g., small journals and newspapers produced at arm's length from the church, the state, and the media conglomerates that Habermas blames for the eventual demise of the public sphere in the twentieth century) and *rational* discourse. Indeed, in Habermas's formulation, an independent print culture is critical to the formation of the public sphere insofar as it provides a viable forum for "rational-critical debate," something apparently only achievable to the extent that one is able to speak not as a privatized individual from a subjective position but rather rationally concerning the regulation of one's private sphere.

What Habermas fails to account for in his formulation of the public sphere is the fact that the boundaries between the individual and the collective and the private and public, as well as the intimate and the public, are often far less easily demarcated than he claims. As his feminist and queer critics (by no means few in number) have repeatedly charged, seemingly individual and private concerns (e.g., housework, marriage, childrearing, and sexuality) are profoundly shaped by public policies and public opinion. Without completely rejecting the Habermasian model of public space, Seyla Benhabib observes that women's issues frequently appear private given their focus on the family and domestic sphere,

but this does not mean they are by definition moral or merely concerned with the private pursuit of the good life. In every sense, these issues are also of relevance to the commons.[4] Theorists of trauma and affect have launched similar critiques of Habermas's formulation, specifically pointing to the ways in which the public-private divide effectively remove the traumas of women and men—including those generated by genocide and war—from public dialogue.[5]

For somewhat different reasons, queer theorists, such as Warner, have also sought to rethink the concepts of public, public sphere, public culture, and public space. "For modern gay men and lesbians," Warner observes, "the possibilities of public or private speech are distorted by what we call the closet."[6] In this "regime of domination," to speak in public may feel like a form of exposure, while to remain private is equated with being in the closet. In essence, as Warner emphasizes, to be known publicly as a homosexual or a heterosexual is simply not of the same order, because the latter is always taken for granted and the former is contingent on some form of public declaration or "coming out." But the trope of the closet and its implied understandings of public and private space are not the only considerations here. Given their historical exile from the intimate sphere of the family, for queers, perhaps especially for gay men, public spaces—for example, the public bathroom, bar, and park—have long also doubled as intimate spheres of sex, friendship, and familial relations. Hence we have Warner's formulation of *publics*, in the plural, and his additional formulation of *counterpublics*. As he suggests, following Habermas, some publics "are defined by their tension with a larger public."[7] While such counterpublics may have much in common with subcultures and may be comprised of subaltern subjects, there is no specific style or practice or identity that defines counterpublics. Rather, he maintains that "a counterpublic, against the background of the public sphere, enables a horizon of opinion and exchange; its exchanges remain distinct from authority and can have a critical

relation to power; its extent is in principle indefinite, because it is not based on a precise demography but mediated by print, theater, diffuse networks of talk, commerce, and the like."[8] It's precisely the *mediated* nature of both publics and counterpublics that concerns me here.

If Warner's position on publics shares anything with the understanding of the public sphere forwarded by Habermas, it is his recognition of the extent to which publics are mediated formations, and mediated in at least two senses: first insofar as they are the products of negotiations, and second insofar as they are the products of media. "The temptation is to think about publics as something we make, through individual heroism and creative inspiration or through common goodwill," writes Warner, but "much of the process ... necessarily remains invisible to consciousness and to reflective agency. The making of a public requires conditions that range from the very general—such as the organization of media, ideologies of reading, institutions of circulation, text genres—to the particular rhetoric of texts."[9] What Warner fails to fully acknowledge is that alongside the conditions he lists, one also needs to consider the medium itself. As such, I would add to Warner's rhetorical question—"Can a public really exist apart from the rhetoric through which it is imagined?"[10]—an equally important question, which is arguably the question with which this chapter and book are most directly preoccupied: "Can a public really exist apart from the *medium* through which it is imagined?"

In essence, what this question seeks to explore is the extent to which publics and counterpublics are imagined not only through rhetoric or discourse, as both Habermas and Warner assert, but on a more material level. After all, the publics and counterpublics that came into being in the early years of movable type were different from the publics produced in a world structured by a tangled network of telegraphic cables in the nineteenth century and from those produced more recently in the wake of the Internet. Each

medium is marked by distinctive proximities, relations, and modes of encounter, just as each medium is marked by distinctive aesthetics and temporalities and lived experiences. This is why Habermas suggests that specific innovations in printing—for example, the production of paperback editions—profoundly altered publics. The production of paperback editions and distribution of classic works via book clubs are both innovations that brought "high-quality literature" to a wider range of people. While Habermas is notoriously skeptical of such developments, concluding that the book clubs of the mid twentieth century represented an erosion of the public sphere to the extent that they "intensif[ied] the direct contact of the editors with the needs of mass taste" and "ease[d] the access to literature not merely economically for consumers from overwhelmingly lower social strata," one might just as easily see such developments as expanding publics and counterpublics.[11] As Janice Radway argues, publics, including publics traditionally not recognized as such (e.g., the publics of working-class women), may form through "low-brow" reading practices, offering otherwise isolated individuals (e.g., those historically exiled to the intimate sphere) an opportunity to engage in public dialogues.[12]

As a medium that is accessible not simply to readers but also to producers, xerography was uniquely situated in the public sphere. But again, if publics might be imagined through specific media, what types of publics became imaginable through xerography that would otherwise have remained unimaginable? In the previous chapter, I maintained that the apparent stability and uniformity of print cultures were effectively interrupted by the heterogeneity fostered by xerography. I further suggested that this resulted in new types of communities—including microcommunities that at times exist in parasitic relationship to the larger imagined community of the nation. Building on this argument, in this and the following chapter I explore how xerography enabled us to imagine and in some cases even realize radically different types

of cities, publics, and counterpublics in the late twentieth century. I first turn my attention to New York's downtown arts scene in the 1970s and 1980s.

COPY MACHINES AND DOWNTOWN SCENES

In the early 1970s, as New York City was in an economic and social downturn, a vibrant arts scene emerged in downtown Manhattan south of 14th Street. From its onset, it was fully aware of its status as a bona fide *scene*. Over the next two and a half decades, the scene gave rise to a generation of innovative artists, writers, and musicians. Yet, even though the downtown scene generated its share of art world celebrities, it was always defined by a distinctly DIY aesthetic and ethic. As Brandon Stosuy emphasizes, in this scene writers and other cultural producers "took an active role in the production process, starting magazines, small and occasional presses, galleries, activist organizations, theaters and clubs," and this was as true for the scene's celebrity artists as it was for its cultural producers working in relative obscurity.[13] Like most scenes, this one was the result of a convergence of historic, economic, and technological factors. As emerging artists actively sought out spaces to occupy rather than negotiate entry to, cheap rent emerged as a key factor in the scene's development (and at the time, cheap rent was not difficult to find).[14] But cheap rent was not the only factor driving the downtown arts scene; it was also contingent on the growing availability of a new medium: the copy machine.

Emerging in the early 1970s just as copy machines started to move out of offices and libraries and into bodegas and copy shops, New York's downtown scene benefited from this new form of inexpensive print production from the outset: musicians without agents lined up at copy machines to turn out homemade posters advertising upcoming gigs; downtown artists embraced copy machines as

a way to move their art out of the gallery and museum and into the street; and writers seized copy machines as a way to self-publish zines, broadsides, and even books. As Marvin Taylor observes, "Downtown work exploded traditional art forms, exposing them as nothing more than cultural constructs. Verbo-visual work, installation art, performance art, appropriation art, graffiti painting, Xerox art, zines, small magazines, self-publishing, outsider galleries, mail art, and a host of other transgressions abounded."[15] Significantly, most of the art forms listed by Taylor depended on xerography either directly or indirectly: it was either the medium these artists were working with or in, the means by which they were publicizing their work, or the medium of production and dissemination.

Not surprisingly, the Downtown Collection, which Taylor founded at NYU's Fales Library and Special Collections in the early 1990s and continues to develop, is a veritable storehouse of xeroxed ephemera. Among the dozens of collections—some donated by individual artist and many others by artist collectives and other downtown organizations and galleries—are countless examples of artworks, posters, flyers, and printed materials turned out on copy machines. Yet, in my various trips to Fales to carry out research for this book, I found it difficult to find a definitive example or set of examples that might help me illustrate just how important xerography was to the development of the downtown scene in the 1970s and 1980s. The collections that comprise the Downtown Collection contain examples of all the types of art mentioned by Taylor—xerox art, zines, small magazines, and mail art alongside thousands of photocopied flyers, ticket stubs, and posters. In some collections, receipts and check stubs reveal just how much money some of the individuals and collectives represented in the collection were spending on xerography at the time. More or less absent, however, are any self-conscious references to xerography. One is left with the impression that, like talking or breathing, xerography was just something people were doing all the time, out

of necessity and convenience. For this reason, it wasn't something anyone spent much time thinking or writing about or documenting in any formal manner.

Photographs of artists hanging out around Xerox machines at all-night copy shops in the East Village may be elusive (which is not to say that such photographs are not in the collection, only that I never found them), but there is no way to visit the Downtown Collection and not leave with a strong impression that in the 1970s to 1980s, xerography was central to the production and dissemination of art and community building in the downtown scene. In some cases, it was how emerging artists established international reputations while conveniently bypassing gatekeepers at established galleries and art museums. Downtown artists like Jenny Holzer and Keith Haring, for example, experimented with xerography in the late 1970s and 1980s before settling on other media. With few exceptions, however, works turned out on copy machines were rarely labeled or categorized as such. The medium, in most cases, was so taken for granted that it was not always identified as a distinct form of image reproduction, even when being used to produce artworks. This is precisely why, on one of my trips to Fales, I asked to look at one of the most iconic works to come out of New York's downtown art scene in the 1980s. David Wojnarowicz's *Arthur Rimbaud in New York* features a photocopied (yes, I confirmed) cutout of Rimbaud's face cast against various iconic locations around New York City. In its acid-free folder at Fales, the mask (likely just one of the many versions used by Wojnarowicz in the series) looks like nothing more or less than a hastily produced, photocopied paper mask. In the series, the flimsy paper mask is repeated again and again, and in each photograph the mask is attached to another body in another space—a gesture that not only underscores the ephemerality and mobility of the xerographic medium but also the power of the multiple as a means to quite literally occupy the city.[16]

While Wojnarowicz along with Holzer and Haring eventually received attention in New York and well beyond, for most artists in the downtown scene the copy machine was less a medium of art than a means of communication and publicity. After all, prior to the development of digital social media platforms in the late 1990s, xeroxed posters and flyers were the primary means by which artists and performers took publicity into their own hands. Unlike more recent forms of social media, which are typically only or primarily visible to people who are already members or subscribers, xerography's platform, in a sense, was the city itself, and anyone strolling by was a potential subscriber.

It's precisely this democratizing effect that David A. Ensminger celebrates in *Visual Vitriol*. While recognizing that most copy machines were produced by the very sorts of large corporations that no self-respecting punk would ever dream of endorsing, Ensminger concludes, "Xerox and others produced machines that freed punk graphic artists from the demands of money, time, and energy by handing them a machine that could act as a Trojan horse."[17] The Trojan horse in question enabled punk and its signature aesthetic to carve out visible spaces not only in New York but in cities across North America and well beyond, at a time when many downtowns were more synonymous with abandonment and crime than cultural production. While not everyone viewed punk as distinct from the social problems plaguing inner cities in the 1970s and 1980s (in many respects, punk was where it was precisely because high crime rates and the divestment of properties had left a convenient space for it to fill), at least in New York the punk scene was, from the outset, deeply entangled with the city's downtown art scene.[18] Punk's visible presence there in the 1970s and 1980s—the walls of posters and flyers for upcoming shows and events of all kinds that appeared as a result—was a sign of life, of a constantly shifting life force in New York's downtown landscape. This aesthetic and energy were in turn

recirculated in much of the work produced by artists who were part of downtown scene at the time.[19]

Xerography, in this sense, offered more than a means of production and distribution that bypassed the expectations and censorship of promoters, curators, and publishers. In the 1970s and 1980s, walls of xeroxed posters and street art distinguished downtown scenes from other neighborhoods by creating constantly changing and highly textured facades. Xerography also effectively blurred the boundary between art making, its context, and its publicity. As a result, as artists, musicians, poets, and performers of all kinds publicized their work and events, the city in turn was transformed. These posters changed what certain neighborhoods looked like and changed the function of these neighborhoods along the way. In an interview for the ACT UP Oral History Project, Avram Finkelstein, artist and cofounder of Gran Fury, recalls, "Eighth Street was literally papered with posters, manifestos and posters and diatribes. It was literally like a billboard, the entire corridor between the East and West Village, and I remember that as a very vital way that people communicated in the street. It was free. Everyone did it. I remember it as a part of my adolescence."[20] In an interview for this book, artist and activist Carrie Yamaoka, reflecting on the downtown scene in the same period, remembers that "back then, you could look at a wall and see a poster and you knew that so and so is playing at the Pyramid on Saturday. … That is really the way you would find out that something was going on. It was a bulletin board, but the bulletin board was everywhere."[21]

One might argue that there have always been posters in downtown cores of cities, making what happened as a result of xerography merely an extension of previous forms of urban advertising. This analogy quickly breaks down, however, since with xerography there was a drastic shift in who was producing the posters and how posters were being produced. As Ensminger emphasizes, the

postering and flyering that were synonymous with the punk scene and more broadly with artistic production during the punk era were not simply about advertising events. Sometimes, after a show was announced, three or four different posters would appear advertising the gig—some made by members of the band and others by fans (something that xerography made possible by drastically reducing both the cost and time of production). Copy machines, in this sense, not only helped to forge social bonds but also arguably changed who could be an active participant in the making of culture.[22] After all, as long as the city was a bulletin board and the bulletin board was everywhere, in a sense we were all living *in* our communication platform. We walked through it, were influenced by its aesthetic, and of course, as my own archival research for this chapter reminded me, we took it mostly for granted too—that is, until downtowns regained their status as sites of economic interest and the aesthetics and content of xeroxed posters began to come under attack.

As downtowns regained their mainstream appeal in the late 1980s and 1990s (both as sites of commerce and as preferred places to live), public postering—with its strong links to art, activism, and the punk scene—was targeted as one of the things to be contained or eliminated (along with other forms of street art). If borrowed time on copy machines and borrowed space on city walls once offered artists and activists a way to carve out a space for themselves in downtowns and actively participate in defining cities, by the late 1990s these practices were increasingly being constructed as antithetical to efforts to clean up, gentrify, and privatize the same public spaces.

XEROGRAPHY IN THE AGE OF THE SANITIZED CITY

In New York City, the crackdown on public postering came as a consequence of the city's much more aggressive crackdown on graffiti in the 1990s.[23] As Yamaoka recalls, "There was a transformation of public space in New York, and it started with Giuliani in the early 1990s."[24] Yamaoka's assertion that the transformation started with Rudy Giuliani's administration (1994–2001) is reflected in statistics on fines issued for postering. From June 1996 to June 1997, the City of New York issued more than twice the number of summonses for illegal postering that it had the pervious year: 7,738 compared to 2,910 (and a negligible number only a decade earlier).[25] While commercial postering companies were not entirely let off the hook, individuals and artist and activist collectives posting xeroxed posters were disproportionately targeted in the city's efforts to eliminate postering. A 1997 letter to the editor in the *New York Times* reveals just how petty the NYPD was in its crackdown on postering. As Greta Pryor reports, "In June, a police officer came to my apartment and asked me, 'Aren't you aware that you have outstanding summonses with the city?' I was shocked! I asked what the summonses were for, and he told me 'postering.' I had been given five tickets of $50 each for taping signs to bus shelters in my neighborhood. (I was trying to sell my air-conditioner for $150.)"[26]

While the crackdown on New York's graffiti artists has been widely documented, the similar crackdown on postering is rarely mentioned in histories of New York street art and histories of gentrification. Indeed, even as the NYPD began to issue hefty fines to anyone daring to post a poster in a public place (e.g., a bus stop), there was little public debate. In other cities across North America, however, where graffiti was perhaps a less obvious or widespread problem, illegal postering became as much of a flashpoint as the graffiti issue did in New York. For reasons that remain unclear to me after a

decade's research on the history of xerography and public postering, the crackdown on postering, while not necessarily more prevalent or aggressive than in the United States, garnered particular public support and collective resistance in several Canadian cities.

As in New York, Chicago, Seattle, and Los Angeles, in most Canadian cities the most striking displays of posters are often comprised of glossy advertisements for new-release films and other events with corporate backing. In the 1990s, however, as city after city launched campaigns to restrict public postering, the aesthetics of the DIY photocopied poster—the kind posted by people looking for a lost cat or announcing a spontaneous march against a proposed garbage dump or advertising an upcoming art opening or gig at a local bar—were consistently targeted as the real source of urban blight. Across municipalities, charges laid for illegal postering targeted individuals posting posters turned out on copy machines rather than businesses blasting entire walls with large glossy posters advertising big-ticket events. While different cities introduced legislation against public postering at different moments (and with varying degrees of vigilance and success), everywhere public officials seeking to control or eliminate postering adopted nearly identical lines of argument.

The most common argument against postering was premised on the view that posters and flyers, especially those turned out on the fly using DIY methods of reproduction such as xerography, were aesthetically undesirable. Like other forms of vandalism (e.g., graffiti), printed ephemera were seen as marring the face of the city. Following the "broken windows" approach to crime prevention, which links small crimes, such as vandalism, to more serious crimes,[27] the argument further asserted that public postering was not only an aesthetic crime but also a practice that fostered an environment in which more serious crimes were likely to emerge. Thus, in contrast to the high level of public tolerance for the illegal copying that takes place in copy shops, which is seen as ultimately

supporting the public good, illegal postering has been attacked because it is assumed to work against the public good. In extreme form, rather than viewed as an innocuous addition to the urban landscape, a xeroxed poster wheatpasted to a mailbox is seen as a calling card for gangs and heroin addicts. Less commonly, public postering has been targeted because of the content that most DIY posters feature (e.g., information that promotes alternative economic activities, lifestyles, and countercultural movements) and even on the basis of the claim that postering public works (e.g., utility polls) might compromise the safety of maintenance workers and even the general public (beware of those errant staples!). In my first (and not-so-urban) experience of a municipal battle over public postering, all of these concerns appeared to coalesce in a case that would eventually reach the Supreme Court of Canada.

In 1990, a rotund and gregarious fiddle-playing small town musician named Reverend Ken inadvertently changed the face of urban landscapes across Canada. Kenneth Ramsden (Reverend Ken's real name) was a fixture of the local arts scene in Peterborough, Canada—a town (technically, a small city) located about two hours northeast of Toronto. Before Reverend Ken's high-profile legal battle, Peterborough was best known for its historic lift-lock system and modern-day book bannings in local schools. In other words, it was neither definitively urban nor progressive. Thus it was an unlikely scene for a legal battle that would ultimately change what Canadian cities look like while also entrenching Canadians' right to poster.

Like many local performers, Ramsden liked to advertise upcoming gigs for his band, Reverend Ken and the Lost Followers, by placing posters on electricity poles and other public works and walls around Peterborough's "downtown core" (picture a few blocks of cafés and storefronts in a college town of about 50,000 residents). Ramsden's posters looked pretty much like all the others stapled and wheatpasted to the town's surfaces, whether they

were advertising an upcoming garage sale or lesbian cabaret or searching for a lost cat or misplaced accordion. In short, they were handmade—usually scrawled on foolscap with a Sharpie—and run off on a perpetually low-in-toner, two-cent-per-page copy machine at a corner store.

Ramsden's troubles with local authorities started in 1988 while he was posting a flyer for an upcoming gig on a lamppost. Although this was something he had done hundreds of times in the past, on this occasion he was surrounded by police officers and handed a hefty $108 fine. A bylaw, dating back to 1937 and amended in the 1980s, clearly stated that "no bill, poster, sign or other advertisement of any nature whatsoever shall be placed on or caused to be placed on any public property."[28] Broadly interpreted, the bylaw prohibited all printed ephemera from being attached to any public property, built or natural, within the city limits, leaving no legal public place to post posters at all.[29] Ramsden not only continued to post his xeroxed posters; with the help of Simon Shields, who ran a local paralegal service known as the CIA (Community Information Agency), he decided to fight the fine. The paralegal and musician argued that the city's bylaw violated Section 2(b) of the Canadian Charter of Rights and Freedoms, which states that everyone has the right to "freedom of thought, belief, opinion and expression, including freedom of the press and other media of communication."[30] Initially, two lower courts rejected the case, arguing that Ramsden's posters were both aesthetically undesirable and apparently a threat to public safety. Then the duo enlisted the help of a Toronto lawyer who agreed to take the case to a provincial appeals court. Here the court ruled in support of Ramsden, recognizing that a total ban on public postering did violate the Canadian Charter of Right and Freedoms. The City of Peterborough in turn appealed the case to the Supreme Court of Canada, making it one of the most high-profile freedom-of-expression cases in Canadian history.[31] Among

the evidence cited in the Supreme Court ruling was art historian Robert Stacey's research in the history of public postering:

> [Stacey] testified it was early recognized that posters were an effective and inexpensive way of reaching a large number of persons [and] utility poles have become the preferred postering place since the inception of the telephone system. ... Posters have always been a medium of communication of revolutionary and unpopular ideas. They have been called "the circulating libraries of the poor." They have been not only a political weapon but also a means of communicating artistic, cultural and commercial messages. Their modern day use for effectively and economically conveying a message testifies to their venerability through the ages.[32]

In the end, the Court agreed with Stacey's assessment—DIY postering, even on utility polls, is an economic way to spread messages, and one measure of a society's openness is its willingness to tolerate such postering. As a result, the Court ruled that in the case of *Ramsden v. Peterborough* the City of Peterborough had contravened the country's Charter of Rights and Freedoms.

Despite the clearly articulated Supreme Court ruling that regular folks, including those who choose to make homemade posters and reproduce them on photocopy machines, have the right to publicly post their posters no matter how ugly or hastily produced they may be, in the early 2000s the City of Toronto embarked on an aggressive crackdown on postering. The crackdown coincided with the development of the city's new privately owned and operated "public square" at Yonge and Dundas. Home to the city's largest indoor shopping mall, the intersection was already part of the city's public face, but to many city councilors it was also an embarrassing blemish. Once visitors exited the pristine indoor shopping environment known as the Toronto Eaton Centre, they were

confronted with dozens of run-down video arcades, porn shops, and record stores, and most of these businesses—along with every newspaper box, trash can, and utility poll in the area—served as a rotating open canvas for posters advertising upcoming music shows, political events, and the printed works of emerging artists from several local colleges. Worried that the intersection with its seedy retail outlets and plethora of do-it-yourself visual ephemera was tarnishing the city's reputation as a safe and sanitized haven for American tourists, the city made efforts to build a public square fit both for residents and tourists, and eliminating posters became a central part of the city's clean-up strategy.

Given the earlier Supreme Court ruling, a total ban on postering was not possible, so steps were taken to make public postering extremely difficult. Following a formal study, the city introduced a bylaw that proposed to restrict the size and locations of posters and afford most public property, excluding utility polls, nearly as much protection as private property. Specifically, the bylaw proposed that:

- Posters would only be allowed on 2% of hydro poles in Toronto,
- Posters would have to be 100 meters apart,
- Poster would have to feature a "date of posting,"
- Posters would require a scannable barcode permit to assist with regulation efforts.[33]

City councilors and concerned citizens in favor of the postering legislation constructed postering as a practice antithetical to the production of safe, clean, and welcoming public spaces. Not surprisingly, support for the postering bylaw was disproportionately expressed by councilors representing constituencies not located in the city's downtown core. One suburban councilor, Rob Ford, who

would later gain notoriety as Toronto's belligerent crack-smoking mayor, maintained that "posters make our city filthy and dirty." Another councilor, who would later serve as speaker of the house under Ford, insisted that "posters are totally disgusting," and even went so far as to declare that "a lot of it is pornography."[34] The city councilors supporting the restriction of posters across the city but specifically in downtown neighborhoods, such as Yonge and Dundas, were acting less on behalf of their constituents than on behalf of the private sector. The Downtown Young Street Business Association, for example, argued that postering should be treated as a form of "vandalism," not communication, since along with graffiti and garbage it tarnishes the city's public face.

Although the postering bylaw did not explicitly target photocopied posters, visual examples circulated in Toronto's seemingly endless debate on the issue consistently highlighted photocopied ephemera, especially posters produced by musicians and marginal political organizations. Moreover, as the public debate escalated, the targets of the city's postering bylaw become even more narrowly and clearly defined. By 2006, having yet to pass the initial postering bylaw, the City of Toronto proposed an amended bylaw that would exclude certain posters (namely those advertising lost people, lost pets, and garage sales). While some welcomed the amended bylaw, activists, artists, and musicians maintained that it simply clarified what they had known all along: the real point of the postering bylaw was to silence downtown artists and activists, effectively shutting them out of efforts to visibly shape public spaces in the city.

In contrast to the rather limited public response to crackdowns on postering in cities throughout the United States, in Toronto the postering debate not only proved especially controversial but served to galvanize efforts to protect citizens' rights to use public spaces as a means of communication. The Toronto Public Space Committee (TPSC), a nonprofit that eventually splintered off into

several related public interest groups (e.g., the Toronto Public Space Initiative and *Spacing* magazine), formed at the height of the postering debate as an "advocate" for the city's "streets, sidewalks, parks and alleyways." As they emphasized in their original mandate, "We are dedicated to protecting our shared common spaces from commercial influence and privatization. While some see the streets as an untapped source of advertising revenue we see protected public spaces as a fundamental pillar of a healthy democracy. If only wealthy advertisers have access to our visual environment, then freedom of speech suffers in our city."[35] Notably, in addition to defending postering in public spaces, specifically postering by the individuals and small groups who rely on copy machines, throughout its existence the TPSC used photocopied posters and flyers to disseminate their message to the city's more than five million residents. "A community without posters," they insisted, "is not a community at all."[36]

As illustrated above, the passionate argument both against and for public postering has at times, especially in Canadian cities, taken on absurd proportions. Some city councilors and citizens have claimed that public postering is a safety hazard; others that postering is filthy and even pornographic. By contrast, advocates of postering have consistently argued that public postering should not only be recognized as a constitutional right to the extent that it is a vital form of public expression but should also be embraced as a practice integral to community building and the solidification of social bonds in otherwise alienating urban spaces. What these "poster wars" reveal—and perhaps most notably by their endurance (in Toronto, city councilors spent over a decade periodically debating the postering issue)—is the extent to which the presence of DIY photocopied posters was a salient marker of urban spaces in the late twentieth century and in some cases remains so today, despite the fact that other inexpensive modes of communication are now readily available to musicians, artists, writers, and activists. Beyond

FIGURE 3.1 The cover of the first issue of *Spacing* magazine—a publication that grew out of a collective effort to fight against the City of Toronto's increasingly aggressive attack on grassroots forms of communication, including postering. Image reproduced with permission from *Spacing* magazine.

the content or aesthetics of the individual posters and flyers, we read clusters of photocopied ephemera as a sign that we're a bit closer to the symbolic and literal margins. This is still, to some extent, part of the experience one has walking east from New York's West Village toward Alphabet City. While Eighth Street is no longer a literal corridor of posters, as it was in the 1980s, at some point the photocopied posters reappear and you realize you're at least a bit closer to what remains of the city's downtown scene. This is also the experience many of us had descending on Zuccotti Park (or any Occupy site) in the fall of 2012. Though most of the protesters were posting updates on Facebook and Twitter, Occupy sites were littered with photocopied posters and flyers. Even in the age of the smart phone, the photocopy reigned at most Occupy sites not simply because it remains a convenient and inexpensive form of communication but because, as I discuss in the final chapter of this book, xerography is readily recognized by people across generations as a medium through which regular folks historically have successfully occupied public spaces. Xerography (or more precisely its digital offspring), while no longer the only way to circulate information, was integral to the Occupy movement because it was the medium through which we could most easily *imagine* achieving the types of public spaces the Occupy movement sought to create in cities across North America and around the world.

THE DETERRITORIALIZATION OF SCENES AND SUBCULTURES IN THE AGE OF XEROGRAPHY

While xerography's gritty aesthetic was one of the markers of downtown scenes across North America in the 1970s to 1990s, and in some cities continues to be part of the semiotics of the city, xerography also enabled us to imagine the possibility of being active participants in urban scenes and subcultures even if we were not

actually *there*. In essence, as much as xerography helped demarcate and in some cases solidify urban scenes and subcultures, it also played a role in their eventual deterritorialization, laying the groundwork for the types of networked communities we would come to take for granted by the early twenty-first century. Zines, the DIY photocopied publications produced by individuals and small collectives that flourished in the 1970s to mid 1990s, played a critical role in this process.

Once relatively unknown outside the underground, since the late 1990s the history of zines has been widely documented by culture and media studies scholars.[37] Zines date back to the 1930s, when science fiction writers and readers began to turn out their own DIY publications on mimeograph machines. The zine explosion, however, is nearly always said to begin in the 1970s, coinciding with the widespread availability of copy machines and the rise of the punk movement. As observed earlier in this chapter, the copy machine was the Trojan horse of the punk movement—a machine capable of reproducing the most vile, offensive, and controversial materials without the censorship, cost, or delay associated with printed forms of reproduction. In the 1970s, most zines took the form of fanzines—often dedicated to promoting a particular band or musician—and typically circulated at concerts and in independent record stores and bookshops. As zines became more widely known, their circulation and points of origin expanded. A zine purchased at a punk show in New York's East Village might end up in the hands of a fourteen-year-old kid living with his parents in a Connecticut suburb. The same kid might produce his or her own zine and trade it with other zine producers who might or might not ever have hung out in New York, let alone caught a show at CBGBs. Of course, zines were by no means only connected to the punk scenes in cities like New York and London. They were also being produced by artists and musicians and lonely teenagers in places like Seattle and Toronto and Toledo and Regina and everywhere in

between. Over time, zines radically changed the conditions under which people could participate in scenes and subcultures and arguably changed understandings of what defined scenes and subcultures along the way. If they were once assumed to be rooted in a particular place, by the 1990s the idea that subcultures might be defined by a fixed location no longer held.

Zines enabled people living in suburbs and small towns and even rural and remote locations to do more than passively bear witness to what was happening in the downtown scenes they were unable to experience firsthand. With the spread of zine networks, they could become active participants in scenes or subcultures rooted in an urban landscape. It was as if zines picked up and made mobile the aesthetics of downtown city streets by transporting a little piece of downtown across the continent—a piece that could in turn easily be reproduced and recirculated on copy machines. After all, many pages of zines look remarkably like the walls of pastiched posters one might have walked by in a downtown neighborhood in the 1980s or early 1990s. But more importantly, because zines represented "a radically democratic and participatory ideal of what culture and society might be ... *ought* to be,"[38] they also recruited readers, turning them into cultural producers whether or not they were part of a downtown scene. With zines, a teenager living on a farm in North Dakota could become a reviewer of New York punk bands and gain his or her own fan base. Finally, and perhaps most notably, as zines became increasingly important in the 1980s and into the early 1990s—in part due to the appearance of review zines, such as *Fact Sheet 5* (a zine dedicated to reviewing

FIGURE 3.2 The cover of *Xerography Debt*, no. 15; cover art by Botda/Bobby Tran Dale. Image reproduced with permission from Davida G. Breier.

other zines and disseminating their mail order addresses)—it became possible for scenes and subcultures to take shape outside urban centers. Riot Grrrl, an all-girl subculture/political and artistic movement that emerged in the early 1990s, represents a notable example of the impact of xerography on the development and spread of subcultures.

In contrast to punk, with its evident roots in urban neighborhoods in cities like London and New York, Riot Grrrl developed in Olympia, Washington, which at the time had fewer than 35,000 residents. Among them in the early 1990s were many transient residents linked to Evergreen College—a state institution nestled in a Pacific Northwest forest. Lisa Darms, who was a student at Evergreen College in the early 1990s and is now Senior Archivist at NYU's Fales Library and Special Collections, where she oversees the Riot Grrrl Collection, suggests that "Riot Grrrl was not a centralized movement. ... [It was] descriptive of a moment as much as a movement.[39] In my own research on Riot Grrrl, which dates back to 1994 when I first started to collect zines and correspond with and interview their producers, the decentralized nature of the movement, if it can even be called a movement, has always been one of its most notable features. While it is possible to locate Riot Grrrl's "origins" in Olympia in the early 1990s, in the end few of the women who published so-called Riot Grrrl zines or identified with the movement and its music and style ever stepped foot in Olympia. Olympia was a starting point, but it did not necessarily become a destination as the East Village did for North American punks. Rather, Riot Grrrl, as I've argued elsewhere, was always a movement that took the form of a dispersed network, and the production, distribution, exchange, and eventual collection of photocopied zines was integral to the movement's development and popularity and remains integral to its ongoing legacy. At a time when "virtual communities" were still only populated by hardcore techies congregating in MOOs and MUDs, Riot Grrrl was proving

just how vast, vibrant, and vital networked communities might be, and it was doing this with the aid of glue, paper, copy machines, and the postal service, not modems and screens.[40]

For all these reasons, I maintain that before digital social media became integral to the development of local and global scenes and subcultures, publics and counterpublics, there was xerography. In many respects, one might even think of xerography as a form of predigital social media. Social media are usually described as digital platforms that enable users to generate, share, and exchange information, often in collaborative ways and usually quickly and with little or no overhead. In contrast to contemporary forms of social media, however, in which users can choose to take a relatively passive role (e.g., simply reposting texts and images from other sources), using copy machines was an active endeavor. Just as making and distributing posters requires a certain degree of effort and even risk, acquiring zines takes considerably more effort than accessing social media sites. In the 1980s and 1990s, it meant going to a show or a used record store, which were among the only places you could purchase zines, or finding an address for a zine (usually in another zine) and corresponding with the zine producer. This correspondence, which usually took the form of handwritten notes and letters slipped into zines, was often personal, even intimate, and it all happened in the slow time of the analog world.

In contrast to earlier forms of print reproduction, zines were deceptively easy to produce and distribute—even for people who have traditionally been unable to engage in the production and dissemination of publications (e.g., teenagers and people living on fixed or limited incomes). Perhaps most notably, zines troubled the line between private and public texts and in the process disrupted established understandings of the relationship between print cultures and public cultures.

If Habermas's objection to forms of mass media is that they allow fewer people the opportunity to voice opinions and subject

more people to a single, authoritative perspective, xerography helped people imagine and realize publics and counterpublics that operate along a startlingly different axis—where the possibility to express and circulate opinions is infinitely expanded, where even opinions expressed by the mass media may be quickly appropriated and put back into circulation as types of critique (consider the pastiches and parodies, often comprised of cut-up materials from mainstream newspapers and magazines, that are commonplace in xeroxed zines or political posters). "A text, to have a public, must continue to circulate through time," contends Warner.[41] To the extent that xerography fostered a high degree of disregard for copyright laws and made recirculation inexpensive and accessible to anyone capable of pressing a button, one might argue that xerography also enabled existing texts to circulate through time and space more widely, thereby expanding what might be imagined as a public. Yet xerography did more than fracture the monolithic voice of the mass media in the last few decades of the twentieth century and expand publics and counterpublics. Some xerographic forms, such as zines, also rendered the divisions between the private (or intimate sphere) and public sphere increasingly irrelevant.

In Habermas's formulation of the public sphere, reading may take place in private but there is an assumption that journals and newspapers are produced in and for the public and ideally reflect the public's broader interest. Zines, however, have never clearly been circulated as public documents. While some zines may be produced for larger audiences, many more, especially the "perzines" that became increasingly popular by the late 1980s and into the 1990s, were written and produced by individuals often for limited audiences (only friends or only people the zine producers deemed to be fellow travelers).[42] But even zines with a wider circulation (e.g., fanzines focused on a particular band) do not carry ISSNs, casting them outside mainstream publication markets.[43] In

addition to deterritorializing scenes and subcultures once synonymous with the city, then, zines demonstrate the extent to which the medium of xerography eroded assumed boundaries between the private and public spheres.

As discussed in the following chapter, perhaps especially for people whose lives have never fit clearly into established notions of the private or publics spheres—a situation most notable for queers but also shared by other people affiliated with the symbolic and lived margins of society—xerography was a particularly adaptable and desirable medium of communication.

EROS, THANATOS, XEROX

> All we had were a lot of very creative people who could make beautiful posters.
>
> **LARRY KRAMER**
>
> This was the marvelous thing about ACT UP. This big, fancy, very expensive Xerox machine. If you had something to do that was related to AIDS and ACT UP, it was possible to do it.
>
> **BILL DOBBS**
>
> With xeroxing and wheatpasting, we could own space. For a certain moment, we could own a whole wall in Soho. We could own a whole wall in the Lower East Side …
>
> **JOY EPISALLA**

In Lizzie Borden's 1983 underground film *Born in Flames*, radical lesbian feminist vigilantes cruise New York City streets on bicycles and in rented U-Haul trucks, taking on everyone from individual sexual harassers to the United States government. At the center of Borden's feature-length film is a radical critique of the mainstream media and a poignant parable about the power of underground forms of media production, from pirate radio to photocopying and wheatpasting.[1] While Borden's film is set in an imagined New York—a city where an army of wheatpasting lesbian feminists eventually blow up the communications tower on top of the World Trade Center and seize control of the media—by the late 1980s the scene of Borden's indie film was the site of a highly politicized battle. The war fought in New York's downtown scene would not take the form of a battle of the sexes but rather a battle against the violent treatment of queers at the height of the AIDS crisis. As in Borden's futuristic film, however, media technologies would prove

integral to this real-life struggle, and copy machines would be deployed on a surprising range of fronts.

Other late twentieth-century social movements also deployed xerographic technologies, but for a variety of reasons AIDS activism and queer rights activism stand as especially rich examples of how this technology impacted social movements during this period. In large part, the place of xerography in the movements was simply a question of timing. By the mid 1980s, the mimeograph, which had played an integral role in earlier activist movements, including the feminist movement of the 1970s, had been largely replaced by xerography.[2] The role of xerography in the AIDS activist and queer rights movements was likely also due to the fact that many of the people involved in these movements (at least in cities such as New York) were also active participants in or at least influenced by the aesthetics of the downtown art and punk scenes, where xerography had already become synonymous with a particular attitude, style, and politics. But could it also be that copy machines were, on some level, queer by design and not simply queered in practice?

On the one hand, there is nothing particularly queer about copy machines. They were engineered to reproduce identical, or nearly identical, copies. They were hardwired for reproduction and replication, and neither are very queer traits. That said, there are things about copy machines that may have made them, by design, especially attractive machines for the queer community. As discussed in previous chapters, in contrast to earlier and established printing methods (e.g., Photostat, mimeograph, offset printing, and so on), xerography offered its users the possibility of reproducing documents without a master copy. Indeed, with xerography you could simply copy a copy or copy a copy of a copy, and no master copy meant no definitive point of origin. As previously emphasized, this is a desirable precondition of reproduction for pornographers and iconoclasts alike. As a result, it is no surprise that xerography

quickly found a home among queers. No master copy also meant no archive. While this is no longer the case (as I discuss in the final chapter, with the arrival of digital copy machines, archives are now housed *in* the same machines we use to reproduce documents), prior to the widespread appearance of digital copiers in the late 1990s, one could reproduce documents on a copy machine without leaving a trace. This enabled queer activists not only to reproduce materials that might otherwise have been subject to some degree of censorship by outside commercial printers but also frequently to do so for free on copy machines in their own workplaces. Finally, copy machines were engineered to speed up the reproduction of documents, and in this respect their temporality was also on the side of activists who often sought to reproduce high volumes of documents immediately and surreptitiously.

Thus copy machines, I maintain, were especially well adapted to the needs and desires of queer activists. In what follows, I turn my attention to the history of ACT UP's deployment of xerography in its campaigns and interventions and examine the role of xerography in the art, activism, and education campaigns of some of the other queer organizations and collectives that were active at the time, including Fierce Pussy, Queer Nation, and the Lesbian Avengers.

ACT UP'S PROPAGANDA MACHINE

In many respects, it's difficult to disentangle AIDS activism from queer activism in the 1980s to mid 1990s. At the time, AIDS was about being gay and being gay was irreparably structured by the presence of AIDS, but this is not to say that there was ever a single community. Queer communities have always been complicated and fractured, but, for a brief period in the 1980s and 1990s, gays and lesbians came together on an unprecedented level to engage in intersecting struggles for rights. The communities' combined

efforts would eventually transform the US Food and Drug Administration's (FDA's) response to the AIDS crisis and along with it public attitudes about AIDS. In the process, much of the groundwork for a second wave of gay rights was also laid. In many respects, the shift in policy and public opinion that took place between the mid 1980s and late 1990s was nothing short of miraculous. In the mid 1980s, a poll conducted by the *Los Angeles Times* discovered that 51 percent of Americans favored quarantining people who were HIV-positive, another 48 percent believed that people with the virus should be issued an ID card disclosing their status, and 15 percent favored tattooing anyone who was HIV-positive.[3] More shocking is the fact that these proposals were not simply part of a moral panic among the general public, but were given serious consideration by several government officials. As artist and activist Gregg Bordowitz recalls, "People don't realize that in the mid-1980s, at very high levels within the Reagan administration, quarantine and mandatory HIV testing were considered viable policy options. You had people like [William F.] Buckley, who said that gay men should be tattooed on their ass, and drug users should be tattooed on their arms, so the invisible threats would be rendered visible."[4] Less than fifteen years later, HIV had become a more or less manageable health issue (at least for those privileged enough to have access to healthcare) and gays and lesbians were beginning to gain traction on other policy fronts from spousal benefits to same-sex adoption rights. The AIDS crisis, which initially threatened to further marginalize the gay community—rolling back any gains made during the early gay rights movement of the 1970s—ultimately galvanized new levels of public support for it. Combined, the AIDS activist and queer rights movements of the 1980s and 1990s arguably represent one of the most effective marketing campaigns launched in the twentieth century. In short, queers not only repackaged a plague and effectively sold it back to homophobes across America as something they should

help battle but also used the crisis to leverage broader rights and visibility. But before AIDS galas became must-go-to events, a long struggle was waged on the street and in more clandestine ways, in research labs, corporate offices, and government agencies across the United States and around the world.

The success of the war on AIDS and the rise of queer rights in the 1980s to 1990s were the result of many factors. Most notably, these overlapping struggles benefited from an unprecedented convergence of energy, skills, and resources that came from all parts of the gay and lesbian communities. Many gay men brought personal resources, corporate connections, and direct access to the art and entertainment industries in which they worked. As a result, from the outset the AIDS activist movement had the money, talent, and connections required to launch public awareness campaigns on a grand scale and to leverage access to worlds typically inaccessible to grassroots activists. As discussed in this chapter, Gran Fury's successful public awareness campaigns, including their "Silence = Death" posters, were products of just such a combination of resources. But neither AIDS nor the struggle for queer rights were battles that could be waged with glossy posters alone. Many lesbians—by then seasoned grassroots activists who had already weathered the struggles of the women's liberation movement—arrived in the midst of the AIDS crisis with other vital skills, including substantial experience working as community organizers, orchestrating direct actions, and developing grassroots media campaigns. In short, they had firsthand experience mobilizing bodies and taking care of them, and just as importantly they knew how to access, reproduce, and distribute large amounts of information, especially related to health issues, using inexpensive and expedient methods (lessons learned during earlier battles over women's health, including reproductive rights). As Maxine Wolfe explains, "Even though the Lesbians were a small group, we were the people who had done politics." But Wolfe emphasizes that even as the movement was

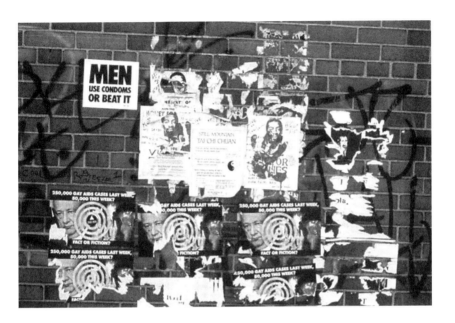

FIGURE 4.1 Wall of Gran Fury posters, New York, 1989. Image reproduced with permission from New York Public Library Archives and Manuscripts Division.

coalescing, some gender divisions were already in place, including those structuring media production: "The men have always been the graphic artists and we do the xeroxing and typesetting. ... Gay men have access to graphics; we have access to reproduction."[5] Despite the gendered divisions of labor cited by Wolfe, this convergence of money and access with affective labor and grassroots organizing experience proved a powerful one. It enabled the queer community to orchestrate civil disobedience actions on a mass scale, to control how the actions were subsequently represented in both community-based and mainstream media venues, and to do so while simultaneously managing the day-to-day care of people who were getting sick and dying. Holding all these actions together meant successfully leveraging both media and administrative technologies, and this is where xerography played a critical role.

Neither the war on AIDS nor the queer rights struggle of the 1980s and 1990s could have been fought without access to an accessible form of document reproduction, most notably to one that did not depend on a third party. After all, much of the material produced by AIDS activists and queer activists during this era—from educational pamphlets to unauthorized reproductions of government reports to queer liberation posters—featured texts and images that otherwise might have been subject to censorship. It is also important to emphasize that for AIDS activists and queer activists, xerography was a multipurpose technology. While copy machines were deployed to produce pamphlets, flyers, posters, and banners of all kinds—in short, they were deployed as propaganda machines—they were also used to recopy, produce, and disseminate an arsenal of scientific and administrative documents, from scientific reports to insurance forms. In this sense, activists deployed copy machines in both intended and unintended ways—in ways that both mirrored and distorted engineers' intentions. And, as I discuss throughout this chapter, because xerography was a highly accessible technology readily available in most activists'

workplaces, its deployment also meant that both the AIDS activist and queer rights movements were partially underwritten by private and public institutions that had yet to embrace either AIDS or queer rights as respectable corporate causes.

While cities across North America were affected by AIDS, the impact on New York's downtown neighborhoods was both more immediate and more devastating. As Sarah Schulman observes, "Manhattan's East and West Village in the 1980s and 90s had such high death rates the infrastructures and cultural ways of these groups were basically destroyed."[6] Yet as much as the AIDS crisis threatened New York's downtown scene, it also galvanized the scene, as artists and activists came together to raise awareness about AIDS and put pressure on the City of New York and federal officials to respond to the crisis. As Larry Kramer recalls, at the onset of the AIDS crisis, "All we had were voices. All we had were a lot of very creative people who could make beautiful posters."[7] The impact of having people who could make beautiful posters, however, cannot be underestimated.

By far the best-known art interventions produced during this period were the campaigns developed by a group of artists and designers who would eventually come to be known as Gran Fury—a stand-alone collective that later became an affinity group within ACT UP. Avram Finkelstein, a founding member of Gran Fury, helped to develop and pay for the initial print run of what is often cited as the collective's first campaign, the "Silence = Death" poster. As he recalls, "We wanted to be heard and to see also if we could stimulate some conversation about [AIDS]."[8] The "Silence = Death" posters were not only professionally printed but also the result of months of careful planning and debate. Despite initial feelings that the recirculation of the pink triangle would evoke victimhood, in the end the triangle and the "Silence = Death" slogan—which Finkelstein explains was somewhat surprisingly inspired by a Marshall McLuhan quotation—stuck.[9] Eventually three

thousand posters were printed with the goal of gaining coverage in several key neighborhoods, including the East Village, the West Village, Chelsea, Hell's Kitchen, and the Upper West Side, for approximately two weeks in 1987. "We were looking for areas that were art-related so there would be non-lesbian and gay audiences who might be sympathetic, or, as we say in advertising, influencing influencers," Finkelstein explains. "But then [we] also [wanted] to be specifically in the gay ghettos." Finkelstein further emphasizes that since the poster "was going to go alongside the commercial posters of the day," the collective agreed that "it would be big, it would be glossy, it would compete in that visual context."[10]

Gran Fury intentionally sought to build on both art and advertising traditions. On the one hand, there was an impulse to emulate the work of New York artists, such as Jenny Holzer and Barbara Kruger, who had already gained a reputation for working in street-based art forms.[11] On the other hand, there was a desire to compete with commercial advertising campaigns. With generous support from the New York art world,[12] the "Silence = Death" campaign and most of Gran Fury's campaigns were produced by commercial printers and distributed by the same "snipers" hired by entertainment companies to ensure maximum impact and coverage of available spaces, typically on construction hoardings.[13] Yet, despite Gran Fury's desire to create high-profile public interventions that actively sought to distance themselves from the DIY aesthetic associated with most activist posters, their posters traveled.

The group's iconic "Read My Lips" poster campaign, originally produced for a day of action against homophobia in 1988,

FIGURE 4.2 One version of Gran Fury's "Read My Lips" posters developed for a 1988 day of action on homophobia. Image reproduced with permission from New York Public Library Archives and Manuscripts Division.

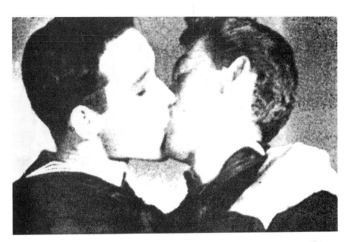

NATIONAL SPRING AIDS ACTION '88

DAY
1: 4/29-*AIDS and Homophobia*: You are here. Trax benefit 11:30
2: 4/30-*AIDS and PWA's*: 11:30 AM University Hospital, 100 Bergen St. Newark NJ-11:00 AM bus from Center
3: 5/1-*AIDS and People of Color*: Day of Rememberance and Solidarity; Outreach to Black and Hispanic churches.
4: 5/2-*AIDS and Substance Abuse*: Noon, City Hall Demo and Rally.
5: 5/3-*AIDS and Prisons*: 4pm Harlem State Office Bldg., 125th and Adam C. Powell Blvd.
6: 5/4-*AIDS and Women*: Safer sex literature to high school students and Shea Stadium Demo
7: 5/5-*AIDS: A World Crisis*: 4pm International Bldg. Rockefeller Ctr.
8: 5/6-*AIDS Testing and Treatment*: 4pm Demo across from F.A.O. Schwartz
9: 5/7-A *NATIONAL DAY OF PROTEST*: Marches, Rallies and Demos at US capitals. 7am bus to Albany from the Center, 208 W. 13th St. Tickets at Oscar Wilde and A Different Light.
For more info on any of the days call 533-8888

included two gender-specific posters—one of two sailors kissing and another of two women from the 1920s about to kiss.[14] The posters were not only widely distributed at the time but continued to circulate for years after the 1988 day of action on homophobia. In the mid 1990s, blurry reproductions of the same posters were still being reproduced across North America. Indeed, the posters were a staple in LGBT community centers and the offices of many student activist groups. While Gran Fury controlled the initial print run of their posters, they by no means controlled the life of their posters once unleashed into the world. While many New Yorkers encountered Gran Fury's posters as glossy and full-color productions, elsewhere their posters frequently only circulated as xeroxed reproductions. Despite Gran Fury's initial aversion to the traditional DIY aesthetic of the activist poster, then, with xerography many of the images and texts they put into circulation went viral, reappearing for years in gritty black and white reproductions made by people who had no contact with Gran Fury's members and who presumably knew nothing about the organization's aesthetic mandate.[15]

Although Gran Fury is best known for its high-profile advertisement-quality posters and billboards (or perhaps for the unauthorized photocopied reproductions of them), the collective did participate in several ACT UP actions where xerographic methods of reproduction were deployed. In 1989, ACT UP was preparing for what would become one of its most successful direct actions. "Everyone knew the Wall Street action was happening," recalls Maria Maggenti. "Gran Fury was already kind of coalesced at this point and was going, what can we do? And then, someone would be, 'Oh, it's got to be something about money.' ... And somebody else is like, 'We'll Xerox money!'"[16] In the end, Gran Fury produced thousands of green dollar bills. "It just looked like Monopoly money. It was so lo-tech. It was Xeroxed literally onto green Xerox paper, and then just like, thrown over the floors," Richard Deagle remembers,

adding that "there was a one, a 50, and a 100 ... on the backside there was a text. One of the texts came from me and it was, 'If You Think Straight White Males Can't Get AIDS, Don't Bank On It.' [Another] was: 'Fuck Your Profiteering, People Are Dying While You Play Business.'"[17] The following day the *New York Post* reported that ACT UP protesters wearing suits and fake badges had marched to the front of the exchange and up a flight of stairs where they chained themselves to the balcony, activated foghorns and threw fake money over the floor.

 It is important to bear in mind that the scale of the art-based activism that emerged out of the AIDS activist and queer rights movements during this period reflected the diversity of social actors engaged in these intersecting struggles. While Gran Fury's well-funded and professionally produced campaigns created a set of powerful visual icons and slogans around which the AIDS activist movement could coalesce, the collective's tactics were not embraced by all members of ACT UP. Deagle, who was involved with several early Gran Fury campaigns, explains, "The working methods of Gran Fury just didn't really work for me." Among Deagle's other interventions was a series of posters for the first Gay Pride Day that took place after the official formation of ACT UP: "I did a Xerox poster. Several of us went out and wheatpasted around Christopher Street the night before and it said, 'Gay Pride Day—What Are You Ashamed Of The Other 364?' Apparently, someone didn't like them because they were all ripped down."[18] While Gran Fury's images have endured, becoming synonymous with both ACT UP and a particular era of queer activism, for every iconic Gran Fury image there were dozens more posters and flyers, like those described by Deagle, that were produced on the fly, often in response to a specific crisis or event, and in many cases produced to speak directly to the queer community rather than the general public, which was Gran Fury's primary audience.

FIGURE 4.3 Xeroxed money (front and back) produced by Gran Fury for ACT UP's Wall Street demonstration. Image reproduced with permission from New York Public Library Archives and Manuscripts Division.

Xerography was not only deployed as a tool of dissemination for posters and flyers but was also an accessible way to produce props for ACT UP's theatrical direct actions. While the dollar bills distributed in the Wall Street demonstration were intentionally made to look like fake currency—the aim was to create something that looked more like Monopoly money than real money—for other actions xerography was used to counterfeit documents. At the onset of the Gulf War, for example, ACT UP members staged two high-profile actions—one at CBS and one at PBS. "It's one of those things that seemed really, really terribly easy, at the time," remembers Dale Peck, who further recalls, "a former CBS employee basically cut the lamination off of her identification card, which at that point had no magnetic strip on it. We took it to a high-quality photocopier, and just replaced our pictures with it. Re-xeroxed the cards."[19] Episalla made the cards for the PBS action, which was scheduled to take place on the same day. "I did an incredible job on paste-up for those," says Episalla, adding, "And, of course, they were done on a color photocopier."[20] On January 22, 1991, seven protesters used Episalla's fake ID cards to enter a PBS studio carrying "Fight AIDS, not Iraq" signs. In the end, several protesters managed to chain themselves to anchorman Robert MacNeil's desk, but they were never shown on air. At CBS, also armed with fake ID cards, three protesters shouting, "Fight AIDS, not Arabs" did interrupt the evening news and one protester briefly appeared on air.[21]

While the xeroxing carried out for the CBS and PBS actions required not only access to color copiers but also the skill of experienced paste-up artists (of which there was no shortage among ACT UP's membership), most of the copying carried out for ACT UP was an entry-level task. Indeed, xerography was not only an inexpensive way for the organization and its affinity groups to produce and disseminate the thousands of posters and flyers required to get their message out to communities impacted by AIDS, the general

public, and government officials, but also a way for a wide range of people to participate in the movement. As David Robinson emphasizes, "There were some people who were not comfortable speaking in front of the whole room, or getting arrested, or whatever. But they could stuff envelopes. They could come to a poster party and make posters. They could do guerilla xeroxing. And that was really valuable; to make it possible for people to contribute in those variety of ways."[22] Elias Guerrero joined ACT UP as one of those volunteers: "I noticed a lot of people didn't want to do the mundane things, and I thought really, an army wins its battles by making sure that mundane things get done. So, if people needed help with Xeroxing ... that's what I did."[23] In the dozens of interviews carried out for the ACT UP Oral History Project, xeroxing is frequently mentioned as a tool of dissemination and as something new volunteers, including those arriving with varying levels of experience and comfort with direct action, did as they entered the movement.

THE RESEARCH AND ADMINISTRATION MACHINE

While the AIDS epidemic is, for some of us, still relatively recent history, it is important to bear in mind that at its height most everyday communication was still taking place via landlines, fax machines, typewriters, Rolodexes, and copy machines. This means organizations were still housed in physical spaces full of phones attached to the wall, bulky filing cabinets crammed with important documents (memos, flyers, newspaper clippings), typewriters, and other early to mid-twentieth-century office machines. Like any organization, ACT UP, with its growing army of volunteers and financial backers, needed to keep track of its members, supporters, and enemies and to keep track of its finances. To this end, it quickly developed its own complex internal bureaucracy, and xerography was naturally part of this machine. While the organization's

internal machine did not, in the end, prove entirely efficient at record keeping, it did do a remarkable job of recruiting and communicating with its members and documenting its history.[24]

In an era when phone trees and newsletters were still standby methods of communication and networking, xerography was how ACT UP reached its vast and varied membership and at times created mechanisms for this membership to shape and critique the organization itself. When ACT UP members arrived at weekly meetings, the first thing they saw was a table covered in xeroxed articles, newsletters, and news clippings. As Bill Dobbs recalls, "the table, full of literature that was out at the beginning of each meeting, was an incredible cornucopia of news and got stuff out in a way that is almost unimaginable now that we are in the computer age."[25] Andrew Miller also remembers the important role "the table" played at ACT UP meetings, again emphasizing that this was "before email": "You would walk into ACT UP, at a Monday-night meeting ... and there would be an information table. And you could pick up stuff. And I would Xerox my articles, and Ann Giudici Fettner would Xerox her articles, and Phil would Xerox his articles, and you'd put it out."[26] However, the table contained more than research articles. Early on, Dobbs recognized the need to create an internal newsletter. In the end, his newsletter, which was distributed in runs of 400 to 600 at ACT UP weekly meetings, became a vital forum for members to both share ideas and opinions and vent frustrations about the organization itself:

> I made an announcement, and passed around a box, and whatever was put into the box got published. Few things I didn't publish, like somebody said, so-and-so's a police agent, I wouldn't feed that. ... I don't know, but it took off like crazy, but it was ahead of its time. It was like what you can do on the Internet now. But in those days, it was both irresistible, the 400 copies or 600 copies would just vanish off the tables, it was a

hot read, but it was sublime, smart, and also petty things. I'd run them all. I'd get attacked. I'd run those attacks. ... It was a little more real than the official publications.²⁷

Notably, Dobbs emphasizes that in many respects the newsletter was possible because ACT UP had its own copy machine: "This was the marvelous thing about ACT UP. This big, fancy, very expensive Xerox machine. If you had something to do that was related to AIDS and ACT UP, it was possible to do it."²⁸

Beyond its widely recognized reputation for creating beautiful posters and its ability to garner media attention on local, national, and international levels, ACT UP was also known for its ability to help people gain access to spaces and treatments that would otherwise have remained unavailable to them. This meant deploying an arsenal of tactics that ranged from the mere reproduction and distribution of required health forms to the acquisition, reproduction, and distribution of emerging research studies. Again xerographic reproduction played a critical role.

Among the many access issues taken up by ACT UP was a legislated threshold for Medicaid users. Karen Timour, who was a member of ACT UP's health insurance subcommittee and later its health access subcommittee, recalls that one year, Medicaid concluded that some users were overusing their Medicaid, because it was free. In response, Medicaid issued "utilization thresholds," which effectively put a cap on how many times per year a patient could visit their doctor. Following an intensive lobby, led in part by ACT UP members, the legislation was passed but with a provision that permitted doctors, at their discretion, to fill out an override form to ensure that thresholds would not be placed on patients with chronic illnesses, such as cancer or AIDS. Unfortunately, neither all the people living with chronic illnesses nor all healthcare professionals were aware of the form. To this end, members of ACT

UP's insurance committed started to photocopy the form and simply distribute it to anyone who might need it. Timour recalls:

> We did this action where we made reams and reams of forms. I mean, we did cases of Xerox paper of forms. And our thing was, that we distributed them on the floor of ACT UP and we said, everybody should take one of these. Give it to every single person you know who's got Medicaid, so that they have a form with them, in their wallet. It was sort of, like, have a condom in your wallet ... have a utilization threshold override form in your wallet, so that when you get to the emergency room and they say, I'm sorry, you know, your Medicaid card isn't working because you've reached your limit, you can whip out your form and say, here's the form, sign the form, and the doctor would have to sign the form.[29]

The action, while deceptively simple in many respects, demonstrates how essential xerography was in the years preceding the web. Without any easy way to access required medical forms or even the means to easily verify one's rights as a patient, interventions such as the one described by Timour were critical.

Helping people living with AIDS gain access to treatments, of course, was also initially contingent on lobbying the government to expand access to treatments. It's a well-known fact that the US FDA was slow to take the AIDS epidemic seriously and later slow to provide access to treatments that promised to save lives or at least make the illness manageable. ACT UP New York's Treatment and Data Subcommittee was at the forefront of much of the research and lobbying that would eventually change FDA policies and expand access to treatments for people living with HIV and AIDS. "The ... issue was to get drugs to be studied faster," emphasizes Mark Harrington.[30]

In order to accomplish this task, the members of the Treatment and Data Subcommittee had to become a virtual research machine—collecting, collating, translating, and redistributing thousands of pages of scientific data and redeploying it as a frontline weapon in the war on AIDS. Like any clearinghouse at the time, the group relied nearly exclusively on copy machines in their effort to reproduce and disseminate documents that would otherwise have remained primarily or solely accessible to people working in the pharmaceutical and medical industries. In this sense, copy machines became a sort of linchpin in cracking open an otherwise closed system of scientific knowledge and policymaking. "ACT UP certainly killed forests, and rented a very expensive copying machine," admits Bill Dobbs, but he says the money spent on xeroxing documents or sending people to conferences to learn about AIDS research still pales in comparison to the money most advocacy groups spent on communication and travel at the time.[31]

The Treatment and Data Subcommittee's first aim was to collectively gain expertise on a vast body of scientific knowledge and to disseminate any data acquired to other AIDS activists across the United States. Bill Bahlman emphasizes that as soon as documents arrived, the group would reproduce and redistribute them: "We got Lambda to give us space to work in, so that we could xerox copies of papers we were getting out of pharmaceutical companies and the NIH."[32] At times, the group was simply xeroxing and bundling up reports and, as Bahlman emphasizes, just "sending them with a cover letter to groups all over the country, going—document one is this, document two is this, and just not really having time to analyze, or even telling people what to think of it. It's just like, here, we got these documents; here, take them, and do with [them] what you wish." For Bahlman and other members of the subcommittee, there was an ethical or moral imperative to redistribute the documents: "We didn't feel comfortable just sitting on them. It was kind of immoral to just sit on them. We managed to get these documents.

We can't really publish them anywhere. But at least send them out to the other groups, so that they have them."[33] Xerography, in this sense, provided a legal way to widely distribute the information they were collecting and collating without actually publishing the documents in question.

For some members, however, the work of the Treatment and Data Subcommittee was considered inaccessible and even somewhat removed from the everyday concerns and struggles of the general membership. Mark Harrington recalls, "The first issue, as far as I was concerned, was that the language that was being used in the Treatment and Data sub-committee needed to be explained to the rest of ACT UP. And the very first thing I did was, I went to their teach-in, and I just wrote down every word that I didn't understand, and I looked it up and made a glossary out of it, and distributed [it] to ACT UP in July, when they had a teach-in." He further recalls, "We came to the floor every week … with these elaborate transcripts … we spent, you know, thousands on Xerox. But, there was still mistrust."[34]

Eventually, the Treatment and Data Subcommittee broke away from ACT UP, largely due to internal battles within ACT UP over race and gender issues and more generally the politics of knowledge. Among other controversies, some members of ACT UP believed the Treatment and Data Subcommittee, like many AIDS researchers, were so focused on the health crisis within the gay male community that they were failing to acknowledge that women were also contracting HIV, getting AIDS, and dying. Specifically, critics charged that treatments tested primarily, and in some cases exclusively, on white gay men might not be the most effective treatments for other populations, including women and visible minorities.[35] As a result, minority groups within ACT UP also eventually started to take research and education into the own hands. Maxine Wolfe was among the ACT UP women who helped author and compile the *Women and AIDS Handbook*: "The handbook that we created for

the women and AIDS teach-in, went all around the world. Not the book, the handbook, in its Xeroxed form, went all over the world. It went to the Australia conference. It just went everywhere. We sent it anywhere to anyone. ... We would just ship them out."[36]

Beyond their immediate impact (helping people living with HIV and AIDS), ACT UP's Treatment and Data Subcommittee and Women's Subcommittee—in large part, by reproducing and in many cases also interpreting, translating, and redistributing information—also helped to radically alter the sanctity of medical knowledge itself. Steven Epstein argues that AIDS represented an epistemic rupture of sorts in the world of science, as the preconditions for making knowledge claims shifted and established scientific protocols (e.g., for new drug treatments) shifted too. As a "politicized epidemic," AIDS had its consequences: "It has resulted in multiplication of the successful pathways to the establishment of credibility and diversification of the personnel beyond the highly credentialized." As such, according to Epstein, "credibility struggles in the AIDS arena have been multilateral: they have involved an unusually wide range of players. And the interventions of laypeople in the proclamation and evaluation of scientific claims have helped shape what is believed to be known about AIDS—just as they have made problematic our understanding of who is a 'layperson' and who is an 'expert.'"[37]

While it is now commonplace to google one's symptoms online before ever seeing a doctor and for many people to feel entitled to tell their practitioner what ails them—even detailing what treatments should be prescribed for their self-diagnosed conditions—prior to the widespread availability of reliable (and sometimes unreliable) medical information on the web, patients were by and large less well informed and generally felt less empowered to take their health into their own hands. The web, in many respects, restructured medicine and altered patient-doctor relationships, in part by loosening medical practitioners' authority as access to

medical and pharmaceutical knowledge expanded. While Epstein's study offers a compelling argument for the fact that the AIDS activist movement "afforded sources of intermediation and communication with the 'experts' and the 'public',"[38] it fails to account for the fact that this "intermediation" was not simply contingent on the fact that many AIDS activists arrived in the movement with considerable cultural capital and expertise. The research machine generated by ACT UP might have been impossible to execute without the aid of a highly accessible and inexpensive form of document reproduction. Xerography, I maintain, was at the heart of the intermediation Epstein refers to here.

Of course, by the late 1980s AIDS activists were already building on a tradition of xerographic-aided interventions in public policy. Writing about the Pentagon Papers scandal, Lisa Gitelman emphasizes that as early as the late 1960s xerography was already making it possible for people to do more than reproduce documents, even top-secret ones; xerography also "offered a way to edit or remake" documents. As Gitelman observes, "[Daniel] Ellsberg edited out some of the Pentagon's History when he decided (though accounts vary) not to copy the four volumes on diplomacy, but more importantly, when he edited out the words 'top secret' wherever he could. ... He contrived a cardboard mask for the Xerox machine, so that every page of the History was copied without its margins, producing new, empty margins: the History literally reframed for public consumption."[39] Following in the footsteps of Ellsberg and his colleagues, members of ACT UP's Treatment and Data Subcommittee were arguably not simply collecting documents, sometimes surreptitiously, and reproducing them; they were also reframing them (e.g., by glossing and annotating reports for a lay audience, bringing them together in ways that highlighted their contradictions and discrepancies, or redistributing them to audiences they were never intended to reach—namely, people living with HIV and AIDS). If, as Gitelman insists, "documentary

reproduction is a labor and a knowledge practice both dynamic and diverse," it is possible to see the xeroxing practices of AIDS activists as both mundane labor and part of a broader epistemic rupture that changed how science was and continues to be carried out and publicly negotiated. In short, AIDS activists, like feminist activists before them, helped to push scientific research into the public, and they did so with the aid of xerography.

ACTIVISTS AND ARTISTS ON CORPORATE MACHINES

Reflecting on the 1980s to mid 1990s exclusively through the lens of the AIDS crisis, one can easily lose sight of the fact that as the queer community was managing an epidemic, it also was gaining heightened visibility and strength. While much of the activism at the time centered around AIDS, organizations and collectives like Queer Nation and the Lesbian Avengers and artist activist groups like Fierce Pussy were simultaneously engaged in broader forms of activism and public awareness. It would be wrong, however, to separate the formation and work of these groups from the work of AIDS activists. Queer Nation was founded in 1990 by members of ACT UP New York who were growing increasingly concerned about violence against queers in New York and elsewhere. The Lesbian Avengers was founded two years later, again with the involvement of key ACT UP members, including Maxine Wolfe and Sarah Schulman. Fierce Pussy, formed in 1991, also included the involvement of several women connected to ACT UP. All three groups were inspired and informed by the tactics of ACT UP, but their mandates were different, and at times their tactics were even more DIY.

 Joy Episalla, an artist and activist who was active with the Maries, ACT UP's direct action affinity group, was a founding member of Fierce Pussy. Usually working on borrowed copy machines

FIGURE 4.4 Members of Fierce Pussy wheatpasting in the Lower East Side, New York, early 1990s. Image reproduced with permission of the collective.

and without the aid of paid postering services (the "snipers" who promised to ensure maximum coverage in high-profile neighborhoods that groups like Gran Fury depended upon), for most of its site-specific projects the collective relied on friends to help maximize coverage. "We would make a new poster," recalls Episalla, "and then a whole cadre of women would show up to go out wheatpasting." Fierce Pussy's campaigns in the early 1990s primarily focused on raising lesbian visibility and, as four of the group's still active members emphasize, on finding ways to communicate directly with other lesbians: "Rather than taking on the critique of mass media, homophobia and the male gaze, we announced ourselves as lesbians and directly addressed other lesbians walking those same streets." Only in retrospect have they come to fully appreciate how important this communication was to the lesbian community in New York at the time. "Two decades later," Episalla explains, "Other lesbians started to tell us that they had our posters, which they had found on the street, still hanging in their apartments."[40]

In their first campaign, "I AM A ... AND PROUD," the collective chose to speak in the first person and to reproduce and recontextualize the derogatory language that has historically been used to denigrate and silence lesbians. The collective's posters, which appeared on construction hoardings and other public sites around the city, featured lists such as "I AM A lezzie butch pervert girlfriend bulldagger sister dyke AND PROUD!" The following year, the collective reconvened to produce a series of posters made from family photos, most featuring the collective's own members as children. In some of the posters, baby photos were reproduced along with the words "DYKE" and "Lover of Women." Other posters featured pairs and groups of unknown people with prompts such as "Companions?" and "Spot the Dyke in this Picture." As the collective explains, "We use our own childhood and baby pictures to reconsider the space of family and personal history as queer space."[41]

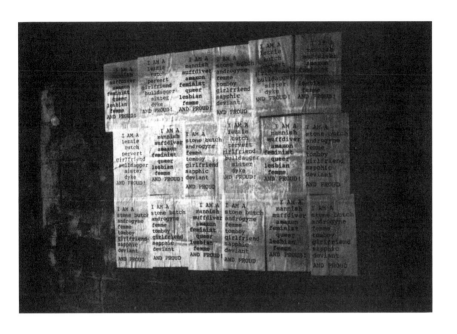

FIGURE 4.5 Wall of Fierce Pussy posters, New York City, early 1990s. Image reproduced with permission of the collective.

The collective was doing more, however, than reconsidering personal history as queer spaces; they were also occupying public spaces, or actively engaging in the production of lesbian-centered counterpublics. As Episalla emphasizes, while their tactics were often deceptively simply and inexpensive (xeroxing and wheatpasting), they enabled the collective to "own space. For a certain moment, we could own a whole wall in Soho. We could own a whole wall in the Lower East Side, and our bombing technique was the way we did this. They might have been 11 x 17 posters but put 50 on a wall and you have a whole different thing."[42] Owning space was integral to their mandate in the early 1990s and remains important to the collective members' mandate today: "We don't see public space as neutral or abstract. We take queerness out of the 'abstract' and enact a queer conversation out in public. Historically, public space has held a contradiction for queer people; on the one hand we have been invisible and on the other hand we are frequently the targets of violence in public. Part of the impulse in making this work has been to let other queer people know that we are here, that queer people are everywhere—simply put, we make ourselves visible."[43]

Being public, not private, was a mandate shared by other queer activist groups at the time. When Queer Nation came together as a radical direct action group, it sought to assert an ardent, at times separatist approach to queer activism—one based on difference rather than assimilation, radicalism rather than conformity. Like Fierce Pussy, its mandate was visibility at all cost. As stated in "An Army of Lovers Cannot Lose," part of the group's inaugural manifesto, "Being queer is not about the right to privacy; it's about the freedom to be public. ... It's about being on the margins, defining ourselves."[44] Unlike Fierce Pussy, which remained a site-specific New York-based art collective, Queer Nation quickly spread from New York to other cities across North America, staging antiviolence protests, self-defense workshops, and queer interventions in

venues as diverse as gay bars and suburban shopping malls along the way. Their interventions were a bold attempt to queer public space, create visible counterpublics within mainstream public spaces, and assert queerness as the basis for a type of imagined community (hence the "nation" in Queer Nation). Xeroxed posters, flyers, and zines played an integral role in Queer Nation's visibility and rapid spread from New York to other cities across North America. To claim queerness as one's identity location was to assert membership in a nation that had no fixed location and infinite potential.

This too was the stance adopted by the Lesbian Avengers, which came together in New York City in 1992. In their widely distributed handbook, which continues to circulate as a photocopied reproduction and online, the Lesbian Avengers state that their primary mandate is to fight for "lesbian survival and visibility."[45] Again, despite the fact that there was considerable overlap between the Lesbian Avengers and ACT UP, from the outset the group was fully committed to a DIY ethic, which included reproducing posters and flyers for free whenever possible and rejecting external funding. Indeed, they raised money inside the lesbian community at $5-a-head events and encouraged members to reproduce posters and flyers on copy machines in their own workplaces. Doing things for free was considered such a vital attribute that they list "Access to resources (Xerox machines)" as the number one Lesbian Avenger quality on an early poster.[46] Again, the viral nature of xerography—its ability to reproduce materials using limited skill and even limited money—was pivotal to the Avengers' impact.

Among the Lesbian Avengers' more high-profile and successful actions was a raid of the *Self* magazine offices. Just after Proposition 2 was passed in Colorado (the legislation essentially made it impossible for gays and lesbians to claim minority status on any basis and thereby impossible to launch discrimination cases across the state), *Self*, a Condé Nast publication, announced that they were hosting a ski weekend in the state, which by then had

become the target of a nationwide boycott. Avengers responded by raiding the magazine's Fifth Avenue offices. While the magazine denied that the Avengers' action was a factor, as Schulman reports, "Within two days the weekend was canceled."[47] What Schulman does not mention is that at the time, Condé Nast had many gays and lesbians on staff, including those with direct connections to organizations such as ACT UP and Fierce Pussy. Artist and founding member of Fierce Pussy Carrie Yamaoka was just one of the many queer artists working for a Condé Nast magazine in the early 1990s. "There were a lot of queer artists working for Condé Nast," she recalls. "We were brought in at certain times of the month to do paste-up and other jobs. This also meant we had access to their equipment." Yamaoka emphasizes that in many respects, the nature of their positions allowed for a certain degree of *perruque*: "There was a lot of time waiting for type to come back so with an hour or two of time to kill, you could be running off posters and making the posters. My boss knew what I was doing with the Fierce Pussy stuff, but Condé Nast had so much money, the paper cost and toner was not a concern to them."[48] To this day, Fierce Pussy begins their public talks by thanking Condé Nast. As Episalla emphasizes, "One of the things we always say, is we would like to thank Conde Nast because even though they have no idea, they underwrote a movement."[49]

In Schulman's interviews for the ACT UP Oral History project and my own interviews for this book, workplace xeroxing is repeatedly cited as one way activists managed to reproduce posters and flyers and other printed matter, and it seemed to be as important

FIGURE 4.6 Cover of the *Lesbian Avengers Handbook*; cover design by Amy Parker and photograph by Carolina Kroon. Image reproduced with permission from the Lesbian Avengers.

a strategy for organizations with a stable funding base, like ACT UP, as for queer artist collectives and organizations without formal spaces, equipment, or sponsors. Marion Banzhaf, who had a day job as a typesetter while she was involved with ACT UP, confesses, "I had this corporate gig, where I was part of a typesetting department of two. And my boss was the early shift, and I was the late shift. So once I finished my corporate work, I just stayed, and would churn out all this political stuff."[50] Jim Eigo credits NBC with providing free copying services to ACT UP: "NBC gave us so much, they will never know. They Xeroxed so many thousands [of] dollars of stuff. We had so many people working within so many of the communications and art industries within New York City that drew upon those industries. That's something that you don't often hear about within ACT UP, and that's something that's always interested me."[51] In another interview for the ACT UP Oral History Project, Steven Keith mentions Microsoft: "We had some patronage. So we went to Microsoft Systems Journal office, at Worldwide Plaza, where they had something that's still remarkable; giant monitors, where you could have multiple pages out at once to do your layouts."[52]

While there is no official record of how many tens of thousands of copies were made free of charge on the backs of corporations such as NBC, Microsoft, or Condé Nast, there seems little doubt that xerography may have been the first benefit extended, albeit unintentionally, to queer employees, their partners and communities. But as Sandy Katz emphasizes, the corporate-based xeroxing that took place within ACT UP and other parts of the queer movement at the time was in fact part of a highly organized machine:

> Everybody had different day jobs. One of the things I remember is—the whole Xeroxing system, and how, if you had something that you needed five thousand copies of, there were so many people who were office workers in ACT UP and they

were very well organized. And it was just a matter of activating a phone tree, and getting these people originals, and then a few hours later, you have five thousand copies of whatever you wanted, courtesy of law firms, and whatever other kinds of institutions people were working for.[53]

On the basis of a similar recognition, in the *Lesbian Avengers Handbook* readers are reminded that "there are Avengers who work in corporations with massive Xerox possibilities."[54] In short, whether one was working as a typesetter or an executive, access to copy machines was widespread and recognized as a critical resource in both the war on AIDS and the struggle for queer rights.

While the xerographic era is technically speaking already over (and has been since the arrival of digital copiers in the mid to late 1990s), just as people continue to fetishize the aesthetic of Russian political posters from the early twentieth century and French political posters from the 1960s, so the gritty aesthetic of xeroxed political posters from the 1980s and 1990s continues to circulate as synonymous with a certain politics or ethos, if not as an actual method of reproduction. Indeed, as I explore in the final chapter, even as xerographic copy machines are relegated to dump yards and museums, the pursuit of the "xerox effect" persists. If the circulation of photocopied materials during the Occupy movement is any indication, the idea, if not reality, of xerography continues to occupy part of our political imaginary in the twenty-first century.

**REQUIEM AT THE COPY
MACHINE MUSEUM**

> Time's of the essence get your ears to the ground
> However else can the hits be found?
> I may look happy, healthy and clean
> A dark brown voice and suit pristine
> But behind the smile there is a zerox machine
>
> I'm a zerox machine, I'm a zerox machine, I'm a zerox machine
>
> **ADAM AND THE ANTS**

In 1979, Adam and the Ants, the post-punk British band that would help to usher in the New Wave sound of the 1980s, released their 7-inch vinyl recording "Zerox." That a band would feel inspired to write and perform a song about an office technology likely says a great deal about the impact xerography had already had on cultural production by the end of the 1970s. Indeed, however much copy machines were associated with office culture, they were also cool enough to merit their own catchy post-punk anthem by a band otherwise remembered for their "Sexual perversion, pirate costumes, visible black lingerie for men, tribal drumming, loud surf guitars, brain-dead lyrics [and] high-pitched shrieks."[1] Whatever one thinks of the band's lyrics, those to "Zerox" (a notably cautious play on the company name) did capture xerography's ethos. Xerography, as the Ants insisted, was about stealing ideas, duplicating them, and doing so after dark without the boss's knowledge. After all, one may "look happy, healthy and clean," but who knows what one is up to if "behind the smile there is a zerox machine"?[2] In 1979, xerography—or more precisely, its clandestine deployment—was ubiquitous enough to inspire popular anthems and rock videos. By 2000, however, the xerographic era was already coming to an end, and, somewhat surprisingly, most people didn't even notice.

COPYING COPYING

By the early 2000s, a growing percentage of copy machines were digital rather than analog. While it may not be immediately visible on paper, the difference is significant. In the analog xerographic method, the document is illuminated by a lamp and the resulting image is projected onto the machine's photoconductive surface, which is in turn used to apply toner to a page. By contrast, digital copiers, which often also function as networked printers and fax machines, scan images to memory just as flatbed scanners do. The digital files are then sent to the machine's printer, which resembles a powerful inkjet copier more than a circa 1970s copy machine. As a result, today most copy machines, even those waiting to be trashed or sent to the developing world for a second life, now contain a hard drive, which, depending on the manufacturer and type of machine, may contain thousands of archived images. In this new digital era of copy machines, then, the clandestine uses of the copy machine celebrated by Adam and the Ants back in 1979 would be difficult if not impossible to duplicate. While copy machines have long been used to build up archives, until recently the machines and their archival output remained entirely separate: documents were reproduced on copy machines and then placed in archives. With the advent of digital copiers, copy machines now carry their archives with them. In theory, any clandestine use is now part of the machine's memory, turning copy machines into loaded guns of data and potentially turning them against their users.

A highly circulated CBS News report in 2010 demonstrated just how vast and revealing a copy machine's hard drive can be. As part of its investigation, CBS visited a warehouse in New Jersey with John Juntunen, a software developer who specializes in erasing copy machine hard drives. After purchasing four machines, they reported, "It took Juntunen just 30 minutes to pull the hard drives out of the copiers. Then, using a forensic software program

available for free on the Internet, he ran a scan, downloading tens of thousands of documents in less than 12 hours."[3] Among other documents, Juntunen discovered detailed domestic violence complaints, a list of wanted sex offenders, 95 pages of pay stubs with names, addresses, and social security numbers, and 300 pages of individual medical records. While the report does not mention the other types of texts and images found on the copy machines' hard drives, it seems likely that mixed in among the pay stubs, the list of sex offenders, and private medical information were hundreds of non-work-related documents.[4]

While people no doubt continue to use copy machines in subversive ways, in a digital era they can no longer do so with a guarantee that they won't leave a trace. Xerography's promise was never simply perpetual replication but replication without the need for a master copy or negative. You could copy an original or copy a copy without leaving evidence that you had done either. As much as we continue to imagine clandestine uses of copy machines, then, in reality there may no longer be anything clandestine about them. In the twenty-first century, the copy machine now scans both our documents and our subversion. In this sense, whether or not most of us realize it, while copy machines continue to be manufactured and used, the xerographic copy machines that so radically adjusted societal margins in the late twentieth century have been replaced; we're already in a post-xerographic era. What we now refer to as a copy machine is usually nothing more than a large scanner and printer that copies and archives documents simultaneously, no more a mere copy machine than a laptop computer is a typewriter. Yet despite the fact that xerographic copy machines are nearing extinction (and were arguably on the brink of extinction by the time we started hoarding supplies for Y2K), in name and possibility they live on, in ways that are notably distinct from many other types of old media technologies.

MUSEUM FÜR FOTOKOPIE

As I was completing this book, I discovered the existence of a German copy machine museum. I happened to be in Germany at the time and immediately made plans to visit the collection. What I discovered, however, is that, like the copy machine itself, the Museum für Fotokopie was long past its prime.

The Museum für Fotokopie was founded by copy art artist Klaus Urbons in 1985. Originally, Urbons's private museum featured 22 copy machines. By the time he donated his collection to the Deutsches Technikmuseum in 1999, it had grown to over 200 machines. Urbons donated his collection when he had completed tracing the history of the copy machine from its inception to the development of digital copiers. But the timing of the donation also suggests that, by the late 1990s, Urbons recognized that the era of the copy machine was effectively over. In essence, from now on there would be no more copy machines to add to his collection unless he wished to expand it to include digital scanners and printers, which evidently he did not.[5]

Before visiting the collection, I envisioned a sort of mausoleum of the copy machine (my perception no doubt informed by the photographs of the Museum für Fotokopie that appear on Urbons's personal website).[6] I imagined Urbons's two hundred or so copy machines lovingly preserved and resting on platforms in a spacious museum hall. I imagined families and groups of school children wandering through the exhibit—a post-xerographic generation asking curious questions about the machines' origins. I imagined security guards keeping a watchful eye over the precious artifacts on display.

When I arrived at the Deutsches Technikmuseum, I announced my intentions to the information officer, explaining that I was only there to see one exhibit—"die Fotokopierer." The information officer looked perplexed. He had seen no "Fotokopierer" in the museum.

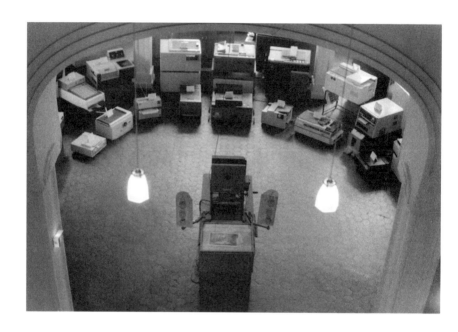

FIGURE 5.1 Copy machines from Klaus Urbons's Museum für Fotokopie-Projekt. Image reproduced with permission from Klaus Urbons.

After making calls to five different offices, he informed me that the collection was not on display—after all, as he explained, people visit the Deutsches Technikmuseum to look at German-engineered cars and planes, not copy machines. If I was still interested, however, I was free to contact a member of the museum staff and request permission to gain access to the machines in their storage facility.

Over a week later, I arrived at the museum's two-hectare storage facility in the north end of Berlin. There the facility's manager led me through dozens of storage buildings containing World War II planes wrapped in tarpaulins, cars from World War I—some rusting away in the warehouse and others perfectly refinished—and thousands of former GDR products, from computers large enough to span a quarter of a city block to television sets, radios, and clocks. Mr. Ruppert, who had been charged with the task of leading me to the copy machine collection, explained that after the Wall came down, every day for six years truckloads of old technologies arrived from the GDR. By virtue of a political transition, the Deutsches Technikmuseum became a sort of graveyard for the GDR's technological castoffs, many still in working condition—a circumstance that further exacerbated the problem since many East Germans were particularly reluctant to trash working machines, no matter how eager they were to embrace Western products. For the first time, I appreciated why media archaeology has dominated German media theory for the past twenty five years—German media theorists were, in every sense, surrounded by media artifacts.[7]

Eventually we arrived at what remained of Urbons's copy machine museum. The machines, I discovered, were not donated to the museum—the collector had hoped the machines would be purchased by the Deutsches Technikmuseum—but no money ever exchanged hands. Indeed, as far as the facilities manager knew, the collection was in a sort of limbo. In contrast to many other items in the massive storage facility he manages, the copy machines appeared somewhat neglected. While many items in the warehouse

were carefully wrapped in tarpaulins, many of the copy machines were fully or partially exposed. More notably, the collection had yet to be inventoried, since its status was unclear. For now, the collection was simply waiting for its next life, its future uncertain.

Stacked three shelves high in the museum's warehouse, the collection included a wide variety of copy machines. Most of them appeared to date from the 1960s to 1980s when xerography was at its height of popularity and already highly accessible. There were massive copiers and small desktop copiers; copiers in an entire spectrum of unappealing colors—some gray, some beige, a few in shades that resembled the color of green or blue hospital scrubs. Some machines featured massive buttons and would have been entirely at home on the starship *Enterprise*'s bridge. Others looked more modern but by no means contemporary.

The most striking copy machine in the collection was a massive one wrapped in a wood-veneer facade. The desire to wrap a copy machine in imitation wood struck me as an especially peculiar gesture. While many entertainment systems from the same period featured a similar aesthetic, in those cases the wood pointed back to the original construction of phonographs, gramophones, and radios, which were once housed in wooden cabinets. Xerographic copiers, however, were never built for wooden boxes, and in fact, given the high temperatures required to fix xeroxed images to paper, wood was never a realistic option. When I later contacted Klaus Urbons about the collection, he explained that this particular copier had been manufactured in the 1960s by Fotoclark in Germany. One can only imagine that whoever created it was engaged in a bold attempt to aestheticize a machine that has otherwise received little attention from designers over the course of its existence.

As my tour guide explained, copy machines aren't the most interesting thing to look at in his collection. From a design standpoint, I had to agree. While many old technologies have an aesthetic

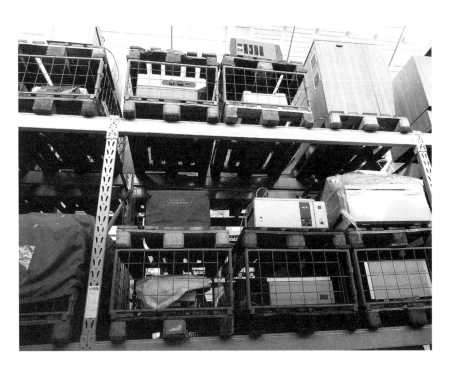

FIGURE 5.2 Klaus Urbons's collection in storage at the Deutsches Technikmuseum in Berlin, July 2014. Photograph by Andrea Gil.

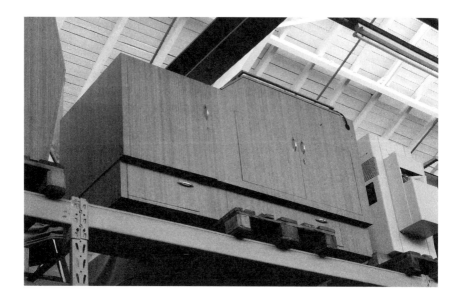

FIGURE 5.3 A copy machine encased in a wood-veneer cabinet, which was manufactured by Fotoclark in the early 1960s. Photograph by Andrea Gil.

appeal—old typewriters and radios and televisions of all kinds—the copy machines in Urbons's collection, like most copy machines, seemed unlikely ever to be reclaimed on this basis. You can't display a copy machine on your bookshelf, and unless you have room for the unique 1960s wood-veneer model mentioned above, they will likely never serve as an accessory to a Danish modern sofa. To fully appreciate the lowly status of copy machines among other old, forgotten and neglected media technologies, it is especially useful to compare them to typewriters.

Typewriters have been vanishing from workplaces since the early 1990s, but they remain easy to find both in whole and in parts. Typewriters not only make attractive shelf ornaments or window display accessories (visit your local independent bookstore and nine times out of ten there will be an old typewriter on display), but you can also take them apart to make earrings, necklaces, and rings. As Darren Wershler-Henry observes, "The sheer variety of typewriter-related detritus up for auction on eBay is staggering, and, as with the relics of saints and pop stars, sometimes the parts are worth more than the whole." Wershler-Henry further observes that as absurd and insignificant as "typewriter jewelry" may be, these wearable documents (they frequently spell out messages in salvaged keys) serve an important function: "They keep the typewriter highly visible at a moment when it IS on the verge of disappearing for good."[8] Etsy crafters are not the only people who have discovered the many uses of old typewriters. Steampunks have a penchant for creating laptop-powered versions that combine the capacity of a computer with the sound and style of nineteenth-century typewriters—a perfect example of what Jay Bolter and Richard Grusin call remediation, at its simplest "the representation of one medium in another."[9] And typewriters are not the only forgotten and neglected technologies that appear to be enjoying a second life. At the popular clothing and accessory outlet Urban Outfitters,

customers can purchase their very own 1960s-style portable turntable, 1970s-style Polaroid camera, or 1980s-style boom box.

Copy machines will likely never share the limelight with other media technologies from bygone eras. As objects, they hold little or no appeal. While even the telegraph still has a few enthusiasts who regularly tap out messages to each other on homemade kits, so far xerographic copy machines appear to have no enthusiasts, crafters, or modifiers carrying them into the future. Despite their significant impact on late twentieth-century art movements, scenes and subcultures, and even the aesthetics of our cities, copy machines are themselves virtually bereft of design considerations. As objects, you might say they are simply flat. Their wonder appears to be located in their output, not their hardware: once the machines stop turning out copies, their appeal wanes. No remediator wants to house a current desktop scanner/printer/copier inside the massive carcass of a 1970s-era copy machine. The look and feel of the older machine, after all, are neither attractive nor bound to evoke much nostalgia from anyone who remembers using one. Similarly, there appears to be no brisk trade in old copy machine parts on eBay and other auction sites. After all, you can't use these machines as décor nor take them apart to make earrings. So what does the copy machine leave us? As I discuss in the final section, while the machines themselves may hold little value, the xerox aesthetic persists.

THE "XEROX EFFECT" AT ZUCCOTTI PARK

Face to face with what remains of the Museum für Fotokopie in the warehouse at the Deutsches Technikmuseum, one might conclude that xerography is not only dead but also quickly drifting out of our consciousness. After all, old xerographic copy machines don't appear to have a viable future even as museum artifacts, let alone as functioning machines. Yet, while the machines themselves—and

along with them the xerographic process—reaches near-extinction, the "xerox effect" persists. Do a search for "xerox effect" and you'll discover dozens of forums where designers provide tips on how to create digital documents that *look* like they were xeroxed:

> Starting with a good contrast (usually) color image ...
>
> Image > Mode > Grayscale
>
> Image > Adjust > Levels ... drag the shadows slider and the highlight slider overtop the midtone slider.
>
> Image > Mode > RGB Color
>
> Select the white (magic wand and Select > Similar), flood (Edit > Fill ...) one color.
>
> Select the black (magic wand and Select > Similar), flood (Edit > Fill ...) the other color.[10]

Bearing in mind that copy machine manufacturers spent decades trying to create machines capable of turning out documents that would look less like photocopies (largely in response to consumer demand), the fact that one might now labor to reproduce the "xerox effect" with digital tools is more than a bit ironic. But technical considerations aside, what remains appealing about the "xerox effect"?

As explored in detail throughout this book, if xerography adjusted the lived and imagined margins of society, it did so on several levels. First, xerography loosened the hold of print culture and the imagined communities it once fostered, most notably the imagined community of the nation itself. As discussed in chapter 2, print cultures are frequently characterized by their homogeneity (e.g., notwithstanding notable exceptions, print cultures are generally associated with the heightened standardization of languages across vast geographical expanses). By contrast, xerography

promoted opportunities for renegade publishers and authors to reproduce documents of all kinds, whether or not they adhered to the linguistic and typographical conventions that had become entrenched with print. With xerography, people were increasingly free to make and distribute texts that neither reflected nor supported print culture's "languages of power." In this sense, the stability and uniformity of print cultures were effectively interrupted by the heterogeneity fostered by xerography. But to the extent that xerography interrupted print culture by prying open new opportunities to produce eclectic types of texts, it also profoundly changed our experience of publics and counterpublics, cities and networks. Maintaining that publics and counterpublics never exist apart from the media through which they are imagined, in chapter 3 I examined some of the specific ways in which xerography helped us imagine different types of spaces in which to live, create, and organize ourselves. As I further argued, however, xerography not only changed our experience of cities. By the late 1980s, it had also emerged as a medium through which to deterritorialize downtown scenes and subcultures, giving way to a myriad of networked or textual communities. In this sense, xerography both intensified the local and laid the groundwork for the virtual communities we would later come to take for granted. Finally, as discussed in detail in chapter 4, xerography changed how social change was enacted. Without dismissing earlier DIY printing methods, such as mimeography, in this book I have made a case for xerography as a medium that was especially well suited to the needs of grassroots political activists. Specifically, I have argued that while not necessarily queer by design, by virtue of historical circumstance and the fact that xerographic copiers were especially well adapted to clandestine uses, xerography came to play an integral role in the intersecting AIDS activist and queer rights movements of the 1980s to 1990s. In summary, in this book I have argued that xerography weakened many of the institutions and conventions established

under print cultures, enabled us to imagine new types of publics, counterpublics, and communities, altered our experiences of cities while simultaneously closing the distance between people living in cities and rural and remote areas, and armed social activists with an especially adaptable, powerful, and inexpensive (often free) tool for propaganda, movement building, and knowledge making. It's on this basis that the claim forwarded in the title—that xerography adjusted the margins—is supported.

Perhaps this also explains why within days of the 2011 occupation of Zuccotti Park in Lower Manhattan, the grounds were littered with photocopied flyers and posters. Despite the fact that the Occupy movement started on social media when the advertisement-free, anticonsumerist magazine *Adbusters* sent an email to its readers encouraging them to "occupy Wall Street" and later created the "#occupywallstreet" hashtag, social media only tell part of the Occupy movement's story. Occupiers were not only sending tweets and uploading images and status updates to Facebook in the fall of 2011, they were turning out posters, flyers, zines, and DIY books of all kinds. It was how protesters created textual communities within and across various Occupy sites throughout North America and beyond. Ironically, in some cases photocopied posters and flyers or copies of copies of posters and flyers were uploaded and sent to other Occupy sites, downloaded, and copied again on copy machines hundreds or thousands of miles away. The copy machine was not a stand-alone medium for occupiers but one in a complex circuit of media technologies, which included the digital social media with which the Occupy movement quickly became synonymous. In all likelihood, none of the printed ephemera associated with the Occupy movement was actually xeroxed, because by 2011 it is almost certain that Occupiers were producing their posters, flyers, and zines on digital copy machines, but this is not to say xerography, or its ghost, was not present on the grounds at Zuccotti Park and other Occupy sites. If photocopied

posters, flyers, and zines still quickly found a place in Occupy, it is because the aesthetic of these forms continues to signify something that exceeds a method of document reproduction. The gritty photocopied aesthetic is anarchic and punk, radical and queer. As I argued earlier in this book, if DIY posters, flyers, and zines turned out on copy machines had a place in Occupy, in part it is because their predecessors—the types of materials turned out on xerographic copiers in the 1970s to 1990s—were already associated with earlier occupations and social movements. For this reason, xerography was a medium through which we could also easily imagine occupying spaces and adjusting margins in the present (whether Zuccotti Park or the 1%). There was, however, also a more practical way in which copy machines came to play a critical role in the Occupy movement. As the social media that had instigated the movement were somewhat predictably turned against Occupiers (it is well known that many marches failed because the activists' routes and tactics were overly visible on social media sites, giving law enforcement agencies unprecedented access to insider knowledge), the need to return to paper became increasingly pressing. As the weeks worn on, photocopied maps and information sheets reemerged as increasingly important modes of communication in Occupy. After all, you can flush a photocopied map down a toilet or, if really desperate, chew and swallow it—the same cannot be said for a status update or tweet.

As I complete this book, most libraries have already replaced their in-stack copy machines with scanners. Rather than photocopy the pages of a book, you can now scan the pages to a portable flash drive or simply snap shots of a book's pages on your mobile phone. The sound, smell, and frustration of carbon copiers have vanished from libraries (and most other locations) and so have the coin machines that once stood beside these copiers. Today, copying is typically free, digital, and odorless.

While digital copiers will no doubt continue to be manufactured in the coming decades, how we use these machines will also continue to change. In another decade, what we refer to as a copy machine will likely be an even more distant and mutated descendant of Carlson's invention—persisting in name but not necessarily in process or function. But there is no reason to believe that xerography will entirely vanish. It will persist as a signifier of a specific style, attitude, and politics that changed how we lived, created, connected, and organized ourselves in public spaces in the late twentieth century. And if xerography mattered because it was a medium through which we imagined how to create new types of publics, counterpublics, cities, and communities, perhaps it is entirely appropriate that its legacy will never take the form of a set of artifacts confined to a glass vitrine in a museum.

NOTES

PREFACE

1. "ACT UP New York: Activism, Art, and the AIDS Crisis, 1987–1993," curated by Helen Molesworth and Claire Grace, first appeared at the Carpenter Center for the Visual Arts and the Harvard University Art Museums in fall 2009. It was remounted at White Columns in New York City from September 9 to October 23, 2010.

2. While the arrival of the World Wide Web technically dates to 1990, I am referring here to a period from 1994 to 1997 when both Netscape Navigator and Internet Explorer, two highly popular and user-friendly commercial browsers, were first released, facilitating increased everyday web traffic in a growing number of workplaces, schools, and homes.

3. See, for example, Harold Innis's "The Problem of Space" in *The Bias of Communication* (Toronto: University of Toronto Press, 1951).

4. An earlier version of the second chapter of this book was presented at the Print Culture and the City conference at McGill University in March 2004; a later version was published as "Breach of Copy/rights: The University Copy District as Abject Zone," *Public Culture* 18, no. 3 (Fall 2006).

5. "Photocopier Rage Is Common," *Nanaimo Daily News*, March 14, 2002, A2.

6. John Brooks, "Xerox, Xerox, Xerox, Xerox," *New Yorker*, April 1, 1967, 57.

INTRODUCTION

1. Christopher Palmeri, "FedEx Whites-Out the Kinko's Name," *Bloomberg Businessweek*, December 17, 2008, http://www.businessweek.com/stories/2008-12-17/fedex-whites-out-the-kinkos-name.

2. Laurie Flynn, "Kinko's Adds Internet Service to Its Copying Business," *New York Times*, March 18, 1996, http://www.nytimes.com/1996/03/18/business/kinko-s-adds-internet-services-to-its-copying-business.html?pagewanted=all&src=pm.

3. Sheldon J. Monnesh, "Original Copy Cats," *Wired*, June 1995, http://www.wired.com/wired/archive/3.06/kinkos.html.

4. "A Brief History of Officing" (display advertisement for Kinko's), *New York Times*, January 29, 1996.

5. Julia Szabo, "Copy Shop Stitches the Urban Crazy Quilt," *New York Times*, July 3, 1994.

6. Palmeri, "FedEx Whites-Out the Kinko's Name."

7. Szabo, "Copy Shop Stitches the Urban Crazy Quilt."

8. Ibid.

9. In 2003, FedEx bought out Kinko's for $2.4 billion. Although the shipping company had been Kinko's exclusive shipper since the late 1980s and already owned shares in the company at the time of the buyout, the new arrangement would eventually result in an overhaul of the operation and the Kinko's brand. In 2008, FedEx announced that FedEx Kinko's would be renamed FedEx Office, severing its final ties to the company founder and his kinky hair.

10. "The Papyrograph," *Daily Alta California*, March 31, 1877, http://cdnc.ucr.edu/cgi-bin/cdnc?a=d&d=DAC18770331.2.2# (accessed January 2, 2015).

11. Ibid.

12. "Electric Pen," Thomas Edison Papers, last modified February 20, 2012, http://edison.rutgers.edu/pen.htm.

13. Thad Ghodish, *Sick Buildings: Definitions, Diagnosis and Mitigations* (Boca Raton, FL: CRC Press, 1995), 107.

14. Elizabeth Eisenstein, *The Printing Revolution in Early Modern Europe* (New York: Cambridge University Press, 1983).

15. See for example Marcus Boon's *In Praise of Copying* (Cambridge: Harvard University Press, 2010) and Hillel Schwartz's *The Culture of the Copy* (New York: Zone Books, 1996), and more directly Lisa Gitelman's "Xerographers of the Mind," in *Paper Knowledge: Toward a Media History of Documents* (Durham: Duke University Press, 2014), 83–110.

16. In 1987, Jean Baudrillard published a short pamphlet in French titled *Le Xerox et l'Infini*; the pamphlet was translated into English as *Xerox and Infinity* in 1988 by Touchpas, London. Although the pamphlet is about machines, it is about virtual machines; here "xerox" refers not to the copy machine but to duplication itself.

17. Marshall McLuhan, *The Gutenberg Galaxy* (Toronto: University of Toronto Press, 1962), 125.

18. This was a recurring theme in McLuhan's work; see among other texts *The Gutenberg Galaxy*.

19. Marshall McLuhan, "Media Hot and Cold," in *Understanding Media: The Extensions of Man* (Cambridge: MIT Press, 2001).

20. As Lisa Gitelman emphasizes, to xerox something is to read it as a document—to recognize its status as a document—regardless of the medium, format, or genre. In this sense, photocopied materials carry forward their status as photocopies in ways that other media do not. For more, see Gitelman, "Xerographers of the Mind."

21. Chester Carlson, "History of Electrostatic Recording," in John H. Dessauer and Harold E. Clark, eds., *Xerography and Related Processes* (London: Focal Press, 1965), 15.

22. Ibid.

23. Ibid., 16.

24. Ibid., 17.

25. David Owen, *Copies in Seconds* (New York: Simon and Schuster, 2004), 97.

26. Haloid Company, press release, October 22, 1948, p. 1.

27. Haloid Company Xerox advertisement, *New York Times*, October 24, 1948.

28. "Xerography: Present and Future Applications," in *Xerography*, brochure produced by the Haloid Company, November 1949; source: Chester Carlson's scrapbooks.

29. Haloid Company, press release, October 22, 1948, p. 2.

30. See Victoria K. McElhemy's *Insisting on the Impossible: The Life of Edwin Land* (New York: Perseus Books, 1998).

31. Herb E. Elliot, "Xerograph Faces the Graph Arts," *Graphic Arts Progress* (May-June 1962).

32. John Tebbel, "The Great Copying Boom," *Saturday Review* 49 (May 14, 1966), 63.

33. Gitelman, *Paper Knowledge*, 84.

34. Owen, *Copies in Seconds*, 191.

35. "Kinko's Inc. History," Funding Universe, http://www.fundinguniverse.com/company-histories/kinko-s-inc-history.

36. See Owen, *Copies in Seconds*, 253.

37. Jon B. Harnett, "Xerography Is the Name: It's Won 25% of Market," *Sales Management* 68 (January 15, 1952), 106.

38. Schwartz, *The Culture of the Copy*, 232–233.

39. See both Owen's *Copies in Seconds* (268) and Schwartz's *The Culture of the Copy* (232–233).

40. David A. Ensminger, *Visual Vitriol: The Street Art and Subcultures of the Punk and Hardcore Movements* (Mississippi: University Press of Mississippi, 2011), 50.

41. Jacques Derrida, *Margins of Philosophy* (Chicago: University of Chicago Press, 1982), xxiii.

42. See, for example, bell hooks's *Feminist Theory: From Margin to Center* (1984; Cambridge, MA: South End Press, 2000).

43. It is important to bear in mind that while xerography had a significant impact on document reproduction in the United States and Canada as early as the 1950s and eventually in other parts of the Western world (e.g., Rank-Xerox, Xerox Corporation's British arm, was established in 1956, a move that would bring copiers not only to the UK but also to other parts of the British Commonwealth), a large part of the world did not gain full access to xerography until after the collapse of the Soviet Union in the late 1980s. Like other communication technologies, then, xerography arrived and impacted different print economies at different historical moments. This book is intentionally limited to an investigation of the copy machine in the two nations that most immediately experienced xerography's impact—the United States and Canada. A future study exploring the absence and in some cases surreptitious use of xerographic technologies in the Soviet Union in the 1950s to late 1980s would offer further insight into the xerographic era.

CHAPTER 1

1. "Paper-work Machines," *Challenge* 2, no. 5 (February 1954), 37.

2. "Oregon County Offices Speed Up Services to Public with Rectigraph Daylight Duplex Photo-Recording Machines," informational advertisement dated September 1947 (publication unavailable); source: Chester Carlson's scrapbooks, New York Public Library, Archives and Manuscripts Division.

3. While the scope and range of sexist stereotypes in early Haloid and later Xerox Corporation marketing campaigns merit more space than an endnote, it is important to emphasize that from the late 1940s to the late 1960s the company consistently featured women and sometimes girls in their advertisements to promote two messages: (1) Xerox copy machines are smarter and less costly than female laborers; and (2) Xerox copy machines are so easy to operate that women and even girls can use them. Indeed, Xerox's early advertising campaigns continue to circulate online today largely because they are legendary examples of sexism in advertising. Especially popular is a 1960s television commercial featuring a secretary in an evening gown who explains that she can't type, sharpen pencils, or file but can use a Xerox 914 copy machine. Indeed, the machine is so effective that the secretary featured in the advertisement explains that she often doesn't even know which document is the original. Xerox has always been a marketing-savvy company, so it's no surprise that by the mid 1970s, as the women's liberation movement was increasingly turning its attention to the circulation of sexist representations in advertising, the company developed a new campaign—not coincidentally focused on a context where there were simply no women to be represented. During the 1976 Super Bowl, Xerox introduced Brother Dominic, a medieval monk discovering the miracle of xerography. The campaign would not only save Xerox from further attacks by feminists but also become one of the most successful marketing campaigns of the late twentieth century. In the end, six Brother Dominic advertisements were produced and aired between 1976 and 1982.

4. "Paper-work Machines," 38.

5. Display advertisements for the Haloid Company's new Xerox machine started to appear in papers such as the *New York Times* in the late 1940s. One 1952 advertisement in the *Times* invited executives to send away for a free 12-page illustrated report that "shows how your company can simplify and speed paper work—and cut costs!"

6. James Beniger, *The Control Revolution: Technological and Economic Origins of the Information Society* (Cambridge: Harvard University Press, 1989).

7. Ibid., 219.

8. Ibid., 393–394.

9. When people talk about copy machines, they often are referring both to mimeographic and xerographic technologies. While these technologies have been used in analogous ways by small press publishers, artists, and activists, they are different technologies with different histories. Mimeograph machines emerged in the late nineteenth century and were more or less replaced by xerographic copy machines by the late 1970s. By contrast, xerography was introduced in the late 1940s and remained a popular form of reproduction until the introduction of digital copiers in the early 2000s. For this reason, this book focuses exclusively on xerographic technologies. That said, a book-length study on mimeography would be a welcome addition to the field of book and publishing history and to studies on radical print cultures in the twentieth century.

10. John Brooks, "Xerox, Xerox, Xerox, Xerox," *New Yorker*, April 1, 1967, 46.

11. Ibid., 47.

12. Ibid.

13. Ibid., 56.

14. In Xerox's first commercial set in a scriptorium, Brother Dominic exits his medieval monastery and walks into a contemporary office with a Xerox 9200 where he turns around 500 copies of a manuscript in a matter of minutes, then returns to his monastery with his "miracle" in hand.

15. Brian Stock, "Textual Communities: Judaism, Christianity and the Definitional Problem," in *Listening for the Text: On the Uses of the Past* (Philadelphia: University of Pennsylvania Press, 1997).

16. See both Harold Innis's *The Bias of Communication* (Toronto: University of Toronto Press, 1951) and Benedict Anderson's *Imagined Communities: Reflections on the Origin and Spread of Nationalism* (New York: Verso, 1983).

17. Michel de Certeau, *The Practice of Everyday Life* (Berkeley: University of California Press, 1988), 29.

18. Early example of xeroxlore, which likely circulated among employees at The Haloid Company; source: Chester Carlson, Scrapbook, volume 4.

19. Alan Dundes and Carl R. Pagter, *Work Hard and You Shall Be Rewarded: Urban Folklore from the Paperwork Empire* (Detroit: Wayne State University Press, 1975), xx–xxi.

20. Ibid., xxii.

21. As I discuss in detail in chapter 4, access to workplace copy machines would ultimately also prove integral to the circulation of photocopied materials in several late twentieth-century activist movements, as activists with day jobs used corporate-owned copy machines to produce materials for the street-level political struggles in which they were engaged when not at work.

22. Marshall McLuhan, "The Emperor's New Clothes," in *The Essential McLuhan*, ed. Eric McLuhan and Frank Zingrone (Toronto: House of Anansi Press, 1995), 339–356.

23. William Jovanovich to Marshall McLuhan, June 13, 1967, Marshall McLuhan Collection, National Archives of Canada, Ottawa, Canada.

24. William Jovanovich to Marshall McLuhan, July 2, 1969, Marshall McLuhan Collection, National Archives of Canada, Ottawa, Canada.

25. This observation was made while looking through a file on xerography housed in the Marshall McLuhan Collection at the National Archives of Canada. McLuhan, however, never wrote extensively about xerography's role in the Pentagon Papers scandal. For a detailed discussion of the topic, see Lisa Gitelman, "Xerographers of the Mind," in *Paper Knowledge: Toward a Media History of Documents* (Durham: Duke University Press, 2014), 83–110.

26. Jovanovich to Marshall McLuhan, July 2, 1969, Marshall McLuhan Collection, National Archives of Canada, Ottawa, Canada.

27. Ibid.

28. William Jovanovich, "The Universal Xerox Life Compiler Machine," *American Scholar* 40, no. 2 (Spring 1971), 249.

29. By 1949, the US Congress had already generated a comprehensive list of documents that could not be photocopied. In an advertisement distributed by the Haloid Company, the list of prohibited materials included bank notes, treasury notes, postage stamps, checks, licenses, passports, immigration papers,

badges, draft registration cards, and amateur radio operators' licenses, among other official forms of documentation (advertisement featured in *Advertiser's Digest*, May 1949).

30. Jovanovich, "The Universal Xerox Life Compiler Machine," 251, 254, 255.

31. For example, while McLuhan maintains that print is "hot" because it is high-definition and requires limited participation on the part of viewers, a comic strip, which often only provides limited visual cues, is "cool" because it is low-definition and requires viewers to fill in the missing details. I invoke McLuhan's problematic binary theory of media here not in an attempt to reify his theory but rather to illustrate the extent to which xerography, which McLuhan did recognize as a distinctive media, troubles his own theory.

32. As Elizabeth Eisenstein observes, some texts and images from the Middle Age were repeatedly duplicated in the early years of print, which resulted in some cases in forgotten concepts being put back into circulation on a wider scale. As she argues, "Printing made more visible long-lived and much used texts that are usually passed over and sometimes mistakenly deemed obsolete when new trends are being traced." Elizabeth L. Eisenstein, *The Printing Revolution in Early Modern Europe* (New York: Cambridge University Press, 1983), 54.

33. Steve Ditlea, "Introduction and Background Information," in Patrick Firpo et al., eds., *Copy Art: The First Complete Guide to the Copy Machine* (New York: Richard Marek Publishers, 1978), 9.

34. Schematic of Generative Systems room expansion, February 18, 1973, one architectural drawing: photocopy. Sonia Landy Sheridan Fonds—0501-110, Daniel Langlois Foundation for Art, Science, and Technology.

35. Kathryn Farley, "Generative Systems: Core Curriculum," Sonia Sheridan and Generative Systems, available at http://www.fondation-langlois.org/html/e/page.php?NumPage=1991.

36. Ibid.

37. Sonia Landy Sheridan as cited in Ditlea, "Introduction and Background Information," 9.

38. Steve Ditlea, "Introduction and Background Information," 10.

39. Farley, "Generative Systems: Core Curriculum."

40. Kathryn Farley, "Process: Hybrid," Sonia Sheridan and Generative Systems, available at http://www.fondation-langlois.org/html/e/page.php?NumPage=2008.

41. "Creative Office Workers Dig Electromagnetic Art," syndicated news article about the "Software" show dated November 25, 1970; source: Sonia Landy Sheridan Fonds, Box 3.

42. Ditlea, "Introduction and Background Information," 10.

43. Marisa Gonzalez, "Copiers, Motion and Metamorphosis," *Leonardo* 23, no. 2/3 (1990), 295.

44. Preface to Firpo et al., *Copy Art*, 5.

45. Firpo et al., *Copy Art*, 135.

46. Ken Friedman and Owen Smith, "Introduction to the Fortieth Anniversary Edition of the *Fluxus Performance Workbook*," in Ken Friedman, Owen Smith, and Lauren Sawchyn, eds., *Fluxus Performance Workbook* (Aberystwyth, UK: Centre for Performance Research, 2002), 1–2.

47. Ellen Gruber Garvey, "Small Press Magazines, the Underground Press, Zines, and Artists' Books," in Scott E. Casper, Joanne D. Chaison, and Jeffrey D. Groves, eds., *Perspectives on American Book History: Artifacts and Commentary* (Amherst: University of Massachusetts Press, 2002), 392.

48. Danny Snelson, "Archival Penumbra," *American Book Review* 34, no. 3 (March/April 2013), 5.

CHAPTER 2

1. Toni Schlesinger, "Shelter," *Village Voice*, February 6, 2001, 20.

2. Marcus Boon, *In Praise of Copying* (Cambridge: Harvard University Press, 2010), 242.

3. Benedict Anderson, *Imagined Communities: Reflections on the Origin and Spread of Nationalism*, rev. ed.(New York: Verso, 2006), 43, 36.

4. Ibid., 44.

5. Ibid., 71.

6. Elizabeth L. Eisenstein, *The Printing Press as an Agent of Change*, vol. 1 (New York: Cambridge University Press, 1979), 117.

7. See discussion in James Carey's "Harold Adams Innis and Marshall McLuhan," in Gary Genosko, ed., *Marshall McLuhan: Critical Evaluations in Cultural Theory*, vol. 2, *Theoretical Elaborations* (New York: Routledge, 2005), 204.

8. Harold Adams Innis, *Empire and Communications* (1950; Toronto: Press Porcépic, 1986), 169.

9. Ibid.

10. Ibid.

11. Here it is important to note that xerography was banned or severely restricted in the Soviet Union for xerography's first four decades—a situation that effectively means that any discussion of xerography's impact on nation-states must be restricted to nations outside the USSR.

12. In his foreword to the 1986 edition of *Empire and Communications*, David Godfrey offers the following explication of Innis's concept of "monopolies of knowledge": "For Innis, efficiency of communications is indicated by the growth of an empire. Monopolies of knowledge flourish within that empire. Monopolies tend to become inflexible and stagnate. Historically, Innis indicates, the new media that tend to destabilize the old empires arise not in the metropolitan centres of cultures, but on the boundaries, in the outbacks, where the competitive forces create the need for new efficiencies and where a strong sense of the vernacular creates a dynamic local environment" (ix). For Innis, a staunch Canadianist long before the appearance of Canadian studies or even Canadian literature (notably, in the late 1940s when he was writing *Empire and Communications*, he was living in a country with a publishing industry that was still embryonic at best), the margins are conceived of as the "outback" or, more precisely, the backwoods.

13. For a more in-depth discussion of these textual communities, see Kate Eichhorn, "Sites Unseen: Ethnographic Research in a Textual Community," *International Journal of Qualitative Studies in Education* 14, no. 4 (2001), 565–578.

14. While the xerographic era was approaching its twilight years by the early 1990s, many Eastern European nations were experiencing a xerographic *incunabulum* of sorts. Under Soviet rule, xerography was banned as were most other methods of document reproduction. The ban was enforced early on, and

restrictions of varying degrees remained until the collapse of the Soviet Union in the early 1990s. As a result, in the 1980s, a burgeoning punk scene in East Germany relied on individual typescripts and mimeograph machines to turn out fanzines. The same media were deployed to produce an entire range of samizdat publications, from censored novels to political tracts. Even as access to copy machines improved in some countries by the late 1980s, their use remained highly regulated. Copy machines available in public libraries, for example, could only be used to reproduce materials already available on the shelves of the library. Yet, as post-glasnost scholarship has brought to light, the eventual collapse of the Soviet Union was also bolstered by the surreptitious use of copy machines—primarily by workers who had access to the machines in their workplaces. Today, as a new era of media restrictions, primarily targeting Internet use, are enforced with increasing militancy on a post-glasnost generation of Russians, xerography may appear to be a viable alternative—an effective way to engage in social media without the surveillance that so easily accompanies the use of digital media platforms—but such assumptions are misleading. Even copy machines are not what they used be.

15. John Duncanson, "Canadian Arabs, Muslims Targets in the War on Terror," *Toronto Star*, September 9, 2002, A07.

16. Graeme Smith, Jonathan Bjerg Moller, and Colin Freeze, "From Copy Clerk to Terror Suspect: Investigators Won't Discuss Evidence Taken from Printing Shop in Toronto," *Globe and Mail*, September 28, 2001.

17. Andrew Mitrovica, "Canadian Connection to Attacks Takes Shape," *Globe and Mail*, October 23, 2001.

18. Peter Cheney and Colin Freeze, "The Mystery of the Invisible al-Marabh: Terrorist Kingpin or Ordinary Store Clerk?," *Globe and Mail*, October 27, 2001.

19. Ibid.

20. Lisa Priest, "Held as Threat, Syrian Sought Peaceful Life, Documents Say," *Globe and Mail*, November 2, 2001.

21. Ibid.

22. The claim appears in an article by *Globe and Mail* reporter Andrew Mitrovica, who writes: "According to the *New York Times*, the Kuwait-born 35-year-old Syrian was identified by U.S. intelligence agents last fall as a lieutenant in

Osama bin Laden's al-Qaeda terrorist network in North American" (Mitrovica, "Canadian Connection to Attacks Takes Shape").

23. It is worth noting that while the copy shop figured prominently in articles about Nabil al-Marabh in the Canadian media, US media appeared more interest in his connection to his uncle, who is described as a religious man, a cleric, and the principal of an Islamic school.

24. Innis, *Empire and Communications*, 135.

25. An April 2014 article in the *Chronicle of Higher Education* reports that "part-time instructors … now account for about half of the faculty of the nation's public and private [institutions]" (Peter Schmidt, "Power in Numbers," *Chronicle of Higher Education*, April 14, 2014). The New Faculty Majority provides higher numbers, maintaining that 75.5% of college faculty are now off the tenure track, representing 1.3 million out of 1.8 million faculty members (New Faculty Majority, "Facts about Adjuncts," available at http://www.newfacultymajority.info/facts-about-adjuncts).

26. A report drafted by Steve Street, Maria Maisto, and Esther Merves of the New Faculty Majority and Gary Rhoades, director of the Center for the Future of Higher Education, reported that "contingent faculty often bear the burden of copying costs, due to insufficient access to departmental/college copying services" ("Who Is Professor Staff: Or How Can This Person Teach So Many Classes," Center for Future of Higher Education, Policy Report no. 2, August 2012, 11).

27. Kate Eichhorn, "Breach of Copy/rights: The University Copy District as Abject Zone," *Public Culture* 18, no. 3 (2006), 551–571.

28. Anne McClintock, *Imperial Leather: Race, Gender and Sexuality in the Colonial Contest* (New York: Routledge, 1995), 72.

29. See, for example, Sara Ahmed's discussion of soft nations in *The Cultural Politics of Emotion* (New York: Routledge, 2004).

30. See Jason Gray, "Best Copy Printing—Al-Qaeda Did My Bootleg Video Jackets" (personal weblog), available at http://jasongray.blogspot.de/2011/05/best-copy-printing-al-qaeda-did-my.html.

31. Ibid.

32. Notably, ten years after the Best Copy incident, terrorism and xerography reappeared in the news on the other side of the border. On May 17, 2011, Carlos Montes, a Chicano activist, founding member of the Brown Berets (a militant Chicano activist group with links to the Black Panthers), and antiwar activist, was arrested at his home in Los Angeles. Reportedly, the police entered his home early in the morning taking documents, photographs, computer disks, and various ephemera connected to Montes's current political activity. In the end, he was arrested on one firearm charge and released the following morning. What was striking about the Montes case is that like al-Marabh and Almrei, his link to Xerox—in this case, his status as a retired Xerox salesman—is repeated in nearly every news article about his arrest and subsequent trial. A report in *Los Angeles Magazine* states, "Montes was not just any retired Xerox salesman. ... In the late 1960s, he had been one of the most visible and militant leaders of the Chicano movement in L.A. Long after the media spotlight had flickered off, he had continued to agitate and organize against police brutality, inequities in the public schools, and U.S. wars abroad." In the same article, one discovers that "Montes, a retired Xerox salesman, had kept a loaded shotgun behind the headboard and a 9mm pistol beneath a pile of towels on a chair beside the bed since the day he had walked in on an armed burglar a year and a half before" ("Never Stop Fighting," *Los Angeles Magazine*, January 3, 2012).

CHAPTER 3

1. Michael Warner, *Publics and Counterpublics* (New York: Zone Books, 2005), 8.

2. Ibid., 9.

3. Jürgen Habermas, *The Structural Transformation of the Public Sphere* (Cambridge: MIT Press, 1991), 25, 48.

4. Seyla Benhabib, "Models of Public Space: Hannah Arendt, the Liberal Tradition, and Jürgen Habermas," in Craig Calhoun, ed., *Habermas and the Public Sphere* (Cambridge: MIT Press, 1992), 73–98.

5. Ann Cvetkovich, *An Archive of Feelings: Trauma, Sexuality, and Lesbian Public Cultures* (Durham: Duke University Press, 2003), 17–18.

6. Warner, *Publics and Counterpublics*, 52.

7. Ibid., 56.

8. Ibid.

9. Ibid., 14.

10. Ibid., 67.

11. Habermas, *The Structural Transformation of the Public Sphere*, 166–167.

12. See Janice Radway's *Reading the Romance* (Chapel Hill: University of North Carolina Press, 1984) and *A Feeling for Books* (Chapel Hill: University of North Carolina Press, 1997).

13. Brandon Stosuy, ed., *Up Is Up, but So Is Down: New York's Downtown Literary Scene, 1974–1992* (New York: New York University Press, 2006), 20.

14. In the 1970s and 1980s, many landlords south of 14th Street chose to abandon their buildings, believing that divestment was more economically viable than repairing old tenements in neighborhoods with reputations for high crime. See in particular Christopher Mele's *Selling the Lower East Side: Culture, Real Estate, and Resistance in New York City* (Minneapolis: University of Minnesota Press, 2000).

15. Marvin J. Taylor, ed., *The Downtown Book: The New York Art Scene, 1974–1984* (Princeton: Princeton University Press, 2006), 23.

16. Cynthia Carr, *Fire in the Belly: The Life and Times of David Wojnarowicz* (New York: Bloomsbury, 2012), 133–136.

17. David A. Ensminger, *Visual Vitriol: The Street Art and Subcultures of the Punk and Hardcore Generations* (Jackson: University Press of Mississippi, 2011), 52.

18. Many of New York's punk icons were well-read, middle- to upper-middle-class emerging artists and writers who were influenced by established art scenes, from the performance scenes that had flourished in the 1960s around storied institutions like Judson Church and St. Mark's Church to the art scene centered around Andy Warhol's midtown Factory. This stood in notable contrast to the more working-class punk scene based in London. In both scenes, however, the medium of xerography emerged as a vital form of communication and quickly became appropriated as part of the punk DIY aesthetic.

19. Soon after Jean-Michel Basquiat arrived in New York in the 1970s, he started appropriating techniques encountered in punk posters and publications to produce postcards and other small works. Basquiat reportedly copied

his postcards on a color copier at a photocopy shop on Prince Street in SoHo and peddled the same postcards to tourists outside the MoMA to make a bit of extra cash. See Eric Fretz's biography, *Jean-Michel Basquiat* (Santa Barbara, CA: Greenwood, 2010).

20. Avram Finkelstein, interview with Sarah Schulman, January 23, 2010, ACT UP Oral History Project, http://www.actuporalhistory.org/.

21. Carrie Yamaoka, personal interview, May 19, 2014.

22. Ensminger, *Visual Vitriol*, 53.

23. See for example Themis Chronopoulos's *Spatial Regulation in New York City: From Urban Renewal to Zero Tolerance* (New York: Routledge, 2011).

24. Yamaoka, personal interview, May 19, 2014.

25. Janet Allon, "Illegal Ads Meet Their Match," *New York Times*, August 24, 1997, http://www.nytimes.com/1997/08/24/nyregion/illegal-ads-meet-their-match.html (accessed January 1, 2015).

26. Greta Pryor, "Take a Lesson from Paris in the Fight against Fliers," *New York Times*, September 14, 1997, http://www.nytimes.com/1997/09/14/nyregion/l-take-a-lesson-from-paris-in-the-fight-against-fliers-088820.html (accessed January 1, 2015).

27. George L. Kelling and James Q. Wilson, "Broken Windows: The Police and Neighborhood Safety," *Atlantic*, March 1, 1982, http://www.theatlantic.com/magazine/archive/1982/03/broken-windows/304465/ (accessed January 3, 2015).

28. Geoff Ellwand, "A Poster Boy for Freedom of Expression," *Lawyers Weekly*, June 3, 2011, 26–27.

29. Ibid.

30. Canadian Charter of Rights and Freedoms, §2(b).

31. Ellwand, "A Poster Boy for Freedom of Expression," 26–27.

32. *Ramsden v. Peterborough (City)*, Supreme Court of Canada (1990), http://scc-csc.lexum.com/scc-csc/scc-csc/en/item/1038/index.do.

33. Toronto Public Space Committee, "History of the Anti-Postering Bylaw," http://www.publicspace.ca/posteringhistory.htm.

34. Ibid.

35. Toronto Public Space Committee, http://www.publicspace.ca.

36. David Meslin of the Toronto Public Space Committee, quoted in Christopher Hutsul, "The Threat of a Tidy Toronto: Why a City Needs Its Messy Posters," *Toronto Star*, February 2, 2005, D1.

37. See among other studies Stephen Duncombe's *Notes from Underground: Zines and the Politics of Alternative Culture* (New York: Verso, 1997); Alison Piepmeier, *Girl Zines: Making Media, Doing Feminism* (New York: New York University Press, 2009); and Anna Poletti, *Intimate Ephemera: Reading Young Lives in Australian Zine Culture* (Melbourne: Melbourne University Publishing, 2008).

38. Duncombe, *Notes from Underground*, 7.

39. Lisa Darms, "Grrrl, Collected," *Paris Review*, July 20, 2013, http://www.theparisreview.org/blog/2013/07/30/grrrl-collected (accessed December 30, 2014).

40. Kate Eichhorn, "Sites Unseen: Ethnographic Research in a Textual Community," *International Journal of Qualitative Studies in Education* 14, no. 4 (2001), 565–578.

41. Warner, *Publics and Counterpublics*, 97.

42. See, for example, Anna Poletti's discussion of "perzines" in *Intimate Ephemera*, 35.

43. Indeed, as zines started to migrate to libraries and archives by the early years of the new millennium, their ambiguous status raised considerable challenges for librarians and archivists alike. Is a zine more akin to a public document, such as a magazine or printed book, or to an archival document, such as a letter or unpublished diary? While archivists, librarians, and zine theorists continue to debate what zines are and whether they should be treated as public or private texts (most insist that they fall somewhere in between and demand an attentiveness to their specificity in this regard), it is important to also consider how these photocopied self-published texts impacted publics and counterpublics. For a more detail discussion of zines' status as documents that challenge the division between private and public spheres, see the second chapter of Kate Eichhorn, *The Archival Turn in Feminism: Outrage in Order* (Philadelphia: Temple University Press, 2013).

CHAPTER 4

1. Lizzie Borden, dir., *Born in Flames* (First Run Features, 1983).

2. Alison Piepmeier, *Girl Zines: Making Media, Doing Feminism* (New York: New York University Press, 2009), 35.

3. Associated Press, "Poll Indicates Majority Support Quarantine for AIDS Victims," *New York Times*, December 20, 1985, http://www.nytimes.com/1985/12/20/us/poll-indicates-majority-favor-quarantine-for-aids-victims.html.

4. Gregg Bordowitz, interview, December 17, 2002, ACT UP Oral History Project, http://www.actuporalhistory.org/interviews/interviews_01.html#bordowitz.

5. Maxine Wolfe, interview, February 19, 2004, ACT UP Oral History Project, http://www.actuporalhistory.org/interviews/interviews_07.html#wolfe.

6. Sarah Schulman, *Rat Bohemia* (Vancouver: Arsenal Pulp, 2008), 8.

7. Larry Kramer, interview, November 15, 2003, ACT UP Oral History Project, http://www.actuporalhistory.org/interviews/interviews_06.html#kramer.

8. Avram Finkelstein, interview, January 23, 2010, ACT UP Oral History Project, http://www.actuporalhistory.org/interviews/interviews_18.html#finkelstein.

9. As Finkelstein explains in his interview with Sarah Schulman for the ACT UP Oral History Project, "it's very funny, the word 'silence,' isn't it? The quote came out of Marshall McLuhan, who I was influenced by and also you could say there's a direct line between Marshall McLuhan and the 'Silence = Death' poster. There definitely is."

10. Finkelstein, interview, ACT UP Oral History Project.

11. See Tommaso Speretta's *Rebels Rebel: AIDS, Arts and Activism in New York, 1979–1989* (Ghent: MER. Paper Kunsthalle, 2014).

12. In a 1995 farewell statement, reprinted in Speretta's *Rebels Rebel*, Gran Fury clarifies: "The bulk of our funding came from art museums and foundations—the New Museum of Contemporary Art, the Whitney Museum of American Art, Los Angeles' MOCA and Creative Time to name a few" (245).

13. Finkelstein, interview, ACT UP Oral History Project.

14. Richard Meyer, *Outlaw Representation: Censorship and Homosexuality in Twentieth Century Art* (New York: Oxford University Press, 2002), 227–228.

15. See, for example, my own account in the preface to this book.

16. Maria Maggenti, interview, January 20, 2003, ACT UP Oral History Project, http://www.actuporalhistory.org/interviews/interviews_02.html#maggenti.

17. Richard Deagle, interview, September 13, 2003, ACT UP Oral History Project, http://www.actuporalhistory.org/interviews/interviews_05.html#deagle.

18. Ibid.

19. Dale Peck, interview, March 17, 2010, ACT UP Oral History Project, http://www.actuporalhistory.org/interviews/interviews_19.html#peck.

20. Joy Episalla, personal interview, May 19, 2014.

21. Jane Hall, "AIDS Activists Barge In on CBS, 'MacNeil/Lehrer' Show," *Los Angeles Times*, January 23, 1991, http://articles.latimes.com/1991-01-23/news/mn-795_1_aids-activists.

22. David Robinson, interview, July 16, 2007, ACT UP Oral History Project, http://www.actuporalhistory.org/interviews/interviews_14.html#robinson.

23. Elias Guerrero, interview, March 17, 2004, ACT UP Oral History Project, http://www.actuporalhistory.org/interviews/interviews_09.html#guerrero.

24. In excess of 250 boxes of ACT UP materials form the core of a collection now housed at the New York Public Library; not surprisingly, the vast majority of these materials are photocopies.

25. Bill Dobbs, interview, November 21, 2006, ACT UP Oral History Project, http://www.actuporalhistory.org/interviews/interviews_11.html#dobbs.

26. Andrew Miller, interview, October 6, 2004, ACT UP Oral History Project, http://www.actuporalhistory.org/interviews/interviews_10.html#miller.

27. Dobbs, interview, ACT UP Oral History Project.

28. Ibid.

29. Karen Timour, interview, April 5, 2003, ACT UP Oral History Project, http://www.actuporalhistory.org/interviews/interviews_03.html#timour.

30. Mark Harrington, interview, March 8, 2003, ACT UP Oral History Project, http://www.actuporalhistory.org/interviews/interviews_02.html#harrington.

31. Dobbs, interview, ACT UP Oral History Project.

32. Bill Bahlman, interview, March 10, 2010, ACT UP Oral History Project, http://www.actuporalhistory.org/interviews/interviews_19.html#bahlman.

33. Ibid.

34. Harrington, interview, ACT UP Oral History Project.

35. Steven Epstein, *Impure Science: AIDS, Activism, and the Politics of Knowledge* (Berkeley: University of California Press, 1996).

36. Wolfe, interview, ACT UP Oral History Project.

37. Epstein, *Impure Science*, 3.

38. Ibid., 12.

39. Lisa Gitelman, *Paper Knowledge: Toward a Media History of Documents* (Durham: Duke University Press, 2014), 89.

40. Episalla, personal interview, May 19, 2014.

41. "Fierce Pussy: Interview," Fierce Pussy, http://fiercepussy.org/www.fiercepussy.org/Interview.html (accessed January 2, 2015).

42. Episalla, personal interview, May 19, 2014.

43. "Fierce Pussy: Interview."

44. "The Queer Nation Manifesto," History Is a Weapon, http://www.historyisaweapon.com/defcon1/queernation.html (accessed January 3, 2015).

45. *The Lesbian Avengers Handbook: A Guide to Homemade Revolution*, reprinted in Sarah Schulman, *My American History: Lesbian and Gay Life During the Reagan/Bush Years* (New York: Routledge, 1994), 290.

46. Ibid., 296.

47. Sarah Schulman, "The Lesbian Avengers, Part 2," in *My American History*, 284.

48. Carrie Yamaoka, personal interview, May 19, 2014.

49. Episalla, personal interview, May 19, 2014.

50. Marion Banzhaf, interview, April 18, 2007, ACT UP Oral History Project, http://www.actuporalhistory.org/interviews/interviews_12.html#banzhaf.

51. Jim Eigo, interview, March 5, 2004, ACT UP Oral History Project, http://www.actuporalhistory.org/interviews/interviews_08.html#eigo.

52. Steven Keith, interview, June 22, 2010, ACT UP Oral History Project, http://www.actuporalhistory.org/interviews/interviews_20.html#keith.

53. Sandy Katz, interview, October 15, 2004, ACT UP Oral History Project, http://www.actuporalhistory.org/interviews/interviews_10.html#katz.

54. *The Lesbian Avengers Handbook*, reprinted in Schulman, *My American History*, 305.

CHAPTER 5

1. Nathan Brackett and Christian Hoard, *New Rolling Stone Album Guide* (New York: Fireside, 2004), 5.

2. Adam and the Ants, *Zerox*, 7-inch vinyl recording, Do It Records, 1979.

3. Armen Keteyian, "Digital Photocopiers Loaded with Secrets," *CBS Evening News* (online edition, April 19, 2010), available at http://www.cbsnews.com/news/digital-photocopiers-loaded-with-secrets.

4. Following the widely circulated CBS report, which resulted in dozens of other reports, security experts and copy machine manufacturers clarified that the security threat may not be as great as Juntunen suggested. Machines at FedEx delete images on a daily basis, while many machines owned by institutions and businesses are programmed to overwrite images at least weekly or monthly—in part due to the fact that it's more economical to build copy machines with smaller rather than larger data basis.

5. For more details see Klaus Urbons's website, http://www.urbons.de/pages/museum.html.

6. Ibid.

7. Among other theorists, I am referring here to the work of Friedrich Kittler and Wolfgang Ernst.

8. Darren Wershler-Henry, *The Iron Whim: A Fragmented History of Typewriting* (Ithaca: Cornell University Press, 2005), 19, 21.

9. Jay Bolter and Richard Grusin, *Remediation: Understanding New Media* (Cambridge: MIT Press, 1998), 45.

10. See, for example, the discussion on this forum: http://www.webmasterworld.com/forum36/609.htm.

WORKS CITED

Adam and the Ants. *Zerox*. 7-inch vinyl recording. Do It Records, 1979.

Ahmed, Sara. *The Cultural Politics of Emotion*. New York: Routledge, 2004.

Allon, Janet. "Illegal Ads Meet Their Match." *New York Times*, August 24, 1997. http://www.nytimes.com/1997/08/24/nyregion/illegal-ads-meet-their-match.html (accessed January 1, 2015).

Anderson, Benedict. *Imagined Communities: Reflections on the Origin and Spread of Nationalism*. Rev. ed. New York: Verso, 2006.

Associated Press. "Poll Indicates Majority Support Quarantine for AIDS Victims." *New York Times*, December 20, 1985. http://www.nytimes.com/1985/12/20/us/poll-indicates-majority-favor-quarantine-for-aids-victims.html (accessed November 10, 2014).

Bahlman, Bill. Interview, March 10, 2010. ACT UP Oral History Project. http://www.actuporalhistory.org/interviews/interviews_19.html#bahlman.

Banzhaf, Marion. Interview, April 18, 2007. ACT UP Oral History Project. http://www.actuporalhistory.org/interviews/interviews_12.html#banzhaf.

Baudrillard, Jean. *Xerox and Infinity* [*Le Xerox et l'Infini*]. London: Touchpas, 1988.

Benhabib, Seyla. "Models of Public Space: Hannah Arendt, the Liberal Tradition, and Jürgen Habermas." In Craig Calhoun, ed., *Habermas and the Public Sphere*. Cambridge: MIT Press, 1992.

Beniger, James. *The Control Revolution: Technological and Economic Origins of the Information Society*. Cambridge: Harvard University Press, 1989.

Bolter, Jay, and Richard Grusin. *Remediation: Understanding New Media*. Cambridge: MIT Press, 1998.

Boon, Marcus. *In Praise of Copying*. Cambridge: Harvard University Press, 2010.

Borden, Lizzie, dir. *Born in Flames*. First Run Features, 1983.

Bordowitz, Gregg. Interview, December 17, 2002. ACT UP Oral History Project. http://www.actuporalhistory.org/interviews/interviews_01.html#bordowitz.

Brackett, Nathan, and Christian Hoard. *New Rolling Stone Album Guide*. New York: Fireside, 2004.

"A Brief History of Officing." Display advertisement for Kinko's. *New York Times*, January 29, 1996.

Brooks, John. "Xerox, Xerox, Xerox, Xerox." *New Yorker*, April 1, 1967.

Canadian Charter of Rights and Freedoms, S 2(b).

Carey, James. "Harold Adams Innis and Marshall McLuhan." In Gary Genosko, ed., *Marshall McLuhan: Critical Evaluations in Cultural Theory*, vol. 2, *Theoretical Elaborations*. New York: Routledge, 2005.

Carr, Cynthia. *Fire in the Belly: The Life and Times of David Wojnarowicz*. New York: Bloomsbury, 2012.

Certeau, Michel de. *The Practice of Everyday Life*. Berkeley: University of California Press, 1988.

Cheney, Peter, and Colin Freeze. "The Mystery of the Invisible al-Marabh: Terrorist Kingpin or Ordinary Store Clerk?" *Globe and Mail*, October 27, 2001.

Chester, Carlson. "History of Electrostatic Recording." In John H. Dessauer and Harold E. Clark, eds., *Xerography and Related Processes*. London: Focal Press, 1965.

Chronopoulos, Themis. *Spatial Regulation in New York City: From Urban Renewal to Zero Tolerance*. New York: Routledge, 2011.

Cohen, Peter F. *Love and Anger: Essays on AIDS, Activism, and Politics*. Binghamton, NY: Haworth Press, 1998.

"Creative Office Workers Dig Electromagnetic Art." Syndicated news article about the "Software" exhibition, dated November 25, 1970. Sonia Landy Sheridan Fonds, Box 3, Daniel Langlois Foundation for Art, Science, and Technology.

Cvetkovich, Ann. *An Archive of Feelings: Trauma, Sexuality, and Lesbian Public Cultures*. Durham: Duke University Press, 2003.

Darms, Lisa. "Grrrl, Collected." *Paris Review*, July 20, 2013. http://www.theparisreview.org/blog/2013/07/30/grrrl-collected (accessed December 30, 2014).

Deagle, Richard. Interview, September 13, 2003. ACT UP Oral History Project. http://www.actuporalhistory.org/interviews/interviews_05.html#deagle.

Derrida, Jacques. *Margins of Philosophy*. Chicago: University of Chicago Press, 1982.

Ditlea, Steve. "Introduction and Background Information." In Patrick Firpo et al., eds., *Copy Art: The First Complete Guide to the Copy Machine.* New York: Richard Marek Publishers, 1978.

Dobbs, Bill. Interview, November 21, 2006. ACT UP Oral History Project. http://www.actuporalhistory.org/interviews/interviews_11.html#dobbs.

Duncanson, John. "Canadian Arabs, Muslims Targets in the War on Terror." *Toronto Star*, September 9, 2002, A07.

Duncombe, Stephen. *Notes from Underground: Zines and the Politics of Alternative Culture.* New York: Verso, 1997.

Dundes, Alan, and Carl R. Pagter. *Work Hard and You Shall Be Rewarded: Urban Folklore from the Paperwork Empire.* Detroit: Wayne State University Press, 1975.

Eichhorn, Kate. *The Archival Turn in Feminism: Outrage in Order.* Philadelphia: Temple University Press, 2013.

Eichhorn, Kate. "Breach of Copy/rights: The University Copy District as Abject Zone." *Public Culture* 18, no. 3 (2006), 551–571.

Eichhorn, Kate. "Sites Unseen: Ethnographic Research in a Textual Community." *International Journal of Qualitative Studies in Education* 14, no. 4 (2001), 565–578.

Eigo, Jim. Interview, March 5, 2004. ACT UP Oral History Project. http://www.actuporalhistory.org/interviews/interviews_08.html#eigo.

Eisenstein, Elizabeth L. *The Printing Press as an Agent of Change: Communications and Cultural Transformations in Early Modern Europe.* 2 vols. New York: Cambridge University Press, 1979.

Eisenstein, Elizabeth L. *The Printing Revolution in Early Modern Europe.* New York: Cambridge University Press, 1983.

Elliot, Herb E. "Xerograph Faces the Graph Arts." *Graphic Arts Progress*, May-June 1962.

Ellwand, Geoff. "A Poster Boy for Freedom of Expression." *Lawyers Weekly*, June 3, 2011, 26–27.

Ensminger, David A. *Visual Vitriol: The Street Art and Subcultures of the Punk and Hardcore Generations*. Jackson: University Press of Mississippi, 2011.

Episalla, Joy. Personal interview, May 19, 2014.

Epstein, Steven. *Impure Science: AIDS, Activism, and the Politics of Knowledge*. Berkeley: University of California Press, 1996.

Ernst, Wolfgang. "Media Archaeology: Method and Machine versus History and Narrative of Media." In Erkki Huhtamo and Jussi Parikka, eds., *Media Archaeology: Approaches, Applications, and Implications*. Berkeley: University of California Press, 2011.

Fales Library and Special Collection. Downtown Collection Finding Aid. Available at http://www.nyu.edu/library/bobst/research/fales/downtown.html.

Farley, Kathryn. "Generative Systems: Core Curriculum." Sonia Sheridan and Generative Systems. Available at http://www.fondation-langlois.org/html/e/page.php?NumPage=1991.

Farley, Kathryn. "Process: Hybrid." Sonia Sheridan and Generative Systems. Available at http://www.fondation-langlois.org/html/e/page.php?NumPage=2008.

"Fierce Pussy: Interview." Fierce Pussy. http://fiercepussy.org/www.fiercepussy.org/Interview.html (accessed January 2, 2015).

Finkelstein, Avram. Interview, January 23, 2010. ACT UP Oral History Project. http://www.actuporalhistory.org/interviews/interviews_18.html#finkelstein.

Firpo, Patrick, Lester Alexander, and Claudia Katayanagi. *Copyart: The First Complete Guide to the Copy Machine*. New York: Horseguard Lane Productions for R. Marek Publishers, 1978.

Flynn, Laurie. "Kinko's Adds Internet Service to Its Copying Business." *New York Times*, March 18, 1996. http://www.nytimes.com/1996/03/18/business/kinko-s-adds-internet-services-to-its-copyingbusiness.html?pagewanted=all&src=pm.

Foucault, Michel. *The Archaeology of Knowledge*. Trans. A. M. Sheridan Smith. New York: Pantheon Books, 1972.

Fretz, Eric. *Jean-Michel Basquiat: A Biography*. Santa Barbara, CA: Greenwood, 2010.

Friedman, Ken, and Owen Smith, and Lauren Sawchyn, eds. *Fluxus Performance Workbook*. Aberystwyth, UK: Centre for Performance Research, 2002.

Garvey, Ellen Gruber. "Small Press Magazines, the Underground Press, Zines, and Artists' Books." In Scott E. Casper, Joanne D. Chaison, and Jeffrey D. Groves, eds., *Perspectives on American Book History: Artifacts and Commentary*, 392. Amherst: University of Massachusetts Press, 2002.

Gitelman, Lisa. *Paper Knowledge: Toward a Media History of Documents*. Durham: Duke University Press, 2014.

Gonzalez, Marisa. "Copiers, Motion and Metamorphosis." *Leonardo* 23, no. 2/3 (1990), 295–300.

Gray, Jason. "Best Copy Printing—Al-Qaeda Did My Bootleg Video Jackets." http://jasongray.blogspot.de/2011/05/best-copy-printing-al-qaeda-did-my.html.

Guerrero, Elias. Interview, March 17, 2004. ACT UP Oral History Project. http://www.actuporalhistory.org/interviews/interviews_09.html#guerrero.

Habermas, Jürgen. "Further Reflections on the Public Sphere." In Craig Calhoun, ed., *Habermas and the Public Sphere*, 73–98. Cambridge: MIT Press, 1999.

Habermas, Jürgen. *The Structural Transformation of the Public Sphere*. Trans. Thomas Burger and Frederick Lawrence. Cambridge: MIT Press, 1991.

Hall, Jane. "AIDS Activists Barge In on CBS, 'MacNeil/Lehrer' Show." *Los Angeles Times*, January 23, 1991. http://articles.latimes.com/1991-01-23/news/mn-795_1_aids-activists.

Haloid Company. Advertisement, *New York Times*, October 24, 1948.

Haloid Company. Press release, October 22, 1948.

Harnett, Jon B. "Xerography Is the Name: It's Won 25% of Market." *Sales Management* 68 (January 15, 1952), 106.

Harrington, Mark. Interview, March 8, 2003. ACT UP Oral History Project. http://www.actuporalhistory.org/interviews/interviews_02.html#harrington.

Huhtamo, Erkki, and Jussi Parikka, eds. *Media Archaeology: Approaches, Applications, and Implications*. Berkeley: University of California Press, 2011.

Hutsul, Christopher. "The Threat of a Tidy Toronto: Why a City Needs Its Messy Posters." *Toronto Star*, February 2, 2005, D1.

Innis, Harold. *The Bias of Communication*. Toronto: University of Toronto Press, 1951.

Innis, Harold. *Empire and Communications*. Toronto: University of Toronto Press, 1950. Rpt., Toronto: Press Porcépic, 1986.

Jovanovich, William. Letter to Marshall McLuhan, dated June 13, 1967. Marshall McLuhan Collection, National Archives of Canada, Ottawa, Canada.

Jovanovich, William. Letter to Marshall McLuhan, dated July 2, 1969. Marshall McLuhan Collection, National Archives of Canada, Ottawa, Canada.

Jovanovich, William. "The Universal Xerox Life Compiler Machine." *American Scholar* 40, no. 2 (Spring 1971), 249–255.

Katz, Sandy. Interview, October 15, 2004. ACT UP Oral History Project. http://www.actuporalhistory.org/interviews/interviews_10.html#katz.

Keith, Steven. Interview, June 22, 2010. ACT UP Oral History Project. http://www.actuporalhistory.org/interviews/interviews_20.html#keith.

Kelling, George L., and James Q. Wilson. "Broken Windows: The Police and Neighborhood Safety." *Atlantic*, March 1, 1982. http://www.theatlantic.com/magazine/archive/1982/03/broken-windows/304465/ (accessed January 3, 2015).

Keteyian, Armen. "Digital Photocopiers Loaded with Secrets." *CBS Evening News* (online edition), April 19, 2010. Available at http://www.cbsnews.com/news/digital-photocopiers-loaded-with-secrets.

"Kinko's Inc. History." *Funding Universe*. http://www.fundinguniverse.com/company-histories/kinko-s-inc-history.

Kittler, Friedrich. *Gramophone, Film, Typewriter*. Trans. Geoffrey Winthrop-Young and Michael Wutz. Stanford: Stanford University Press, 1999.

Kramer, Larry. Interview, November 15, 2003. ACT UP Oral History Project. http://www.actuporalhistory.org/interviews/interviews_06.html#kramer.

Lesbian Avengers. *The Lesbian Avenger Handbook: A Handy Guide to Homemade Revolution*. Available at http://www.lesbianavengers.com.

Maggenti, Maria. Interview, January 20, 2003. ACT UP Oral History Project. http://www.actuporalhistory.org/interviews/interviews_02.html#maggenti.

McClintock, Anne. *Imperial Leather: Race, Gender and Sexuality in the Colonial Contest*. New York: Routledge, 1995.

McElhemy, Victoria K. *Insisting on the Impossible: The Life of Edwin Land*. New York: Perseus Books, 1998.

McLuhan, Marshall. "The Emperor's New Clothes." In *The Essential McLuhan*, ed. Eric McLuhan and Frank Zingrone. Toronto: House of Anansi Press, 1995.

McLuhan, Marshall. *The Gutenberg Galaxy*. Toronto: University of Toronto Press, 1962.

McLuhan, Marshall. "Media Hot and Cold." In *Understanding Media: The Extensions of Man*. Cambridge: MIT Press, 2001.

Mele, Christopher. *Selling the Lower East Side: Culture, Real Estate, and Resistance in New York City*. Minneapolis: University of Minnesota Press, 2000.

Meyer, Richard. *Outlaw Representation: Censorship and Homosexuality in Twentieth-Century Art*. New York: Oxford University Press, 2002.

Miller, Andrew. Interview, October 6, 2004. ACT UP Oral History Project. http://www.actuporalhistory.org/interviews/interviews_10.html#miller.

Mitrovica, Andrew. "Canadian Connection to Attacks Takes Shape." *Globe and Mail*, October 23, 2001.

Monnesh, Sheldon J. "Original Copy Cats." *Wired*, June 1995. Available at http://www.wired.com/wired/archive/3.06/kinkos.html.

"Never Stop Fighting." *Los Angeles Magazine*, January 3, 2012.

New Faculty Majority. "Facts about Adjuncts." Available at http://www.newfacultymajority.info/facts-about-adjuncts.

"Oregon County Offices Speed Up Services to Public with Rectigraph Daylight Duplex Photo-Recording Machines." Informational advertisement dated September 1947 (publication unavailable). Chester Carlson's scrapbooks, New York Public Library, Archives and Manuscripts Division.

Owen, David. *Copies in Seconds*. New York: Simon and Schuster, 2004.

Palmeri, Christopher. "FedEx Whites-Out the Kinko's Name." *Bloomberg Businessweek*, December 17, 2008. Available at http://www.businessweek.com/stories/2008-12-17/fedex-whites-out-the-kinkos-name.

"Paper-work Machines." *Challenge* 2, no. 5 (February 1954), 37.

Parikka, Jussi. *What Is Media Archaeology?* Malden, MA: Polity Press, 2012.

Patterson, Clayton. *Resistance: A Radical Social and Political History of the Lower East Side*. New York: Seven Stories Press, 2007.

Peck, Dale. Interview, March 17, 2010. ACT UP Oral History Project. http://www.actuporalhistory.org/interviews/interviews_19.html#peck.

Penley, Constance, and Andrew Ross. *Technoculture*. Minneapolis: University of Minnesota Press, 1991.

"Photocopier Rage Is Common." *Nanaimo Daily News*, March 14, 2002, A2.

Piepmeier, Alison. *Girl Zines: Making Media, Doing Feminism*. New York: New York University Press, 2009.

Poletti, Anna. *Intimate Ephemera: Reading Young Lives in Australian Zine Culture*. Melbourne: Melbourne University Publishing, 2008.

Priest, Lisa. "Held as Threat, Syrian Sought Peaceful Life, Documents Say." *Globe and Mail*, November 2, 2001.

Pryor, Greta. "Take a Lesson from Paris in the Fight against Fliers." *New York Times*, September 14, 1997. Available at http://www.nytimes.com/1997/09/14/nyregion/l-take-a-lesson-from-paris-in-the-fight-against-fliers-088820.html (accessed January 1, 2015).

"The Queer Nation Manifesto." Available at http://www.historyisaweapon.com/defcon1/queernation.html.

Radway, Janice. *A Feeling for Books*. Chapel Hill: University of North Carolina Press, 1997.

Radway, Janice. *Reading the Romance*. Chapel Hill: University of North Carolina Press, 1984.

Ramsden v. Peterborough (City). Supreme Court of Canada (1990). Available at http://scc-csc.lexum.com/scc-csc/scc-csc/en/item/1038/index.do.

Robinson, David. Interview, July 16, 2007. ACT UP Oral History Project. http://www.actuporalhistory.org/interviews/interviews_14.html#robinson.

Schmidt, Peter. "Power in Numbers." *Chronicle of Higher Education* (April) (2014): 14.

Schulman, Sarah. *My American History: Lesbian and Gay Life during the Reagan/Bush Years*. New York: Routledge, 1994.

Schulman, Sarah. *Rat Bohemia*. Vancouver: Arsenal Pulp, 2008.

Schwartz, Hillel. *The Culture of the Copy*. New York: Zone Books, 1996.

Smith, Graeme, Jonathan Bjerg Moller, and Colin Freeze. "From Copy Clerk to Terror Suspect: Investigators Won't Discuss Evidence Taken from Printing Shop in Toronto." *Globe and Mail*, September 28, 2001.

Snelson, Danny. "Archival Penumbra." *American Book Review* 34, no. 3 (March/April 2013).

Speretta, Tommaso. *Rebels Rebel: AIDS, Arts and Activism in New York, 1979–1989*. Ghent: MER. Paper Kunsthalle, 2014.

Sterne, Jonathan. *MP3: The Meaning of a Format*. Durham: Duke University Press, 2012.

Stock, Brian. *Listening for the Text: On the Uses of the Past*. Philadelphia: University of Pennsylvania Press, 1997.

Stosuy, Brandon, ed. *Up Is Up, but So Is Down: New York's Downtown Literary Scene, 1974–1972*. New York: New York University Press, 2006.

Street, Steve, Maria Maisto, Esther Merves, and Gary Rhoades. "Who Is Professor Staff: Or How Can This Person Teach So Many Classes." Center for Future of Higher Education, Policy Report no. 2, August 2012.

Szabo, Julia. "Copy Shop Stitches the Urban Crazy Quilt." *New York Times*, July 3, 1994. Available at http://www.nytimes.com/1994/07/03/style/copy-shop-stitches-the-urban-crazy-quilt.html.

Taylor, Marvin J., ed. *The Downtown Book: The New York Art Scene, 1974–1984*. Princeton: Princeton University Press, 2006.

Tebbel, John. "The Great Copying Boom." *Saturday Review* 49 (May 14, 1966).

Timour, Karen. Interview, April 5, 2003. ACT UP Oral History Project. http://www.actuporalhistory.org/interviews/interviews_03.html#timour.

Toronto Public Space Committee. "History of the Anti-Postering Bylaw." http://www.publicspace.ca/posteringhistory.htm.

Urbons, Klaus. "Das Museum für Fotokopie-Projekt." Available at http://urbons.de/pages/museum.html.

Warner, Michael. *Publics and Counterpublics*. New York: Zone Books, 2005.

Wershler-Henry, Darren. *The Iron Whim: A Fragmented History of Typewriting*. Ithaca: Cornell University Press, 2005.

Wolfe, Maxine. Interview, February 19, 2004. ACT UP Oral History Project. http://www.actuporalhistory.org/interviews/interviews_07.html#wolfe.

"Xerography: Present and Future Applications." In "Xerography," brochure produced by the Haloid Company, November 1949. Chester Carlson's scrapbooks, New York Public Library, Archives and Manuscripts Division.

Yamaoka, Carrie. Personal interview, May 19, 2014.

Zaitchik, Alexander. "The Lonely Truth Quest of Sander Hicks."*New York Observer*, July 21, 2010. Available at http://observer.com/2010/07/the-lonely-truth-quest-of-sander-hicks.

INDEX

1940s, ix, 13–14, 16–17, 19, 169, 170, 174
1950s, 9, 12, 14, 16, 18, 28, 32, 33, 58, 63, 65, 168
1960s, x, 18, 20, 23, 33, 37–38, 44–45, 52–53, 55, 65, 135, 145, 154, 156–158, 169, 177–178
1970s, viii, 2, 4, 6, 24, 29, 33, 39, 44, 45, 47–48, 53–54, 82–83, 89–93, 104–105, 117, 148–149, 158, 162, 169, 170, 178
1980s, vii–ix, 6, 21, 22, 24, 52–53, 74–75, 83, 89, 91–94, 98, 104, 106, 109, 110, 114–118, 120–121, 135–136, 145, 148, 154, 158, 160, 166, 168, 175, 178
1990s, vii–ix, 2–4, 21, 24, 50, 54, 74–75, 78, 90, 92, 94–97, 104, 105–106, 109–110, 116–120, 124, 136–140, 143, 145, 151, 157, 160, 162, 165, 174, 175
3M, 45, 48
9/11, 23, 67, 68, 70–72, 76, 78–79

Activism, vii, 7, 24–25, 94, 114–145, 160–162, 170, 171, 177
ACT UP, vii–viii, 24, 93, 114–145
 Treatment and Data Subcommittee, 131–135
 Wall Street demonstration, 124, 126, 127
 women in, 133–136
Adam and the Ants, 148–149
Administrative work. *See* Clerical work
AIDS, viii, ix, 24–25, 114–145, 160
 activism, 24, 114–145
Anarchy, ix, 2–4, 162
Anderson, Benedict, 61–66
Andrews, Bruce, 53

Art, vii–x, 3–4, 7, 14, 16, 23–24, 28, 41, 44–55, 82, 84, 89–96, 99–100, 101, 105–106, 107, 114–128, 136–145, 151, 158, 178

Bahlman, Bill, 132
Banzhaf, Marion, 144
Baudrillard, Jean, 8, 166
Benhabib, Seyla, 85
Beniger, James, 30–32
Bernstein, Charles, 53
Best Copy, Toronto, 67–79
Bolter, Jay, 157
Boon, Marcus, 59
Borden, Lizzie, 114
Bordowitz, Gregg, 117
Born in Flames, 114
Brooks, John, 32
Buckley, William F., 117
Burnham, Jack, 48

Canadian Charter of Rights and Freedoms, 98
Carlson, Chester, 8–9, 12–13, 17–21, 30, 35–36
Censorship, 7, 93, 105, 116, 120
Certeau, Michel de, 35
Challenge (journal), 28
Chicago, viii, 23, 28, 45, 47–48, 68, 70, 96
Clerical work, 3, 23, 28, 29, 44, 62, 66, 120, 169
Condé Nast, 141, 143–144
Copy art, 45–46, 50–52, 151. *See also* Fierce Pussy; Sheridan, Sonia Landy; Urbons, Klaus
Copy Art: The First Complete Guide to the Copy Machine, 46, 50, 51

INDEX

Copy districts, 73–76
 as abject zone, 72–75
Copying body parts, 33
Copy machines, ix–xii, 2, 4–8, 10, 13, 16–18, 20–23, 25–26, 28–29, 32–35, 37–38, 41–46, 48, 50–55, 72, 82, 89–92, 94, 96, 98–99, 102, 105–106, 109, 115–116, 120, 128, 130, 132, 136, 141, 145, 147, 148–163, 168, 169, 170, 171, 175, 184
 abuse of, x, 10
 in advertising, 29, 33
 archives in, 116, 149–150
 in cartoons, 35
 as transforming robots, 10
Copyright, 19, 34, 40, 42, 55, 59–60, 74, 110
Copy shops, xi, 3, 16, 23, 53, 58–60, 67–79, 89, 91, 96, 176, 179
 Best Copy, Toronto, 67–78, 177
 Kinko's, 2–4, 20, 58
 Village Copier, New York, 58
Counterpublics, 24–25, 79, 81–111, 140–141, 160–163, 180. *See also* Publics
Cyclostyle, 4

Darms, Lisa, 108
Deagle, Richard, 124–125
Derrida, Jacques, 22
Deutsches Technikmuseum, 25, 151–158
Dick, A. B., 5
Dilbert, 10
Ditlea, Steve, 46
Ditto Machine, 4, 6
Dobbs, Bill, 114, 129, 130, 132

Do-it-yourself (DIY), viii, 3, 24, 34, 54, 89, 96–99, 102, 105, 122, 124, 136, 141, 160–162, 178
Dundes, Alan, 36–37

Edison, Thomas, 5
Eigo, Jim, 144
Eisenstein, Elizabeth, 7, 62, 172
Electric Pen, 5
Ellsberg, Daniel, 135
Ensminger, David A., 21, 92–93
Episalla, Joy, 114, 127, 136, 138, 140, 143
Epstein, Stephen, 134–135

Facebook, vii, 104, 161. *See also* Social media
Fanzines, 6, 105, 110, 175. *See also* Zines
Fettner, Ann Giudici, 129
Fierce Pussy, 116, 136–140, 143
Finkelstein, Avram, 93, 121–122
Fluxus, 52
Flyers, 25, 90, 92, 96, 102, 104, 120, 125, 127, 141, 143, 161–162
Ford, Rob, 100–101
Foucault, Michel, 59

Garvey, Ellen Gruber, 53
Generative systems, 23, 28, 44–46
Gilbert, William, 12
Gitelman, Lisa, 18, 135
Giuliani, Rudy, 95
Globe and Mail, 70–71
Gonzalez, Marisa, 50
Gran Fury, vii, 93, 118, 119, 121–126, 138, 181
Graphic Arts Progress, 17
Grusin, Richard, 157

INDEX

Guerrero, Elias, 128
Gutenberg, Johannes, 7, 61

Habermas, Jürgen, 84–88, 109–110
Haloid, 5–9, 13–20, 29, 46, 169, 171
Haloid-Xerox. *See* Haloid
Haring, Keith, 91–92
Harrington, Mark, 131, 133
Hewlett-Packard Canada Ltd., x
Higgins, Dick, 52
Holzer, Jenny, 91–92, 122

Innis, Harold, 58, 63–65, 174
Internet, 87, 129, 150, 175
Islamophobia, 79

Jovanovich, William, 38–41, 44, 54
Juntunen, John, 149–150

Katz, Sandy, 144–145
Keith, Steven, 144
Kinko's, 2–4, 20, 58
Kodak, 6, 45
Kornei, Otto, 13
Kramer, Larry, 114, 121
Kruger, Barbara, 122

Land, Edward, 16
LDX. *See* Long Distance Xerography System
Lesbian, 88, 98, 114, 116–118, 122, 136, 138, 140–141, 143, 145. *See also* Queer
Lesbian Avengers, 116, 136, 141, 143, 145
Lesbian Avengers Handbook, 143, 145
Lichtenberg, Georg Christoph, 12
Lithography, 14
Long Distance Xerography System, 17

Maggenti, Maria, 124
Mail art, 24, 44, 54, 66, 90
Margins, xi, 21, 25–26, 73, 104, 111, 135, 140, 150, 159, 161, 162, 174
McClintock, Anne, 75
McLuhan, Marshall, 4, 8, 10, 38–42, 54, 63, 121, 171, 177
Media archaeology, 153
Microsoft, 144
Miller, Andrew, 129
Mimeograph, 4–7, 32, 52, 105, 115, 160, 170, 175
Montes, Carlos, 177
Museum fur Fotokopie, 25, 151–152, 158

Nationalism, 23, 34, 60–67
NBC, 144
New York City, vii, viii, 3, 12, 24, 36, 43, 48, 54, 58, 82, 83, 89, 91–92, 95–96, 104–108, 114–115, 119, 121–122, 124–126, 131, 136–141, 144, 178
 Department of Sanitation, 82
 downtown art scene, 24, 54, 91–92
 Giuliani administration, 95

Occupy movement, 25, 104, 145, 161–162
Orfalea, Paul, 2, 4
Owen, David, 20

Pagter, Carl, 36–37
Papyrograph, 4–5
Peck, Dale, 127
Pentagon Papers, 39, 135, 171
Perruque, 34–35, 143
Peterborough, Canada, 97–99
Photocopying, vii–x, 37, 50, 70, 74–75, 114. *See also* Xerography
 guerrilla, 128

Photography, 12–13, 14, 16–17, 39, 45, 50, 60
Photostat, 4, 6, 32, 115
Poetry, 6, 44, 53
L=A=N=G=U=A=G=E magazine, 53
Posters, vii–viii, 24–25, 64, 81–111, 114, 118–122, 124–125, 127–128, 130, 138–145, 161–162, 178
Print culture, 7–8, 10, 34, 37, 40–42, 62–63, 65, 67, 85, 88, 109, 159–161, 170
Pryor, Greta, 95
Publics, 24–25, 36, 79, 81–89, 109–111, 160–163, 180. *See also* Counterpublics
Public sphere, 37, 40, 84–88, 110–111
Punk, viii–ix, xi, 3, 24, 54, 66, 92, 94, 105–106, 108, 115, 162

Queer, vii, ix, xi, 24–25, 85–86, 111, 114–118, 120–121, 125, 136, 138, 140–141, 143–145, 160, 162
 activism, 116, 125, 140
 Queer Nation, 116, 136, 140–141
 rights, ix, 24–25, 115, 120–121, 125, 145, 160

Radway, Janice, 88
Ramsden, Kenneth, 97–99
Rapid Duplicator, 4
Rectigraph, 6, 9, 29
Recordak, 32
Riess, P. T., 12
Rimbaud, Arthur, 91
Riot Grrrl, 108
Robinson, David, 128

Saroyan, William, 40
Saturday Review, 17
Schlesinger, Toni, 58

Schonfeld, Zoe, 58
School of the Art Institute of Chicago, 23, 28, 45, 47–48
Schulman, Sarah, 121, 136, 143
Schwartz, Hillel, 20
Seattle, 96–106
Self magazine, 141
Shakespeare, William, 43
Shehab, Ahmad, 68, 71
Sheridan, Sonia Landy, 23, 28, 45–50
Shields, Simon, 98
Siegelaub, Seth, 52
Snelson, Danny, 53–54
Social media, viii, 24, 82, 92, 109, 161–162, 175
"Software" exhibition, 48
Soviet Union, access to xerography in, 168, 175
Spacing magazine, 102, 103
Spirit Duplicator, 6
Stacey, Robert, 99
Stosuy, Brandon, 89
Street art, viii, 24, 93–95
Subaltern, 21, 86
Subculture, viii, 21, 54, 66, 82–83, 86, 104–111, 158, 160
Supreme Court of Canada, 97–98
Szabo, Julia, 3, 4

Taylor, Marvin, 90
Terrorism, 57–79, 177
Timour, Karen, 130, 131
Toronto, viii, 23, 67–74, 77, 97–105
Toronto Public Space Committee, 101–102
Toronto Star, 68
Twain, Mark, 43
Twitter, viii, 104. *See also* Social media

INDEX

Urbons, Klaus, 151–157

Village Copier, New York, 58

Wall Street, 124, 126, 127, 161
Warner, Michael, 84, 86–87, 110
Wendler, John W., 52
Wershler-Henry, Darren, 157
Wheatpaste, viii, 82, 97, 125
Wojnarowicz, David, 91–92
Wolfe, Maxine, 118, 120, 133, 136

Xerography, 4, 6, 10, 12–21, 23–25, 29, 32–41, 43, 48, 52–54, 60, 61, 64–67, 79, 83–84, 88, 90–94, 96, 104–105, 107, 109–111, 115–116, 120, 124, 127–129, 131, 133, 135–136, 141, 145, 148, 150, 154, 158, 159–163, 168, 169, 170, 171, 172, 174, 175, 177, 178
Xerography and Infinity, 8
Xerography Debt, 108
Xerox (company), x, xi, 8, 9, 13, 17–19, 20–21, 28, 29, 30, 33, 36, 40, 45, 46, 92, 168–169, 177
Xerox 914, x, 26, 169
Xerox Book (Untitled), 52
Xeroxed money, 124, 126
Xerox effect, 25, 145, 158–159
Xeroxlore, 35–36, 64

Yamaoka, Carrie, 93, 95, 143

Zines, xi, 3–4, 6, 24–25, 54, 66, 90, 105–111, 141, 161–162
Xerography Debt, 108
Zuccotti Park, New York, 104, 158, 161–162